Botánicas

S0-CXX-280

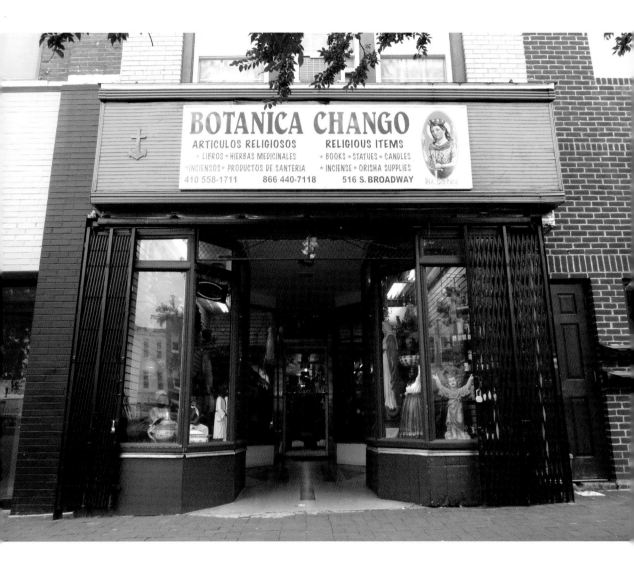

Botánicas

Sacred Spaces of Healing and Devotion in Urban America

Joseph M. Murphy

University Press of Mississippi *Jackson*

www.upress.state.ms.us

The University Press of Mississippi is a member of the Association of American University Presses.

All photographs © Joseph M. Murphy unless otherwise indicated.

Copyright © 2015 by University Press of Mississippi
All rights reserved
Manufactured in Singapore

Frontis: Botánica Changó, Baltimore.

First printing 2015 ∞

Library of Congress Cataloging-in-Publication Data

Murphy, Joseph M., 1951–
 Botánicas : sacred spaces of healing and devotion in urban America / Joseph M. Murphy.
 pages cm
 Includes bibliographical references and index.
 ISBN 978-1-62846-207-4 (cloth : alk. paper) — ISBN 978-1-62674-535-3 (ebook) 1. Hispanic Americans—Religion. 2. Sacred space—United States. 3. Specialty stores—United States. I. Title.
 BR563.H57M87 2015
 200.89'68073—dc23 2014024121

British Library Cataloging-in-Publication Data available

Contents

Preface

Botánicas are religious goods stores in largely Latino neighborhoods that sell herbs, candles, and other wares for the veneration of gods, saints, and heroes from Europe, Africa, Asia, and the indigenous Americas. The online business directory Manta lists nearly 1,400 companies with the word *botánica* in their titles, and there are many more botánicas without it. I first came upon botánicas over thirty years ago when I was learning about the religious tradition often called Santería, which had been brought to the United States by Cuban exiles from the revolution of 1959. Botánicas sell religious articles for Santería ceremonies, and I visited the stores—first in Philadelphia, then in New York and Miami—to learn about the meanings and uses of the ritual objects. I first found botánicas mysterious places, full of strange objects from different cultures brought together in startling ways. Yet amid the unsettling presence of the uncanny and occult, the atmosphere of the stores was warm and welcoming. Owners and clients were almost always generous with their time and patient with my awkwardness with the culture and language. I began sending my students to botánicas in Washington, D.C., to learn about African and Latino religions in diaspora, and from these positive encounters I developed friendships with several of the owners. With their encouragement, I began in 2005 an in-depth study of the stores in the area. I was often accompanied in these visits by undergraduate researchers who offered invaluable help in innumerable ways. For the next few years, whenever I visited a new city I would look to visit its botánicas, and I've conducted interviews and taken photographs in New York, Philadelphia, Miami, Atlanta, San Francisco, Los Angeles, Hartford, Boston, San Antonio, Austin, and New Orleans. Still the botánicas near my home in D.C. provided the bulk of the material for the book and my most enduring relationships with owners and patrons. For owners and patrons who have spoken "on the record," I have used their own names, while for other interlocutors I've invented pseudonyms.

There is quite a bit of literature on botánicas as dispensers of health care in the Latino communities of the United States. Underserved by professional health services, many Latinos have found effective care in the herbal treatments and psychological support that botánicas offer. I've tried to incorporate the research of these studies in viewing botánicas as "pharmacies for the poor." I've been still more influenced by four outstanding studies that deserve mention here: Mary Ann Borrello and Elizabeth Mathias's groundbreaking article on the relationship between botánicas and Puerto Rican spiritism, Carolyn Morrow Long's thorough study of the business of "spiritual merchants," and Patrick Polk's marvelous illustrated book on botánica culture in Los Angeles. Finally, José Antonio Lammoglia's master's

thesis on botánicas in Miami and Havana was an inspiration, and our work together a joy as we visited store after store in Miami.

My own interest in botánicas lies in what I'm calling the "religion" of the botánica, that is, the interactive relationship between devotee and the spiritual beings called *santos* along with the material expressions of it in the wares and shrines of the stores. What may strike the casual visitor as superstitious or tacky strikes me as a beautiful and sophisticated way of encountering a sacred world of power where bodies, hearts, and minds can be transformed. My goal is to try to construct a bridge of understanding between what an outsider would see and what a devotee would feel in encountering the santos at botánicas. In the pages that follow, I sketch something of the eclectic and densely populated spiritual world of the botánica, a reflection of the rich cultural diversity of Latin America, now in dialogue with new powers in new ages in the United States. Botánicas are the public face of a new multiculturalism in America that embraces its indigenous, African, European, and Asian heritages and combines them into potent medicines for survival and triumph in the brave new world of the United States.

It remains to acknowledge the assistance of so many people that underlies the production of this book. First, thanks to my undergraduate research assistants whose keen eyes and ears revealed many things that would have been closed to me: Tanya Olmos, Alejandro Gonzalez, Anahi Cortada, Anne Addison Meriwether, and José Madrid. Thanks to botánica owners for patience and wisdom, especially Maria Calderon, Michele Rios, Marta Bedoya, Andrés Echevarria, José and Carmen Solorzano, Maggie Velazquez, Jason Mizrahi, and Rosa Chicas. Thanks to learned friends for all kinds of research help: Terry Rey, Tony Lammoglia, Maria Concordia, Rosa Parrilla, and Willie Ramos. Thanks to colleagues extraordinaire Bud Ruf and Theresa Sanders. Thanks to David Hagen and Michael Matison for much photographic help. Thanks to Paul and Chandler Tagliabue for gracious and generous support of this inter-religious project. Y gracias a Juana, mi amor.

Botánicas

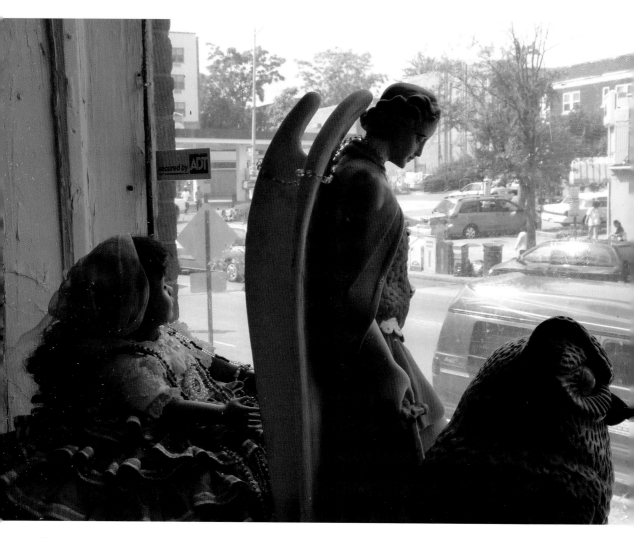

Storefront window, Botánica
San Rafael, Washington, D.C.

Introduction:
Celestial Storefronts

In most Latino neighborhoods in American cities, among bodegas and *taquerías*, a visitor will likely see small shops selling *articulos religiosos*, religious goods. These stores are called botánicas, after the healing herbs and plants that made up their original merchandise. Botánicas have grown with the Latino population and expanded to provide an amazing variety of goods and services addressing the personal and spiritual problems of the people of their communities. As the visitor looks in from the street, he or she will often see large statues of Catholic saints in the storefront window of a botánica. The serene presence of the saints, often draped in hand-stitched garments and ringed by offerings, tells the visitor that the botánica is something more than a retail store. For most of its neighbors, a botánica is a site of healing and succor, a place of mysterious but sympathetic power that acts as a refuge from and remedy for the mean streets of the city.

Should the visitor step inside the store, he or she would find an astonishing array of merchandise referencing scores of spiritual traditions: statues of saints and indigenous heroes, beads and candles, oils and perfumes, all stacked upon one another on high shelves around the walls. Products offer the customer hope in many forms: good luck, the removal of hexes, or the fidelity of a lover. The goods seem to suggest a world open to infinite possibility, where blocked ways can be opened, harsh circumstances lightened, broken relationships repaired. The presence of this other world is signaled by active shrines nestled in different corners of the stores. The niches are often hung in satins and silks, and the plaster figures of saints and other spiritual persons are clothed in sumptuous capes and royal crowns. Surrounding them are offerings of glowing candles, foods, and money. These are the spiritual patrons of the botánica and they bring their presence to the store to protect the owners and come to the aid of their clients.

Time can move at a leisurely pace at botánicas, and owners and clients often chat easily. People come to exchange news and gossip, but also to ask advice. "People come with problems," says botánica owner Maggie Velazquez in suburban Washington, D.C. "Half are problems with relationships, half other kinds. You name it: kids in trouble, pregnant, in gangs." Maggie, like most owners of botánicas, has long experience with these problems. Her sympathy for her clients and willingness to listen to them gives her a special ability to address their concerns. She offers solutions from an encyclopedic knowledge of remedies and paths of action. She says, "People from different places need different spells: some ingredients might work for one but not for another; you have to appeal to each person's spirituality and mix ingredients for each."

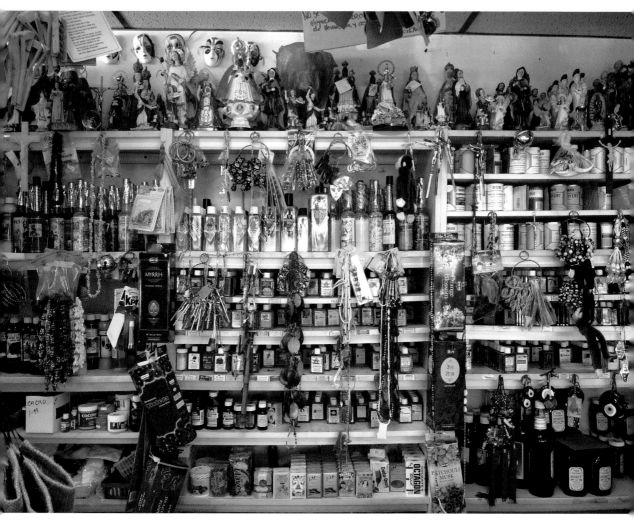

Shelves, Botánica Marie Mercé,
Hialeah, Florida.

In addition to casual advice, most botánicas offer more formal, professional consultations, using a variety of tools to diagnose the spiritual causes of problems and prescribe the appropriate actions to remedy them. Most botánicas have an office at the rear of the store, where owners or other experienced persons provide spiritual readings for clients, delving into their personal lives to assess the causes of their misfortune. Using cards, or water, or shells, the reader can uncover the sources of the client's problem and a path of action to address it. A busy botánica will have a line of chairs with people waiting to consult the diviner. Many clients speak of accurate readings and miraculous solutions and cures. Mirta came to the United States from Cuba in the 1960s and lived in New York. Several years ago, she moved to Virginia and found herself growing ill. "In 2000, I was diagnosed with Alzheimer's," she tells us at Botánica Santa Barbara, "[Owner] Michele did a *trabajo* (spiritual work) for me and I have been healthy ever since."

Marisol is from Colombia and has been struggling to make it in a cable service business in Maryland. She came to Botánica El Salvador del Mundo and was advised by owner José to make an of-fering to San Simón/Maximón, the indigenous saint of Guatemala. With José's help, she made a trabajo for the *santo*, and she tells us, "I had a dream in which San Simón said that I'd receive a phone call. I felt something poking me awake and then the phone rang. It was a client with a big contract: was I interested? Before I said yes I covered the phone and shouted 'Thank you San Simón!' I'm here at the botánica today to thank him with flowers."

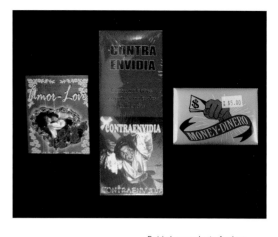

Botánica products for love, protection, money.

Marisol goes on to express a frequently heard sentiment at botánicas: she says, "the saints work because of *la fe*. I don't know how to trans-late it into English. It will move mountains. If I gave you this drink and told you it would make you better, if you have *la fe*, you'll get better." Bo-tánicas are about the healing power of faith, localized in the special idioms of the multiple heritages of American Latinos. Jaime is a carpenter from the Dominican Republic who has come to work at Botánica Gran Poder in Maryland. He says he likes the work and enjoys meeting different people and discussing their life experiences. About the goods of the botánica he says, "People have faith, but they also need to be able to see their faith. So in reality it is not the object which provides the help, but the object is nec-essary to *see* that faith. What we do here [at the botánica] is to provide that object."[1]

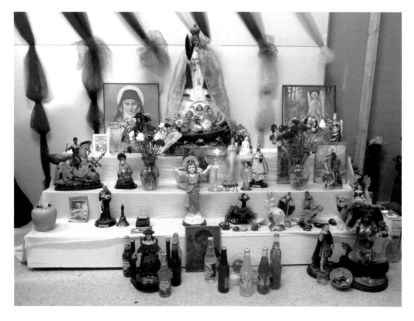

Shrine for twenty-one santos, Botánica San Miguel, New Britain, Connecticut.

Consulting room, Botánica
Santa Barbara, Alexandria,
Virginia.

This tradition of concretizing faith into arrangements of objects and actions has deep roots in Latin American folk piety. Often underserved by official medical and religious authorities, Latin American peoples have developed strong alternative healing systems and venerated patterns of lay leadership. In traditions such as *santería*, *brujería*, *espiritismo*, or *curanderismo*, ordinary people have developed and passed on healing spiritualities that reflect the complex cultural heritages that intertwine in their communities. *Santeros*, *brujos*, *espiritististas*, and *curanderos* have created, often under harsh and oppressive conditions, sophisticated courses of study and criteria of mastery so that practitioners can serve the needs of communities in which they live. They have integrated age-old indigenous healing and spiritual traditions with folk Christianity, African and Asian religions to produce local and now international patterns of remedy. The ingredients for these trabajos are culled from native plants and mixed into teas, baths, and sprays. These are often supplemented with fragrant oils, colognes, and

the flames of votive candles. Prayers and incantations are addressed to pre-Columbian gods and heroes, to African or Asian spirits, to canonized Catholic saints, or to the myriad folk saints unrecognized by clergy but dear to ordinary people.

These deep traditions of independent, alternative spirituality show botánicas to be much more than curiosity shops or religious goods stores. They are vital, interactive sites of healing, offering emotional, physical, and spiritual resources for communities often under stress in urban America. Our plan for this book will be to explore botánicas and to appreciate their world and the world of the spirit they reflect. We begin, like the visitor, from the outsider's perspective of first encounter: coming upon a remarkable spiritual world "hidden in plain sight." The bright colors, perfumed odors, old-fashioned Catholic statues and magical remedies strike many outsiders as naïve and retrograde, but we will recognize them to be complex cultural objects that allow people to "see" a profound faith. The spirituality of the botánica will be revealed to be a creative and effective wisdom path that empowers its followers to survive in the harsh world of urban America. For the botánicas express an extraordinary layering of cultural experience, juxtaposing European, African, Asian, and Native American symbols to effect transformations in the lives of their patrons.

In the chapters that follow, we examine botánicas as stores, as consulting rooms, and as shrines. We start with the historical and cultural foundations of the stores and how they came to be ubiquitous on the streets of urban Latino America. From there we cross the threshold into this alternate world to consider the wares of the botánica and what they mean to patrons. We move next to the consultation room at the back of the store where diviners diagnose problems and prescribe the remedies their clients seek. From here we can consider the spiritual devotions of the botánica, the saints and heroes who can be marshaled in quest of healing. We conclude with a consideration of the magic and of the religion of the botánica, and their power to heal and transform.

1

Foundations of the Botánica

"I'm a Catholic and I go to Mass. It means a lot to me but it's a religion of the ear. The orishas *are the religion of my heart. I put them both together and it helps me grow as a person."*
Teresa, patron at Botánica La Sirene, San Francisco

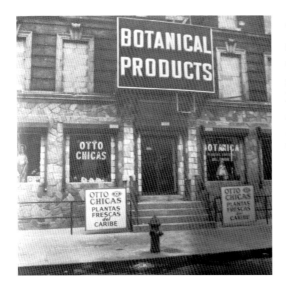

An old photo of Botanical
Gardens/Otto Chicas store,
courtesy of Otto Chicas.

Teresa's participation in multiple and layered spiritual traditions reflects the religious experience of many Latinos in the United States. Each region of Latin America has its own herbal and healing traditions, its own pantheon of saints and heroes, and its own organization of its indigenous, European, African, and Asian heritages. These have become reblended and juxtaposed in the United States, making botánicas highly pluralist spiritual sites. Yet depending on the backgrounds and inclinations of the botánica owners and clientele, a store will feature some traditions more than others. Botánicas in California, for example, are more likely to highlight Mexican traditions like the Virgin of Guadalupe and La Santa Muerte, while a store in New York might be centered on Dominican devotions such as Papa Candelo or Anaisa Pie. Yet different communities are in contact and often communion with others, and so tradition is layered upon tradition in ways that are seen by practitioners to be mutually enhancing.

Amid this diversity and eclecticism, however, there are certain cultural and religious bases that most botánicas share. The origin of the institution in its present form is almost certainly Latin Caribbean and arises in the mixture of cultures in the City of New York. The first botánica to be so called was documented in 1942 by Rómulo Lachatañeré, a Cuban living in New York with the apt qualifications of pharmacist and ethnographer. Lachatañeré had studied African-derived religious traditions in his native Cuba, and he was struck by their presence at a store called Botanical Gardens in East Harlem. The neighborhood, he said, "seems like a Puerto Rican city, but there are lots of Cubans, Dominicans and people from all over Hispanoamérica." He saw the store as "a factor of importance in the life of the Spanish-speaking community of the barrio of Harlem," and he recognized in it something of the Latin Caribbean spiritual world in North America.[1]

Herb stall, Calle Moncada, Santiago, Cuba, 2001.

Man selling iron and candles for the orishas, Calle Moncada, Santiago, Cuba, 2001.

The Botanical Gardens shop reminded him of the Caribbean, or as he prefers to say, "Antillean" stores called *boticas*, small folk pharmacies that sell herbal and magical remedies. He writes:

Undoubtedly the "Botanical Gardens" shows an aspect of the religious life of Antilleans that we observe in Harlem. It expresses the cross between the *botica* of the islands and the North American drug store. It constitutes the acculturation of the *botica* that is popular everywhere in the Antilles. In these

Man selling *orisha* pots, Havana, 2001.

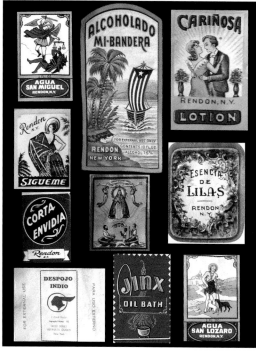

Rendon herbal preparations.

boticas, the pharmacists have to study in depth not only of the scientific but the magical properties of medical herbs that are activated by supernatural forces . . . they have to know the formulae of incantation in order to, for example, arouse or kill sexual powers . . . and there must be cooperation with *curanderos* [healers] if they are not healers themselves, and with those who are called, often inexactly, *brujos* and *brujas* sorcerers.[2]

The Botanical Gardens was already something of a Harlem institution when Lachatañeré came across it in the 1940s. It had been founded some twenty years earlier by a Guatemalan herbalist named Alberto Rendon. The *New York Times* *noted* his passing in 1979 and said his customers considered him "the class of the barrio's flourishing botanica trade, offering fair prices, tracking the most exotic customer requests, devising himself some of the more powerful elixirs, to stir life's love and good fortune and to hold off an enemy's ill will."[3] According to Migene Gonzalez-Wippler, the store originally catered to English-speaking West Indians and African Americans seeking fresh herbs, but in the 1940s "they were soon vastly outnumbered by the large numbers of Puerto Ricans clamoring for spiritual relief from their problems of adaptation to their new homes."[4] It was the store's Puerto Rican customers, says Gonzalez-Wippler, who shortened the name to La Botánica, and the name stuck as a generic term for the unique institution

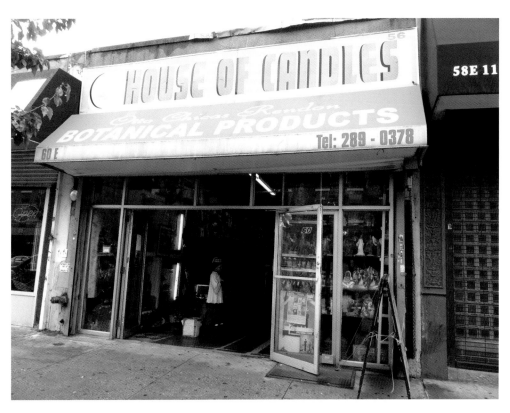

The Botanical Gardens/Otto Chicas store in 2011.

now found in Latino neighborhoods throughout the United States.[5] The Botanical Gardens store survives today in East Harlem, where it is known as La Casa de las Velas (The House of Candles) and is run by Rendon's nephew, Otto Chicas, and his wife, Rosa Chicas.

Carolyn Morrow Long has documented the history of "spiritual merchants" in the United States, beginning with African American root doctors and seers in the South of the nineteenth century. By the early twentieth century, "hoodoo drugstores" prepared remedies for those seeking help with love, money, health, and all the new challenges of urban life. In those days before federal regulations, pharmacies sold all manner of remedies and ingredients important in charm making such as alum, saltpeter, and laundry blue. In spite of professionalization, a few pharmacists continued to make magical preparations, but the bulk of the "hoodoo" market was taken up by entrepreneurs. Long cites the famous study of 1930s Black Chicago by Saint Clair Drake and Horace Clayton that spoke of hundreds of "spiritual advisors" on the city's South Side. Notable among them was Professor Edward Lowe, astro-numerologist, whose store sold "policy numbers, roots and herbs, lodestones, oils, and occult texts such as the *Sixth and Seventh Books of Moses*."[6] In the late 1960s, David Winslow created a compelling portrait of Bishop E. E. Everett, who had come to Philadelphia from North Carolina and owned and operated a "spiritual supply store" in Philadelphia.[7] A store handout announced:

Everett's Spiritual Supply Store
All Your Needs
Bishop Everett is a Man of Faith and Power Who Can Help You Regardless
of What Your Troubles or Circumstances Are. Since the Opening of His Beauti-
ful Store, Homes Have Been Brought Together, Jobs Have Been Gotten, Evil
Has Disappeared From The Shadows Of Many Doorsteps.[8]

In addition to roots and oils, the bishop sold a great variety of candles and did occult work with them on behalf of his clients. Winslow provides a detailed example of candlework to treat a client in "a crossed condition" involving six different candles carefully juxtaposed, dressed with appropriate oils, and energized with Bible verses over the course of three days. This care to detail and to the health and confidence of his clients led Winslow to conclude about the bishop's work, "I strongly suspect that his program is bringing more hope, security, satisfaction, and happiness to the ghetto than all the 'poverty programs' vainly attempting to solve urban problems."[9]

Few of these African American hoodoo drugstores and candle shops are here today; their place taken by botánicas with the waves of Latino migration in the latter part of the twentieth century. Still, an important part of the clientele of contemporary botánicas is African American, and the stores' continuity with southern herbalism and with the African spiritualities reintroduced to the United States by Latinos make contemporary botánicas appealing to African Americans and Latinos alike. Latinos bring to this herbalist heritage distinctive spiritual traditions that expand its metaphysical array. Among the vast variety of Latin American religious traditions present in the botánica, ubiquitous and nearly universal is what can be called folk Catholicism. This comprehends an assortment of beliefs and practices alongside the official Catholicism taught by the *magisterium* of the Roman Catholic Church and promulgated by its clergy.[10] While the line between "folk" and "official" Catholicism may often be difficult to determine, it might be seen in shaded contrasts in the religious lives of Latin Americans. In his studies of the Yucatan, Robert Redfield spoke of a dynamic interaction between a "great tradition," brought from Europe by the Spanish and imposed from above by elites, and a "little tradition," developed by indigenous and creole laypeople that integrated pre-Columbian beliefs and practices with those of the "great tradition."[11] Other observers have recognized a similar dynamic in the religious lives of ordinary people and have posited a distinction between "other-worldly" or "philosophical" religion that is concerned with salvation and the afterlife and "this-worldly" or "practical" religion that seeks remedies for the ordinary problems of life, particularly health in all its senses.[12]

In addition to its practical orientation, folk Catholicism validates lay authority. It is often led and practiced by women and treats domestic and personal problems that afflict the family. Finally, folk Catholicism is centered much more on devotions to the Virgin and the saints, both canon-

ized and not, rather than to God and Jesus. These devotions are deeply reciprocal, characterized by *promesas*, vows of offering to the saints in exchange for their help. Most promesas involve external devotions at the shrines of saints, including pilgrimage to sacred sites and the elaboration of home altars. The material expression of devotion to the saints and other spiritual beings is a common thread of ordinary Latin piety and thus of the spirituality of the botánica.[13]

Together with folk Catholicism, each Latin American people brings to the botánica a host of indigenous experience unique to each nation and region. All these traditions come together in the barrios of the United States, where Latinos are assembling identities and spiritualities from elements both old and new. While we speak of Latinos bringing traditions to the U.S., we should bear in mind that at the same time, the U.S. is absorbing traditions of Latinos. In the words of Mexican-American writer and filmmaker Luis Valdéz, "We did not, in fact, come to the United States at all. The United States came to us."[14] It is too often forgotten that Florida, much of Georgia, Alabama, Mississippi, and all of the Southwest were once Latino and only became part of the United States through much-contested acquisitions in the nineteenth century. Parts of what was known as West Florida were annexed by the United States in 1810 and 1812, and the rest of the territory was ceded in 1821. War with Mexico brought to the United States first Texas and then New Mexico, Arizona, California, and parts of six other current states, each containing substantial populations of Mexican citizens and Native Americans. By the time the Treaty of Guadalupe-Hidalgo was signed in 1848, perhaps as many as eighty thousand people of Mexican and Spanish origin were living in the new American territories.[15]

At the end of the nineteenth century, another set of territorial acquisitions spurred the Latino presence in the cities of the United States. At the conclusion of the Spanish American War in 1898, the United States acquired control over Cuba and Puerto Rico. Cuba gained independence in 1902 while Puerto Rico became a U.S. territory in 1917, its population made American citizens by law. While there had been significant exile communities of Puerto Ricans and Cubans in the United States during the islands' struggle for independence in the nineteenth century, it was the Great Depression and post–World War II economic growth that brought hundreds of thousands of Puerto Rican migrants to the cities of Northeast, most especially to New York. In the 1940s, Lachatañeré said that East Harlem might be thought "a Puerto Rican city," and it was coming to be known as El Barrio by its residents and as Spanish Harlem by others. By 1960 over six hundred thousand New Yorkers were of Puerto Rican birth or heritage, and an estimated one million Puerto Rican citizens of the United States had migrated to the mainland in the postwar period.[16] Today it is estimated that some two million Puerto Ricans have come to the mainland and nearly four and a half million mainland Americans identify themselves to be of Puerto Rican heritage.[17]

Puerto Ricans brought with them Espiritismo, a highly developed and variable tradition of contact with the dead and other incorporeal spirits. Its roots are in European spiritist sessions of the mid-nineteenth century, but the staid séances of Europe took on new dimensions in the intersections of Spanish, African, and Native cultures in Puerto Rico.[18] The creole spirits of Espiritismo manifest in their mediums in dramatic trances often stimulated by percussive music and song. They heal with herbs and demand material offerings, and so botánicas in New York and other cities of the Northeast came to stock the merchandise to interact with these spirits.

In the 1960s, a new wave of Latino immigrants transformed the botánica once again. Over the course of the decade, hundreds of thousands of Cubans relocated to the U.S., exiles from the revolution of 1959. With the famous Mariel boatlift of 1981, the total number of Cubans emigrating neared one million people, one seventh of the island's total population.[19] Early settlement programs for these exiles proposed by the U.S. government attempted to disperse Cubans throughout the United States, but centers quickly developed in New York and Miami.[20] Some Cubans brought the African-derived traditions popularly known as Palo and Santería and so created demand for broad new categories of goods and services at botánicas.[21] Palo is an African-derived tradition of interaction with the dead. Through the rites and objects of Palo, devotees are brought into relationships with deceased persons who can be induced to aid the living. *Paleros* and *paleras* construct home altars with bones, wooden staves (hence the name *palo*, or stick) and other natural substances to provide a symbolic body for the deceased. Through offerings, prayers, and other inducements the *nfume*, or deceased spirit, can guide the living to success in undertakings. Santería is probably the best-known name for the Afro-Cuban tradition of veneration of spirits called orishas. People close to the tradition are more likely to call it Ocha, a hispanicized form of orisha. Some devotees call it Lucumi after the Afro-Cuban ethnic group that developed the religion in Cuba. The name Santería refers to the veneration of *santos*, which only roughly translates as "saints" in English. While the santos of Afro-Cuban traditions include saints familiar to Roman Catholic piety, they encompass much more, particularly the orisha divinities whose devotions were carried to the island by enslaved Africans in the nineteenth century. Ritual knowledge in orisha devotion is extraordinarily complex and requires a lifetime of learning to master. Priests and priestesses of the orishas are called *santeros* and *santeras*, those who "work" with the santos. A santero or santera is ordained to the priesthood only after a course of rigorous instruction and elaborate and costly initiation rites. All this "work" with orishas requires an array of *herramientas para santo*, or "tools for the santos." As Santería/Ocha grew in New York and other cities, botánicas became the principle source of these tools, adding them to the roots and herbs, candles and oils essential in Espiritismo and African American hoodoo.

Herramientas para santo at Original Products Botánica, Bronx, New York.

From these bases in herbalism, folk Catholicism, Espiritismo, Palo, and Santería/Ocha, contemporary botánicas layer traditions from all over Latin America and the world. Dominicans came to the U.S. in significant numbers after the assassination of Rafael Trujillo in 1961 and the subsequent U.S. occupation of the country in 1965. Another, larger immigration wave came after 1980, making Dominicans the fastest-growing population in New York and several other cities of the Northeast. Today some 1.3 million Americans identify themselves as of Dominican heritage. They bring to botánicas spiritual traditions developed out of their long and often ambivalent relationship with their neighbor Haiti. Dominican Vodu, Gagá, and 21 Division are integrations of Spiritism and the Haitian veneration of African spirits into a uniquely Dominican idiom.[22]

The impact of Haitian traditions on botánicas is an important dimension in their history. The Haitian Revolution of 1791–1803 sent shock waves throughout the Atlantic world as slaveholders feared rebellion and slaves and other people of color were encouraged at the prospect of liberation. A large population of Haitians came to Louisiana in flight from the fighting and transplanted African-derived traditions that came to be called New Orleans Voodoo. *Voodoo* and *Hoodoo* are variants of the same Ewe word from Dahomey (present-day Benin in West Africa) and mean

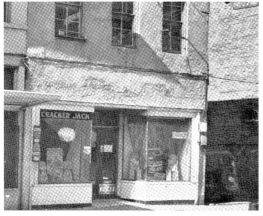

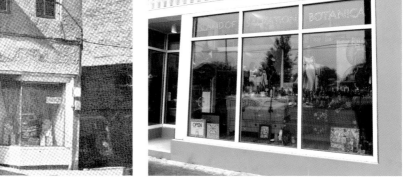

Cracker Jack hoodoo drugstore, New Orleans, ca. 1951, photo courtesy of *Ebony*.

Island of Salvation Botánica, New Orleans.

Marie Laveau's House of Voodoo, Bourbon Street, New Orleans.

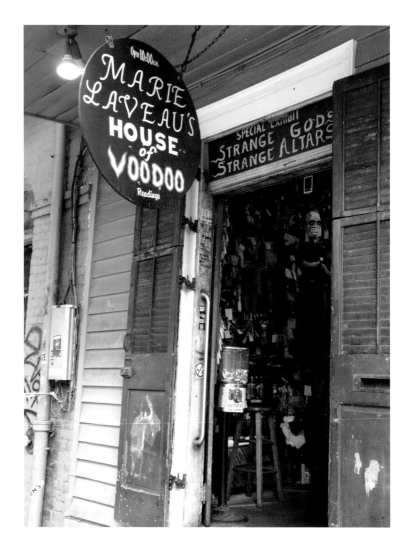

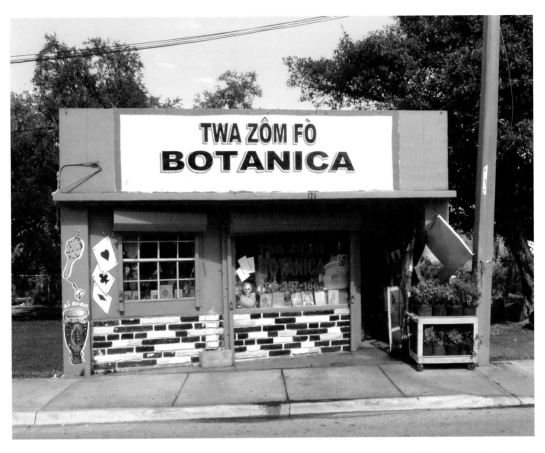

Haitian botánica Twa Zôm Fò, "Three Man Force," Miami.

roughly "spirit." Carolyn Long, in her survey of spiritual merchants, speaks of several New Orleans hoodoo stores dating back to the late nineteenth century, though she found none in operation today. Yet as recently as the 1950s, Edward Clayton wrote in *Ebony* that

the most commercial evidences of voodoo are to be found in crowded South Rampart Street where at least a half-dozen drugstores carry full stocks of *gris-gris* for customers seeking money, power, or straying husbands. These druggists fill voodoo prescriptions with the same dispatch and attention they would give to a regular medical draft, although most admit they don't know if "the stuff" works or not.[23]

Recently, the romance of New Orleans Voodoo and its most famous practitioner, Marie Laveau, have become an attractions for tourists, and shops have sprung up to reimagine the spiritual world of the city's past. American Vodou practitioners have found a home in the city, and the Island of Salvation Botánica serves an active community as well as a large online clientele. Their website offers "a wide assortment of materials for people interested in reaching the Spirit," many made by the store's proprietor, Vodou priestess Sallie Ann Glassman.[24]

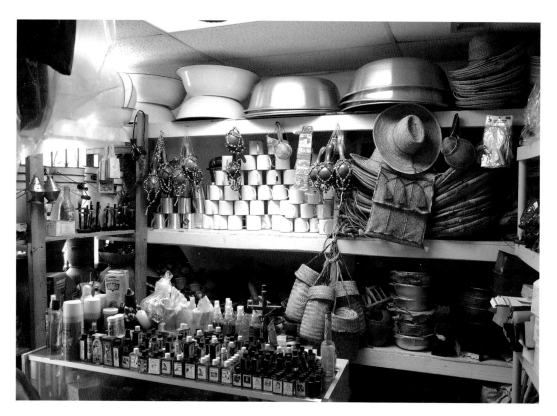

Ason (rattle), *makout* (seed bag), and other articles for Haitian Vodou, Botánica St. Nicolas, Miami.

In the past few decades, Haitians have come to the United States in refuge from political violence and crushing poverty. Highlighted by the tragic boat exodus of thousands of Haitians who fled the island in dangerously small craft in the late 1970s and again in the early 1990s, the total population of Haitian Americans is now some 830,000 people, the bulk of whom live in South Florida and New York.[25] Little Haiti in northeastern Miami boasts several thriving shops to meet the spiritual needs of its immigrant population.[26] The Haitian stores have adopted the Spanish name botánica and stock much the same merchandise as the Latino stores, but they specialize in items for devotions to the *lwa*, African ancestral spirits who have been venerated in Haiti for centuries. A visitor to a Haitian botánica would notice that, in addition to the merchandise for Miami's Santería/Ocha community, there are ritual clothing and vessels, statues and sweet drinks, all used exclusively for the Iwa in Haitian Vodou.

The largest Latino population in the United States is, of course, of Mexican heritage, numbering over thirty-one million Americans. As the Antillean traditions have been forged with European and African symbols with some Taino Indian elements, those from Mexico and Mesoamerica were built with symbols from Europe and Native traditions, particularly Mexica and Maya spiritualities. Here the umbrella term for these often highly localized traditions is Curanderismo and so centers on healing the body and the soul. *Curanderos* and *curanderas* use herbs, oils, and prayer in many ways

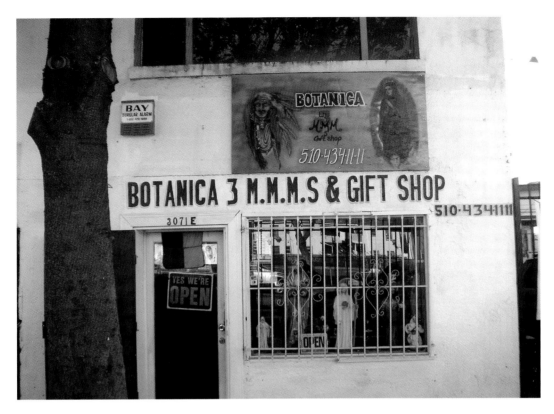

Botánica 3MMM, Oakland, California.

comparable with the Antillean spiritualities that we have been sketching. They petition a wide variety of Catholic saints with promesas of pilgrimage and sacrifice, and they invoke a host of indigenous Mexican santos. A botánica in Oakland, California, venerates santos who show something of the span of Mexican folk piety: Nuestra Señora de Guadalupe and La Santa Muerte. Guadalupe is the patron saint of Mexico and the Americas who appeared to a Mexica convert soon after the Spanish Conquest. While the Spanish identified her as an apparition of the Virgin Mary, she is La Virgen Morena, a beautiful amalgam of Spanish and indigenous symbolism. La Santa Muerte is a more recent devotion; she is the skeleton saint, the inexorable and egalitarian power of death who might be persuaded to protect a people living in a violent and unstable world.[27] These two "totems of Mexican national history," in Claudio Lomnitz's phrase, are important devotions brought to the botánica and now part of multicultural array of spiritual powers to be found there.[28]

A final Latin American group to be considered among contributors to spiritualities of the botánica are immigrants from Central America, particularly Guatemalans and Salvadorans who came to the U.S. as a refuge from devastating civil wars. The Guatemalan war spanned thirty-six years only to end in 1996 with some 200,000 deaths, the majority indigenous Maya peoples. It is estimated that nearly one million Guatemalans came to the U.S. legally and illegally during this period, and today the official record is

Maximón shrine, Paco's
Botánica, New York, New York.

La Santa Muerte shrine,
Botánica Green and White,
Austin, Texas.

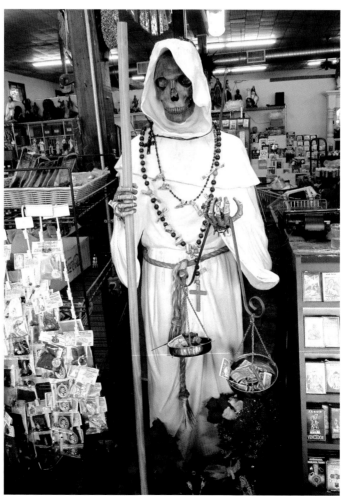

Table 1. Hispanics Living in the U.S.

Pew Hispanic Center 2009*

Heritage Self Identification	No.	% of U.S. Hispanic Population
Mexico	31.7 m	65.5
Puerto Rico	4.4 m	9.1
El Salvador	1.7 m	3.6
Cuba	1.7 m	3.5
Dominican Republic	1.4 m	2.8
Guatemala	1.1 m	2.2
Colombia	917,000	1.9
Honduras	625,000	1.3
Ecuador	611,000	1.3
Peru	557,000	1.2

*Pewhispanic.org.

over a million Americans who identify themselves as of Guatemalan background.[29] The war in El Salvador is dated from 1979 to the peace accords of 1992. An estimated 75,000 Salvadorans died in the "dirty war" of insurgency and clandestine death squads. Anywhere from twenty to thirty percent of the population emigrated, sending 500,000 to a million Salvadorans to the United States. Today 1.7 million Americans trace their ancestry to El Salvador.[30]

Guatemalans and Salvadorans brought to the botánica their own "little traditions," adaptations of folk Catholicism and indigenous Maya beliefs and practices. Prominent among them, and highly visible in Mesoamerican-influenced botánicas, is San Simón, also known by his more indigenous name of Maximón, or simply Mam (Grandfather). He is said to be a more recent incarnation of a pre-Columbian deity of wealth and sexual power who transforms the seasons and the fortunes of those who make offerings to him.[31]

Many other Latin American groups have made contributions to the botánica, as we shall see. In the cities of the United States, peoples and traditions from all over the world are encountering each other, and the older blends of European, African, and Indigenous spiritualities are meeting those of Buddhism and Hinduism and New Age hybrids. The botánicas in the cities of the United States are providing a medium and an institution to share spiritual experience and provide pathways for healing and empowerment.

From this sketch of the history and social context of the botánica, it is time to cross the threshold and visit a store. There is no better place to start than my own home botánica, Botánica Yemayá y Changó in Washington, D.C.

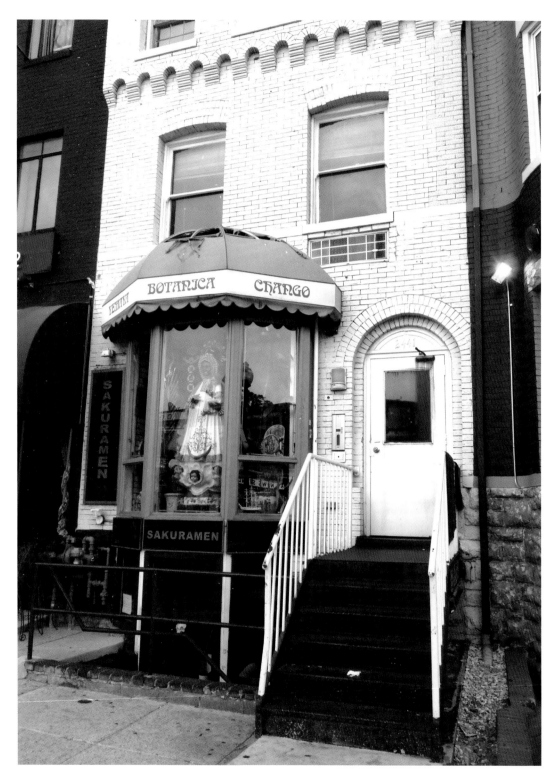

Botánica Yemayá y Changó, Washington, D.C.

2

Wares of the Botánica

People need things to attend their saints; we try to have things for every religion.
Vincente, Botánica Boricua, Wheaton, Maryland

Botánica Yemayá y Changó lies on a busy commercial street in the Adams-Morgan section of Washington. The resident neighbors are largely Latino, but the active nightlife of the area draws visitors from all over Washington and tourists from all over the world. The store is on the first floor of a building that was once an imposing town house, its front door up a steep, heavy, wrought-iron staircase. To the left of the door, a large bay window dominates the facade. The faded blue domed awning says Botanica in its center panel, with Yemaya to its left and Chango to the right. Above the letters are the symbols of these two patron spirits of the botánica's founders: an anchor for the ocean orisha Yemayá and a double-headed ax for the thunder orisha Changó. Enshrined and resplendent in the recess of the window is a life-sized statue of the Virgin of Regla, the patron of the harbor of Havana, and a well-recognized avatar of the African Yemayá. Her striking size and central placement jutting into the street draw the passerby's attention to an otherworldly presence within, and her placid gaze and rich vestments hint at the tranquility and power available inside the store.

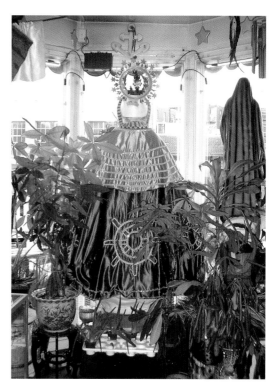

Regla/Yemayá in the window, Botánica Yemayá y Changó, Washington, D.C.

Crossing the threshold, one enters a space of strong sensory experience: a place filled with shelved merchandise in bright, primary colors, flickering votive candles, resounding with recorded music of drums and chants and permeated with sweet incense. It might be overload for the unprepared or an ethereal alternative space for those accustomed to it. The music is a recording of sacred songs to the orishas performed by Afro-Cuban devotees of Santería/Ocha. The choral singing and forceful, precise drumming are intended to bring listeners into communion with the orishas, who stand beside the Catholic saints in the devotional life of many of the botánica's patrons. The candles and incense are active expressions of these devotions, and at several points around and amid the shelves of merchandise there

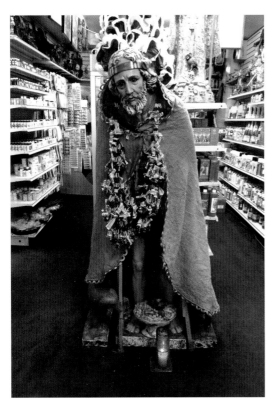

San Lázaro/Babalú Ayé, Botánica Yemayá y Changó, Washington, D.C.

are statues surrounded by glass-encased candles, burning joss sticks, and offerings of water, flowers, tobacco, rum, or money. Each shrine represents a votive occasion for owner and patrons alike. At Botánica Yemayá y Changó, there are at least six active shrines to spiritual patrons. Yemayá is in the window in the guise of the Virgin of Regla; Changó sits mounted as the virgin martyr Santa Barbara, framed in splendid royal drapery just within the doorway. Guarding the door are Eleggua, Ogun, and Ochosi, the warrior protectors of the threshold. The Congo ancestor spirits Francisco and Francisca are seated at the old hearth of the building. And the Maya spirit San Simón, or Maximón, sits in state on the floor between them. Ochún as the Virgin of Charity stands amid gold drapery. And Babalu Ayé as San Lázaro rests on his crutches as dogs lick his wounds. Other botánicas may feature other spiritual patrons such as Maria Lionza, the indigenous queen of Venezuela; or an Andean ékékó spirit; or Santa Marta Dominadora, a water spirit known throughout West Africa and the African diaspora; or a Chinese Buddha.

Pu Tai Buddha, Botánica
Tres Potencias, Falls Church,
Virginia.

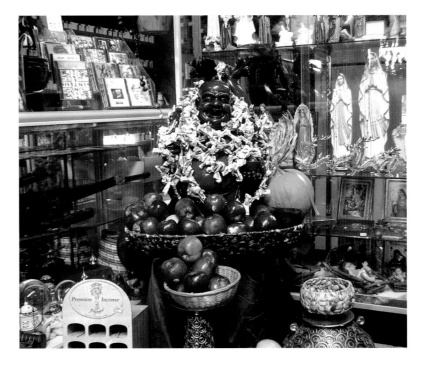

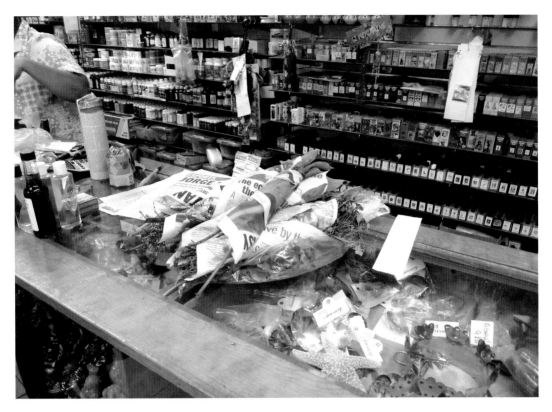

Fresh herbs, Botánica Ochún, New York, New York.

From the shrines, the eye might move to the shelves of multicolored and strongly scented packages, bottles, and jars. These are the wares of the retail dimension of the botánica, energizing objects for purchase. We will look at four characteristic categories of objects for sale: herbs and herb derivatives; candles; statues; and *herramientas para Santo*, tools for Santería/Ocha, Afro-Cuban veneration of the orisha spirits.

Herbs

Pride of place belongs to the supply of herbs: freshly picked and refrigerated at some botánicas, more commonly found dried and packaged in plastic, shipped from Mexico. The herbs are the foundation of the botánica, giving the store its name, a place where "botanicals" are sold. Rosa Chicas, owner of the successor store to the original Botanical Gardens in Harlem says that Mr. Rendon and her husband Otto Chicas began importing fresh herbs from Puerto Rico in response to customers' requests. "Otto had a notebook writing down what people wanted: herbs like the *albahaca*, the *romero*, and there was, like, *abrecamino*, *rompe zaraguey*. He'd say 'OK, I don't have it today, but I'll have it in a couple of weeks or a month.'"

The connection to nature and natural power is central to the spiritual efficacy of the botánica, and herb lore is vast among many Latin American peoples. Every conceivable disorder— physical; mental; spiritual; and, per-

Herbalists Rita and Rafael, Original Products Botánica, Bronx, New York.

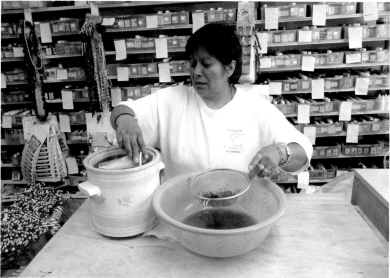

Carmen prepares herbs at Botánica El Salvador del Mundo, Gaithersburg, Maryland.

haps especially, social—can be treated with herbs.[1] Rosa Chicas says that her business is "una farmacia para la gente pobre," a pharmacy for poor people. While botánicas function as dispensaries for people without access to adequate medical care, they are also important to many people for the continuities with traditions from their homelands. Botánicas are places where they can speak comfortably in their own language with sympathetic and knowledgeable people to help them. They can talk about spiritually caused disorders such as *empacho* (indigestion) or *mal de ojo* (evil eye), which are badly understood by medical professionals but are recognized and treated at the botánica.[2] Rosa continues, "The business is a kind of so-

cial work itself, the way you treat a person, if you know how to help them, you do it. It's a service to them, making them feel like they are in their own country."

Herbal preparations can be taken internally, as baths for the body, or aspirated into mists for purifying the home. The basic division, says herbalist Rita Martinez of Original Products Botánica in the Bronx, is between bitter and sweet herbs.

The bitter ones are for protection and removing negativity: the sweet ones are for good luck. *Ruda* or rue is perhaps the most popular: it's a bitter herb used for protection against evil influences. High John the Conqueror is a very powerful plant, people put it in their pockets for protection. *Gotu Kola* is brewed in a tea for memory; *fenugreco* for diabetes, dandelion for liver problems. I'm not a doctor; I only make suggestions. But if people get better they come back.

Escoba amarga/bitterweed is used in baths and cleansings to control contagious fevers and to combat rheumatism. It can also be employed as an abortifacient. *Malavacaea*, or "marvel of Peru," is used in baths and can be taken to treat ear pain. Its roots can be prepared to control menstruation and, in concentrated form, induce abortion. Rosemary is used in cleansings to ease the pain of childbirth. The herb "sandbox tree" can be aspirated to ritually cleanse a house after a corpse has been removed. And wild pine and bastard cedar neutralize sorcery.[3]

The issue of prepackaged and manufactured herbal products can be a contentious one among some practitioners, with purists demanding that herbs be picked under ritual conditions and used when fresh, while others will accept herbs if they are simply fresh, and still others are content with dried and packaged products. Many products for sale at the botánica

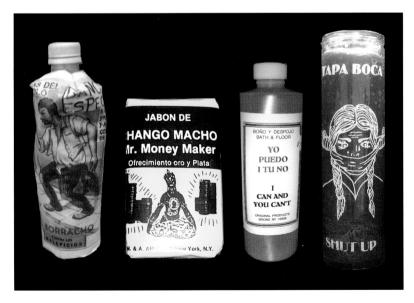

Manufactured products for sale.

are derived from herbs or function as if they were. Manufactured products often claim the effects of the herbal preparations when used in baths and cleansings (*baños y despojos*). Borracho baño y despojo, contra malificios protects the user against the destructiveness of drunkards; while Baño especial del estudiante: maravillos cambios del estudiante offers marvelous changes for struggling students. Jabon de Chango Macho, Mr. Money Maker, Ofrecimiento oro y plata brings money to the bather and Yo Puedo y Tu No: baños y despojo gives the user power over others.

Herbs are essential for the preparation of sacred objects and human bodies in Ocha ceremonies. Combinations of herbs sacred to individual orishas are prepared as baths to cool the powerful *aché* or transformative power of the orishas as it is seated in fundamental stones, shells, or the human body. *Omiero* (soft water) is the vital herbal water that empowers all the tools of the santos, including their human vessels.[4] Orisha priestess Oggun Gbemi writes of sacred herbs (*ewe*) in the Lucumi tradition:

> The *ewes* are indispensible. We cannot practice our tradition without them. There is no negotiation on this. Without Osain [the orisha of herbs] we are weaponless. Every aspiring Lucumi priest must know about the basics of the *ewe* in order to have the most minimal ability to navigate in this world. . . . You will notice that most of our *ewe* are aggressive plants. They are survivor plants, with a strong will to live and will often dominate and even take over or eliminate other plants. Many of them are classified as "noxious weeds" and are on the hit list of the Department of Agriculture in various states. It is no coincidence that our ewes are dominators. The Ashe or "spiritual power" of our *ewe* is about survival. This is the same Ashe that we consecrate our bodies and ritual implements with. The life force of resiliency and adaptability and regeneration is what we receive when we perform the sacred act of making Osain [preparing the herbs of the orisha of leaves].[5]

Candles

Although the herbs are *fundamento*, fundamental objects of power in the botánica, the biggest sellers are candles. Some botánicas such as Otto Chicas's in New York or Botánica Gran Poder in Maryland, advertise themselves as *candle shops*, a term long in use in the African American community as a store selling objects for spiritual work.[6]

The candles might be said to have both magical and religious uses, though, as we will see, these categories overlap and blur. Candles are said to energize the wishes or needs of their users, changing the world by focusing the power of the user's will and connecting it to great powers natural and supernatural.[7] And they can be placed before specific spirit-persons to attract and please folk santos, such as the Catholic saints from Europe, or Yoruba orishas, or Congo *enquisis* from Africa, or Buddhas from China, or indigenous Indians from the Americas. Shelves upon shelves of candles line

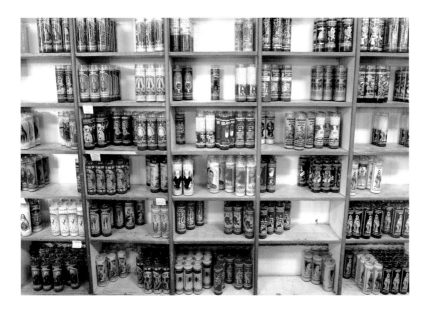

Candles, Botánica Green and White, Austin, Texas.

the walls of stores displaying a multicolored spectrum of color sheathed in glass. The colors are coded in a variety of ways, their meanings layered by the intentions and backgrounds of their users. They are called votive candles (*velas votivas*) because they are the expression of wishes and vows on the part of those who employ them to address the problems of life: white candles for wishes of peace and tranquility, red for passion and energetic action, green for money and procreation, black for retreat and malice.[8] Often pieces of paper are placed under the candle to signal the wish/vow that is being energized. Upon them can be written the name of a lover to attract or an enemy to punish, the hope for a cure for an illness, or a lucky number for a lottery windfall. If the user is a devotee of the orishas, the colors take on additional meanings as each orisha is associated with a particular color or color combination.

Though some candles are set in clear glass with only their color to hint at their powers, most are imprinted with words and images to amplify the message of the color. Many candle names reflect the magical intentions of the baths: Fast Money Blessing, Contra la Ley: Law Stay Away, Haras Mi Voluntado: Do As I Say. Others reinforce petitions brought before spirits such as the Virgen del Cobré, Eleggua, Happy Buddha, El Congo Real. Even Pancho Villa has a candle to access his not inconsiderable powers. Many of the candles have prayer texts imprinted on their glass holders that may be recited to accompany their lighting and placement. Here the petitioner is instructed to make his or her petition to Santa Barbara: "Oh Lord, keep away the wicked, miserable people who lurk in the shadows seeking to harm me. Oh holy, generous, Christian protector, Santa Barbara, open your heart for the good people, do not allow any interruption of my Chris-

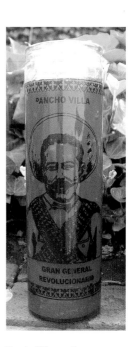

Pancho Villa candle.

Santa Barbara shrine with
candle, Botánica 3x3, Miami.

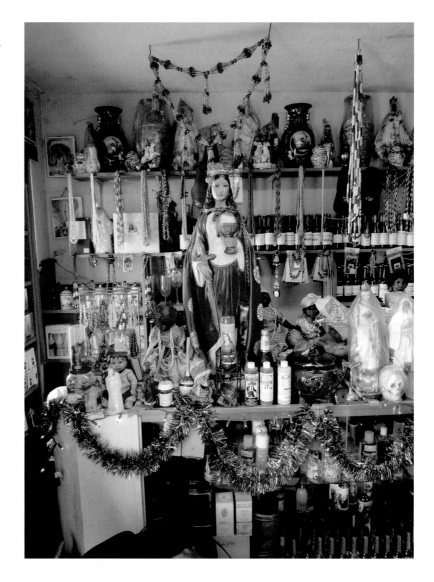

tian path. Protect and save me from all harm." The text for the candle "Tapa Boca/Shut Up" is more aggressive: "To you [insert name] or any other person who tries to harass or harm or impair me through rumors or gossip. I will instantly cover and recover your mouth. Then I will cover and re-cover the ears of those you speak to. Finally if you continue to bother me with evil tongues I will destroy your character to those around you."

A popular instruction book for candle work offers this list of wishes that candles might address:

To illuminate the way for spirit-souls
To obtain the end of a difficult love affair
To obtain peace and tranquility in the home
For the knowledge of the truth

To make a change in luck
To acquire a defense against evil spirits
To obtain lost harmony in marriage.[9]

The book offers several procedures for working with candles to attract a lover, including elaborate instructions on "How to Conquer the Man You Love." A shorter work to tie up a man involves these actions: "Put the name of the person that you desire on a piece of paper wrapped with a bit of your panties, put some perfume that you use on it, light a yellow candle in offering to [Ochún] the goddess of love, and ask her to bring the person to you."[10]

While sometimes there are instructions to substitute appropriate articles for men seeking women, the actions are overwhelmingly addressing concerns of women: peace in the home, the end of malicious gossip, and the fidelity of men.

Statuary

We have already spoken of a few of the many spirit-personalities whose aid is sought by botánica patrons through devotion and promesas. A rough count would find represented some sixty different spirits with origins in each of the five continents. Many of these are imaged by small plaster statues arranged on shelves along the botánica's walls. They are usually between eight and eighteen inches in height, painted in bright colors; the clothes are archaic, the faces sweetly sentimental. Most are well-known to Latin Catholic piety and identifiable by centuries-old iconographic conventions. Santa Barbara, whose life-sized image dominates the entryway at Botánica Yemayá y Changó, can be found in several small versions for sale on the shelves. She is nearly always depicted as a young woman with long flowing hair, the red cape of the martyr draped over her shoulders, and holding the sword of her martyrdom in one hand. Her other hand holds the eucharistic cup, as it is believed that a devotion to her will ensure that the believer will be able to receive the Eucharist at the hour of death. San Miguel the archangel is shown in Roman legionnaire's dress with armor breastplate and skirt, lance raised high poised to thrust at the defeated Devil at his feet.

Santa Barbara statues, Botánica Yemayá y Changó, Washington, D.C.

From these figures known throughout the Catholic world, we find other saints whose devotion arises in specific Latin American regions and whose emigrants have brought their veneration to Washington. The Cuban Virgen del Cobre holds the Christ child in one arm and a cross in the other, standing serenely above three sailors in a storm-tossed boat. These "three Juans" were seventeenth-century Cubans who prayed to the Virgin for shelter in a storm and were answered with calm waters and the gift of her miraculous statue for veneration. The Mexican Señora de Guadalupe is depicted with a

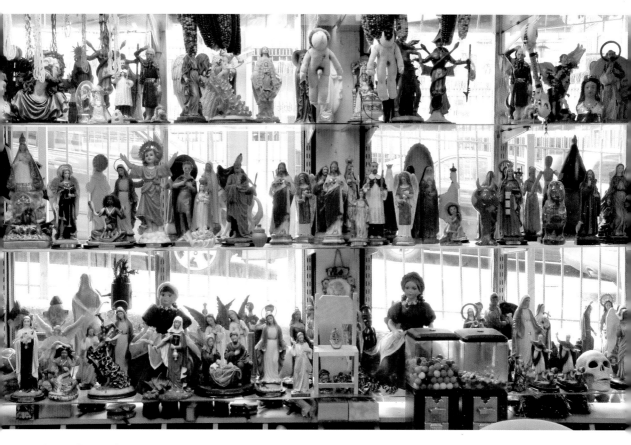

Statues, Botánica Ochún, New York.

Above left: Dr. José Gregorio of Caracas, Botánica Yemayá y Changó.
Above right: San Simón/Maximón, Botánica Yemayá y Changó, Washington, D.C.

distinctive green mantle, embroidered with stars and bristling with rays of the *maguey* cactus. She stands on a crescent moon, her mantle held out by an angel. This mantle recalls her miraculous image on the cloak of the Mexica convert Juan Diego Cuauhtlatoatzin, who brought the garment to Mexico City for the protection and empowerment of the Mexican people.

Still other statues are of folk santos unrecognized by the Church, but important to local communities who venerate them. Images of the Venezuelan physician José Gregorio Hernández are available both in bust form as well as standing full figure. He wears a clipped mustache and a black suit in the style of the early twentieth century with a black homburg hat on his head. He is remembered for his selfless service to the poor and miraculous cures, including raising a man from the dead. He is not to be confused with a folk santo from the Guatemalan highlands known as San Simón or Maximón.[11] He too sports an old-fashioned suit with bright tie and a flat brimmed hat. Like his Maya antecedents,

he sits on a chair receiving petitioners, and his elegance conveys an air of worldliness. With offerings of liquor and tobacco, he might be persuaded to act on less altruistic requests from petitioners. Felicia at Botánica Boriqua told us that while José Gregorio only acts for good, San Simón can be used for good or for evil. A final example of the populous spirit world of the botánica is the devotion to a Venezuelan triumvirate known as Las Tres Potencias: the queen Maria Lionza, the Indian *cacique* or chief Guaicaipuro, and Afro-Venezuelan magician Felipe. These spirits represent the multiple heritages of the region, their combined power and cooperation a marshaling of all the wisdom of the Americas.[12]

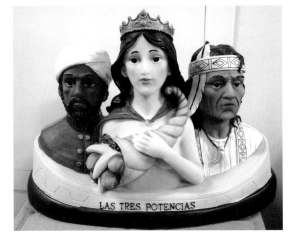

Las Tres Potencias, Botánica Santa Barbara, Alexandria, Virginia.

It is a pervasive tradition in Latino homes to set aside an area for a shrine to the important spiritual personalities in the devotional life of the family.[13] It may be a simple space on a bureau or shelf in a corner, or it can grow to take over entire rooms. Usually, the shrine is set apart with some finery such as satin or brocade drapery. Candles, flowers, and other sweet or precious offerings are placed at the shrine to please and empower the spirit venerated. The botánica provides the furnishings for the home altar, the shrineware if you will, in order to construct a beautiful and effective site for petitioning the spirit. It is here where most statues are placed, candles lit, incense burned, and offerings laid. The candle text for the patron saint of Cuba, Nuestra Señora de La Caridad del Cobré, Our Lady of Charity of [the Eastern Cuban town of] Cobré states: "Oh Blessed Lady of Charity, give me the strength

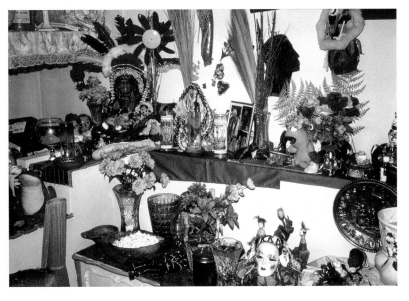

Home altar room, Arlington, Virginia.

Caridad del Cobré/Ochún candle, photo by David Hagen.

and help me against all enemies. Holy Lady of Charity, I humbly and fervently ask that my prayers be heard and answered. I thank Thee for all Thy infinite goodness. Bless the house where [your] image is exposed and honored. Grant me my humble petitions."[14]

The shrine of the santo, either in the home of the devotee or at the botánica, is the site of the promesa, the pact between petitioner and spirit. Here the petitioner vows to perform devotional acts in exchange for the power of the spirit to change the petitioner's situation. The petitioner might promise to perform good deeds, go on a pilgrimage, or change bad habits. And there is usually some promise to maintain and perhaps embellish or expand the home shrine. This principle of exchange is crucial in the spiritual economy of the botánica. While spirits are thought to be able to act as they wish, they can be expected to act within the conditions of the promesa, and they can be enticed to act with offerings that serve to bind them to the agreement. The botánica is capable of furnishing all the articles to make the shrine attractive to the spirits. And the people at the botánica have the knowledge to help the petitioner learn the distinctive tastes of each spirit: the different adornments and offerings that each spirit might enjoy.

Herramientas para Santo

This last category of "holy tools" represents a more esoteric application of botánica merchandise. While the devotions and agreements of exchange are common—if sometimes unorthodox—examples of Latin Catholic piety, the "santo" in this category encompasses another spirituality altogether. We have noted that botánicas sell goods for the practice of the Afro-Cuban tradition called Santería or Ocha, where the santos include African orisha spirits whose veneration is elaborate and often guarded with secrecy. In the early nineteenth century, over a hundred thousand men and women of the Yoruba nations of what is now Nigeria were enslaved and taken to Cuba to work in the canefields. They brought with them religious devotions to the orishas to whom they prayed for strength and wisdom. In Cuba it became expedient to represent the orishas through the iconography of the Catholic saints and a complex and insightful correspondence was developed between *santo* and *orisha*: hence the name "Santería," the way of the santos. In this way images of many Catholic saints not only represent the well-known public figures of Catholic piety but also, to those who know, the orishas of the Yoruba pantheon. Altars in the homes of devotees of Santería/Ocha will often feature an image of a Catholic saint such as Santa Barbara, but her presence and adornments will mean much more to santeros than to ordinary Catholics, for they will know that Santa Barbara

is a public face for the orisha Changó, the lord of thunder, lightning, and justice. San Lázaro, who also has a shrine at Botánica Yemayá y Changó, is a representation of Babalú Ayé, the orisha of the transformative power of disease.

This practice of coding the African tradition within the Catholic one is something of an open secret in the Latin Caribbean community, yet out of long habit of association and the all-too-frequent experience of prejudice against non-Christian religions, the saintly "euphemisms" for the orishas are often used.[15] More recently, there has been a movement among practitioners of orisha religions to come out into the open as members of a distinct religion among others in the community of faiths in the United States. In 1993, members of an orisha-devoted community in Florida won a landmark case before the Supreme Court for the free exercise of their religion.[16] This growing confidence and embrace of American values of religious identity can be seen in the botánica as an increasing array of products references the orishas directly. Along with the names of saintly patrons or their dramatic effects, many packages of herbs, sprays, and soaps are also named after orishas such as Orunla Aerosol Spray or perfumed Oshun Water. Candles are imprinted with orishas' names and colors. And new statues are being sold that represent the orishas, not through the sentimentalized, European-featured plaster casts, but as people of color in ceremonial costume cast in high-definition resins.

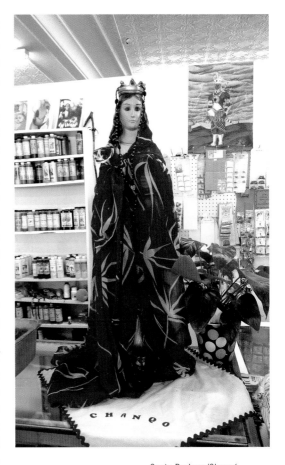

Santa Barbara/Changó, Botánica San Miguel, New Britain, Connecticut

The actual herramientas tools are presented to Ocha initiates during initiation ceremonies, and their uses, as mentioned, are often protected by secrecy. Behind the counter on a row of pegs hang scores of beaded necklaces made of up of small "seed" beads in a variety of colors and strung to about twenty to thirty inches in circumference. They are called *elekes* in the Afro-Cuban language of Lucumi and are given to new initiates when they join an Ocha congregation. A trained Ocha priest or priestess blesses a set of usually four or five elekes determined to be the special orisha protectors of the initiate. Their colors reveal which orishas are guarding the neophyte: red and black for Eleggua, the orisha of transitions; all-white for Obatalá, the king of tranquility; blue and crystal for Yemayá, the ocean mother; red and white for Changó, the lord of lightning; and yellow for Ochún, the mother of riches. These are to be worn every day and will protect the "head" or inner soul of the initiate from all kinds of negative influences

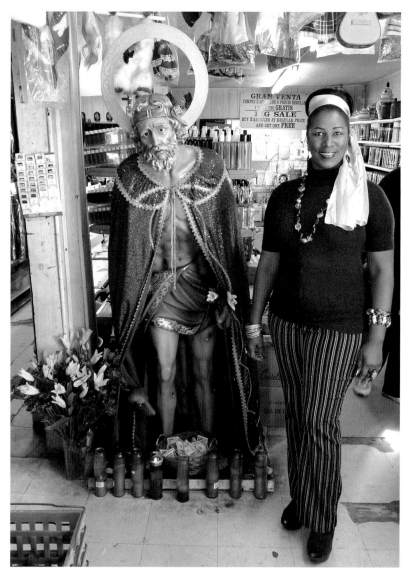

Oshun Water, Botánica Gran Poder, Hyattsville, Maryland.

Devotee with San Lázaro/ Babalú Ayé, Botánica San Lázaro, Hialeah, Florida.

Orisha statues, Botánica Yemayá y Changó, Washington, D.C.

Elekes/necklaces, Botánica Yemayá y Changó, Washington, D.C.

such as addictive habits or the malice of others. The elekes hanging in the botánica are unblessed, and it is expected that a purchaser will have a committed relationship with an Ocha priest or priestess who can carry out the rites to energize the necklaces so that they will perform their protective role.

In a case near the counter, a row of small sculptures reveals another Ocha devotion. A dozen concrete cones, four to six inches high, are set with three cowrie shells to make two slit eyes and a jagged mouth. This is an image of Eleggua, the orisha who guards the threshold of the home and, more generally, safeguards dangerous transitions and opens the paths of opportunity. An Eleggua sculpture, too, is part of the basic initiation into Ocha, and it also must be blessed by a senior priest or priestess in order to perform its deeds on behalf of the initiate. Once blessed, Eleggua is placed at the threshold of the home and must be greeted and periodically "fed"

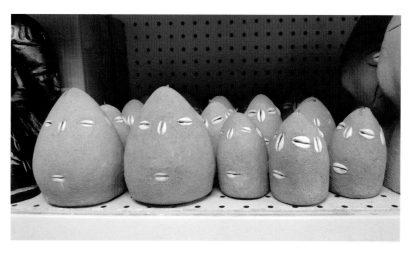

Eleggua sculptures for sale, Botánica Changó, Baltimore.

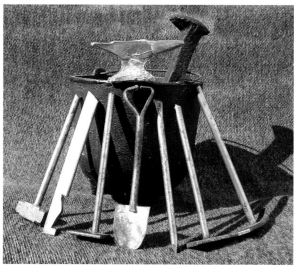

Ogun caldron and tools.

with offerings to remain a source of power and creativity for its owner. Along with Eleggua, the visitor will see small iron cauldrons filled with miniature tools such as hammers and machetes. These are the tools of the blacksmith orisha Ogun, and this symbol of his presence and power is often placed beside the conical Eleggua as they are said to "walk together" to clear the path of life for the initiate.

A final example of Ocha initiation ware might be found in the crockery for sale at the botánica. Soup tureens called *soperas* can be seen in orisha-coded colors, and they signal a higher and more serious level of initiation and commitment to the orishas. After an apprenticeship under a senior priest or priestess, the orishas may demand that an initiate become a priest or priestess him or herself. An elaborate seven-day rite of passage is entailed when the new priest or priestess is made a human vessel for the orishas, and perhaps their medium in holy trance. A sign of this profound commitment is the initiate's investiture with sacred stones that are the earthly "faces" of the orishas and are stored in the soperas. The stones receive the sacrifices of the initiate and his or her community and they radiate the orishas' presence when they are displayed in the soperas at the home altar.

Initiation into this serious commitment to the orishas involves a week-long process of purification and spiritual transformation. In a series of formal ceremonies, the orisha is placed "upon the head" of the neophyte, literally within the body through the application of sacred herbs into small incisions in the scalp. The neophyte is called an *iyawo*, or "bride of the spirit," and like a bride must purchase new clothing, herbs, foods, and drinks

Soperas for sale, Botánica Obatalá, Philadelphia.

Basic home altar featuring soperas, Philadelphia, 1980.

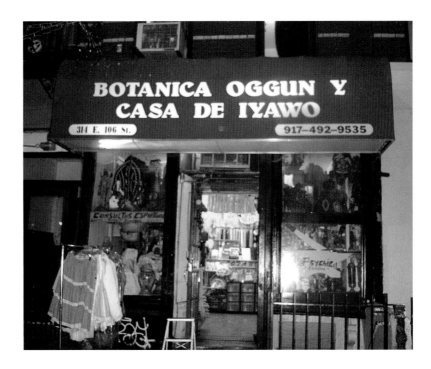

for the ceremonies and feasts and provide honoraria for the priests, priest-
esses, and drummers whose expertise is necessary for the proper protocols
of the long ritual process. The entire community of devotees is mobilized,
and it takes formidable organizational skills to conduct the week of cer-
emonies. Botánicas serve a vital role in this preparatory process, and a few
are actively engaged in the work.

Henry Lara of Botánica La Madrina in Atlanta told me of his innovative
service for prospective initiates and their sponsors. His website advertises:

We offer services of "ceremony coordinator." Ask us about this great service.
We offer guidance from the first mass to the plaza day!!!!!
If you are starting and get confused about all you have to do call us. We also
have all the products that you need.
Be a successful priest/ess having control of all ceremonies and be organized.[17]

While this complete service is, as Henry says, *muy novedoso* (very novel),
many botánicas stock the clothes and other orisha tools for initiation. Ja-
son at Botánica Original Products in the Bronx says his large store is "a one
stop shop" for initiates, and he stocks everything he can to meet their lists
of ingredients.

All these wares—herbs and their derivatives, candles, statues, orisha
tools—are the objects of *la fe*, material symbols of divine power that can be
arranged in patterns to change consciousness and fortune. The knowledge
of these transformative patterns rests with seers and mediums, diviners
and healers, priests and priestesses who have long functioned in the Latino

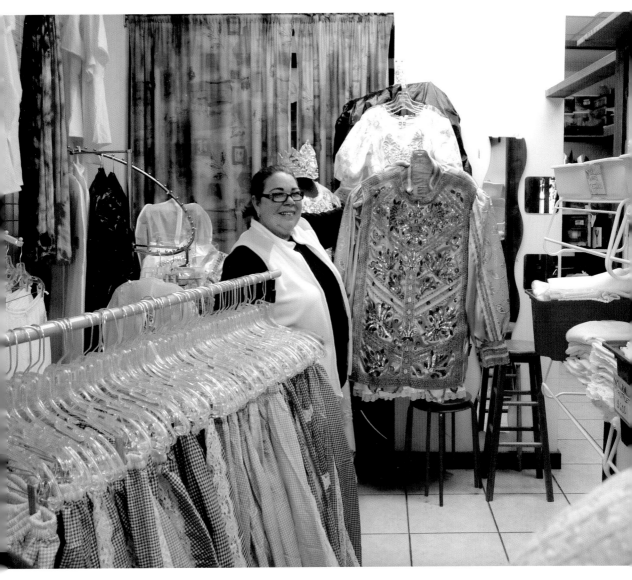

Maria Elena Larralde in her workshop with Ochún initiation garment, Botánica Ilé Orisha, Hialeah, Florida.

community as sources of aid. In addition to being stores of spiritual merchandise, botánicas are also centers of consultation where ordinary people can receive a sympathetic hearing and a path of resolution for their problems. We can look now at the consulting life of the botánica, the people who come and the people who care for them.

3

Consultation: People, Problems, Prescriptions

"If you see somebody in a botánica, they have a problem."

Vincente, Botánica Boricua, Wheaton, Maryland

Even more than stores selling spiritual goods, botánicas are sites of consultation, where people come with problems of health, problems of money, problems of love.[1] Most botánica owners are experienced "readers" of these problems and can prescribe solutions for their clients that become effective through faith, prayer, and careful activation of the ritual objects at the store. In this chapter, we will sketch the seekers and their problems, the readers and their techniques, and the ways in which objects and faith are mobilized in ritual remedies.

People and Problems

Botánica owners are proud of the diversity of their clientele and quick to point it out when asked. "Everyone comes here," says Maria of Botánica San Rafael, "Latinos . . . even Americans." "My clients come from all over," says Marta of Botánica Yemayá y Changó. "I have Arabs, Chinese, Koreans coming." Elena of Botánica Boriqua says, "We have customers from all over but mainly from Bolivia because that's where we're from. But people come from all over. We have Muslim customers who come because they feel their religion isn't working." Maggie at Botánica Gran Poder says, "We have mostly Latinos, but many African Americans too." Her helper, Jaime, estimates that the clientele is half Latino and half African American. Maggie says, "It helps that I'm bilingual and can work with all different kinds of people. Other botánicas can't do that."

Botánica owners will stress that both men and women come for help, though observation shows that most clients are women. "I've heard hundreds of stories. I want to write them down and make a book. They're amazing!" says Maggie. Nearly all the stories she tells involve the problems of women: unfaithful or wayward men, infertility, children in trouble, malicious gossip, domestic strife.

I can't tell you how many women have come to me wishing to become pregnant and have succeeded because of candles to Ochún! And sometimes people have health problems. The other day a woman came in with swollen legs: a rash had

spread from one leg to the other. The doctors told her nothing was wrong with her. She came to me and I saw that she'd stepped in something—some powder—either set for her or for someone else she didn't know. But she was surely hexed. I prescribed some anti-jinx preparations and I expect she'll be better soon.

Women are often the consultants as well as the clients at the botánica. The great majority of the stores that I have visited over the years were staffed, and usually owned, by women. Women can find sympathetic and knowledgeable peers at botánicas, persons who speak their language and who share many of their concerns and problems. Botánicas also provide an opportunity for women's leadership and authority in religious life, opportunities denied to them in the "official" religion into which most were born. At the botánica, women's religious authority can be developed as a livelihood and as a resource for others. The botánica is a site of power that can enable women to live as equals with men, and perhaps, to use Maggie's word, even "dominate" them. She points to an altar featuring a statue of a woman with great unbound hair holding aloft a python. "She's called Santa Marta Dominadora because she dominates snakes, and so, dominates men. That's hard for women to do, to dominate men."

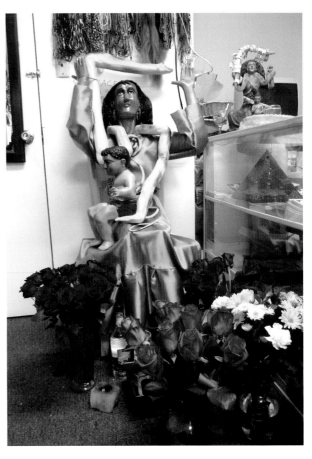

Santa Marta Dominadora, Botánica El Salvador del Mundo, Gaithersburg, Maryland.

Camila at Botánica San Antonio says that most of her clients are women and who come essentially for problems with their husbands and sometimes with their children. It is troubled relationships that bring the majority of women into the botánica, although health and job problems are also prominent. Yet Diana of Botánica Obatala says that she sees more men than women. She says that men come because they want to keep their women or they are lonely and want to attract them. She told of a young man who was looking for perfumes that would bring a girl to him. "You're young; you don't need this," she told him, "but he bought it anyway."

Botánica owners will also stress the economic diversity of their clientele. Jason at Original Products botánica in New York said that the biggest change that he'd seen in thirty years of business is the rising presence of middle-class and wealthy people coming into his store in the Bronx. "Last

week we had a wealthy white woman come in with a long list of things for her initiation into Santería. That would never have happened twenty years ago." Marta tells a favorite story of an illustrious client. A hotel worker whom she had helped was grateful and called to ask her to do a consultation for someone else, a famous *artista* who was staying at the hotel. He said that he could not tell her the famous man's name, but that when she saw him, she would recognize the person. She went to the hotel and was brought to a room to wait. When the artista walked in she was totally star struck. "No, I can't tell you his name," she says. "But I was there until 5:00 in the morning doing the reading and the trabajo for him."

Still, these are exceptions. Most botánica customers are Latina women and they are often poor and struggling with unstable relationships and jobs. Most are immigrants who are living at the margins of the American economy, trying simply to get a foothold in American society. They are underserved by social services and have difficulty getting access to medical and legal help.[2] Ordinary family problems like marital infidelity or children failing in schools are exacerbated by poverty, language barriers, and unstable and dangerous neighborhoods. The people who come to the botánica are trying to build stable lives under these conditions. The spiritual remedies of the botánica seem appropriate responses to problems because so much is out of their control. While middle-class people can afford safe neighborhoods with effective policing and good schools where teachers and administrators speak their language, most botánica patrons have to get along without these privileges, compensating for their absence with very hard work and titanic willpower. The spiritual remedies of the botánica are the embodiment and reinforcement of that willpower, focusing the energy of the devotee on the task at hand. "There are lots of poor people in the religion," says Diana. "They might be poor but at least they are healthy."

Botánica Yemayá y Changó has a flier which lists the kinds of problems dealt with at the botánica. It reads:

All your problems have solutions!
Is your love life not going well?
Would you like to know if your partner is unfaithful?
Are you the victim of a curse or *hechicería* [sorcery]?
Do you have problems with alcohol and can't cure yourself?
Do you want to get ahead in your job or business?
Let us help you.

Michele of Botánica Santa Barbara said that 50 percent of her clients' problems were about relationships (and these largely about infidelity) and the other 50 percent about financial problems. Jennifer said that most of what they do at Botánica Caridad is putting relationships back together. Her father—who sometimes works at the store—agreed, saying that he wished more people came for reasons other than breakups, which can be

tiring and unpleasant to work with. Elena at Botánica Boriqua spoke of both men and women coming to the botánica, especially for issues with their partners. Sometimes parents will bring their children to the botánica, usually when they fall ill. "When parents separate," Elena explained, "the mother-in-law can send *brujería* (sorcery) and the kids are the ones who receive it. We try to talk people into doing good, but they come with their minds set to have some revenge and do *brujería* too."

It is not surprising that issues of aggression and protection loom large in the problems and products of the botánica. In a world of scarce resources, without the protections of property and police, people are vulnerable to malice. When an African American informant to folklorist Niles Newbell Puckett was asked about hoodoo, he referred to charms as "the poor man's lawyer."[3] All the botánica owners and workers that we spoke to over many years of visits were firm that they will not do brujería to harm people. They would often hint that others were not so scrupulous but would never identify anyone as dealing in injurious sorcery.

Maggie at Botánica Gran Poder says, "A lot of what I do is dealing with people's negativity. A woman came in asking for me to fix a car crash to kill someone she worked with who was awful to her. I told her to get out of the store! But they want vengeance. Why not fix the person so that they get another job? You get back what you put in."

This universal principle of reciprocity—what goes around comes around—informs most botánica owners' professional ethics. Maggie tells a story of a disturbed young man who came into the store seeking a preparation that "will destroy the world." He pointed to a candle called Run Devil Run because he thought he was being tempted by the Devil. Maggie confronted him: "Why do you want to destroy the world? What are you going to do when there's no one left? What kind of world will there be if there's only you? What's the matter with you? You're nice looking. You're young. Why don't you use your energy to do some good?"

Listening to this story, researcher Tanya Olmos said later of Maggie, "What spiritual confidence! Maggie feels the responsibility to confront negativity directly." Maggie says of herself, "I'm not in business for the money but for blessings. I've been blessed with healthy, good kids. I'm a millionaire in blessings which is better than a millionaire in money. My reward is people coming back and thanking me for my help."

The Diviners

While not all botánica owners do formal consultations, most work as diviners, skilled "readers" of a client's spiritual situation. For a professional fee, they will use their knowledge and gifts to "read" their clients, diagnosing the spiritual roots of their problems and offering ritual solutions specifically designed for their clients' needs. Some prescriptions involve a ritual

"work" (trabajos, obras) that the client can do on her or his own, while others require the specialized knowledge of the diviner to perform correctly. A typical consultation will cost anywhere from twenty-five to seventy-five dollars and the solutions, depending on the time spent and ingredients used, can be much more. Most works involves a spiritual cleansing of the person (*limpia* or *limpieza*). Michele of Botánica Santa Barbara says,

It takes 14, 21, 28, or 38 days for a work to happen. Some people charge $2000–$3000 for a cleaning. If the spirits tell me to give a person the tools for doing work or to perform a consultation without charging, I have to do it. I last charged $621 for a *trabajo* because the spirits told me to. You could pay $4000 at another botánica. People seem to think that the higher the price the more "official" or the better the consultation and the *trabajo*.

Botánica diviners use a variety of techniques to "read" their clients, ranging from bowls of water, to cards, to shells, to simply "seeing" into a person's spiritual life by their gifts of second sight. Many diviners say that they were born with a gift of spiritual sight and developed it as a result of doing readings for others. Juana at Botánica Santa Barbara in D.C. said that she started having premonitory dreams when she was nine years old in the Dominican Republic. When she was a young woman, she came to the U.S. and began divining with coffee grounds. People started to come to her for consultations. One man was so grateful for the help Juana had given to his daughter that he set her up in the botánica, and she has been consulting and healing with herbs at her botánica for seventeen years. Maria at Botánica San Rafael has a similar story of the development of gifts emerging in childhood. She told us:

I started in this religion since I was in Cuba. When I was little I would tell my mom that something was going to happen, but she wouldn't believe me. She would call me crazy. She was part of an evangelical church. . . . Six years ago I began to work with the owner of this botánica. She was a Venezuelan who worked with the cards very well. She got tired of it and looked for another job. She sold me the store and I bought it. . . . I started developing my spirit not only with coconut shells but also with a glass of water. Through the glass of water I would see a lot of things that were happening to the person consulting me, and I would also read the cards and through my spirit I could see what types of problems people would bring. . . . The problems that people bring get reflected in the water. Some people come with health related problems, or love, or lack of progress. Everyone brings a different problem. Some people have problems with the law or the police. . . . In order to help them, sometimes we have to do *limpiezas* [cleanings] but other times with must do stronger things, like *rompimientos* [breakings], because they have a really bad spirit. I have taken a lot of bad things from people who have been on drugs and they have started a normal and calm life.[4]

The cards that Maria refers to are usually called *cartas españolas* and look like antique playing cards divided into four suits of ten cards each. At a divination session they are arranged in patterns to reveal the past, present, and future of the querent. Each card can refer to a person, quality, or situation, such as "a black man" or "a new beginning." At the botánica, the cards can identify the spirits who are interacting with the querent and suggest ways in which the spirit might be placated or induced to help in solving the querent's problem.

The coconut shells that Maria speaks of are an elementary form of divination called *obi* brought from West Africa to Cuba and other regions of the Caribbean and South America by enslaved Yoruba men and women in the nineteenth century. Obi works by throwing four pieces of fresh coconut shell on the ground in order to determine a proper course of action, usually whether an offering is acceptable to the orisha or other spirit being petitioned. Prayers are said to the relevant spirits, especially Eleggua, who is the orisha of communication between the worlds. The fall of the shells speaks in five *letras* (signs), and thus the oracle offers five interpretative possibilities. Four shells white side up is Alafia, which indicates a conditional positive answer; three white sides and one brown is Etawe and indicates possibility; two white and two brown is Eyife, a clear positive; one white and three brown is Ocana Sorde, which is a clear no; and the final fall, four brown sides upmost, is Oyeku and means danger, probably a spirit of the dead who needs to be appeased.

The coconut obi oracle is just one of the African forms of divination available at many botánicas. Marta at Botánica Yemayá y Changó uses cowrie shells to read for her clients. Marta emigrated from Colombia thirty-five years ago and has been the proprietor of her botánica for over seventeen years. She, too, says that she was born with a spiritual gift and speaks of her first encounters with developing it. "For 15 years I used to go to a Brazilian lady who read cards in New York, but one day I was read with the shell and I liked it and that's how I started to get involved with the religion." She learned the art of cowrie shell divination when she was initiated into the orisha priesthood ten years ago in Philadelphia. Her *madrina* (godmother in the religion) was Puerto Rican, and she crowned Marta with the *orishas* Yemayá and Ogun.

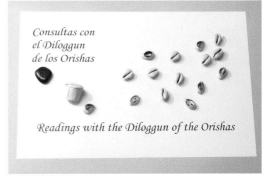

Sign advertising sixteen cowrie divination, Botánica Yemayá y Changó, Washington, D.C.

Like obi, divination with cowries was brought to the Americas by enslaved Yoruba women and men. It is known as *diloggun* in the Cuban Yoruba dialect called Lucumi and means literally "sixteen," referring to the number of shells used. As obi speaks with five letras and can be used by any devotee, diloggun uses sixteen cowrie shells and speaks with seventeen primary letras with many more supplementary ones. Each letra refers

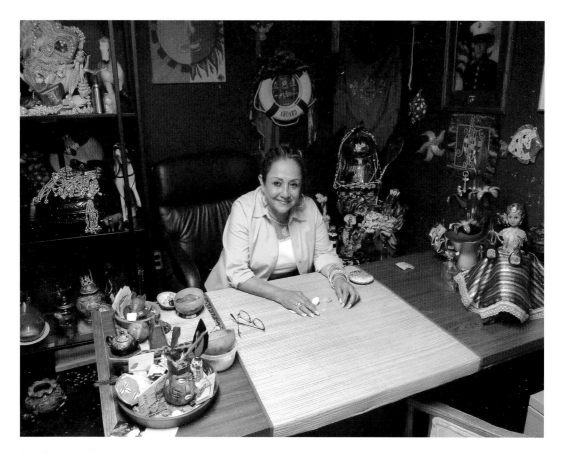

Marta Bedoya, Botánica Yemayá y Changó, Washington, D.C.

to a proverb and a cluster of *pataki*, stories about the spirits in the mythical past. The stories function as archetypal situations, dramas that prefigure the problems and solutions that apply to the client's own situation. With so many interpretative possibilities, diloggun takes years to master and is widely considered to be authoritative in its pronouncements. Its use is restricted to those who are priests and priestesses of the orishas.

The cowries are thrown on to a reed mat and the letra is determined by the number of cowries landing with their open end or "mouth" uppermost or with the mouth downward. Because the backs of cowries are naturally rounded, diviners will file down the backs so that there is an even chance of it falling mouth up or mouth down.

Some botánicas offer another form of African-derived divination known as Ifá, which was also brought to Cuba by enslaved Yoruba. Priests of Ifá, called *babalawos* or "fathers of the mystery," maintained their own systems of instruction and initiation as they developed the oracle in Cuba. Ifá works on much the same principles as diloggun but begins with a system of 256 letras, indicating a wide array of spiritual situations in which the querent might find him or herself. The advanced training of the babalawos gives them a special prestige in the communities of the botánica, and their counsel is often highly valued. In my researches, I only found only a

handful of stores where the owners identified themselves as babalawos, but several stores make Ifá consultations available to clients.

With all these divinatory techniques available, it is interesting that some botánica owners say that they don't need them. "The shells never told me anything," says Michele. "I know it takes a lot of work and training to read with shells, but I can read people just by seeing them." Maggie also seems impatient with divination systems. "I'll read shells in an emergency but generally I don't do it. It takes too much time away from the business. I can usually advise people informally. I think it's better for people to spend their money on the tools that they need rather than fifty dollars for a consultation."

All the diviners we interviewed spoke about spiritual gifts that often manifested in their early years. For the majority, the divination systems worked together with the gifts to provide what they felt was an impartial and accurate reading

Sign for divination services with *babalawo* priest, Botánica Gran Poder, Hyattsville, Maryland.

for the client. Many of the techniques involve randomness: the chance fall of shells or cards. The purpose of the randomness is to get beyond human intention and bias and thus speak clearly with the voice of the spirits or of fate. We might see botánica divination as a series of systems on a continuum: from geomantic systems like the African Ifá and diloggun that rely on the acquired knowledge and the application of traditional verses coded to the random fall of the shells; to cards that have archetypal images but are less specific in scope and so require gifts for interpretation; to water gazing that relies entirely on the reader's gifts; to full mediumship, where the reader is the vehicle for the voice and even personality of the spirit.

I decided to see the divination process at work and, in November 2011, I consulted Maria about the problems of writing this book. I sat in her small consulting room at the back of the store. The room was crammed with spiritual objects arranged in shrines for her own pantheon of spiritual guides and patrons. On a table to the side of her desk was a *boveda*, literally a "vault" or "tomb" of the dead. It was an arrangement of nine glasses of water surrounding a central, grand brandy glass, also filled with water with a cross submerged in it. Maria would glance at it throughout the reading, particularly when questions of the influence of the dead were uppermost.

As she shuffled the deck of cartas españolas, she said prayers in Lucumi and Congo, the ritual languages of the two Afro-Cuban traditions into which she is initiated. She asked me to cut the deck into three stacks, and she laid out the cards in rows from each of the stacks sequentially. I had framed a somewhat impersonal question about the hope for the success of this book, but Maria's diagnostic questions quickly became personal indeed.

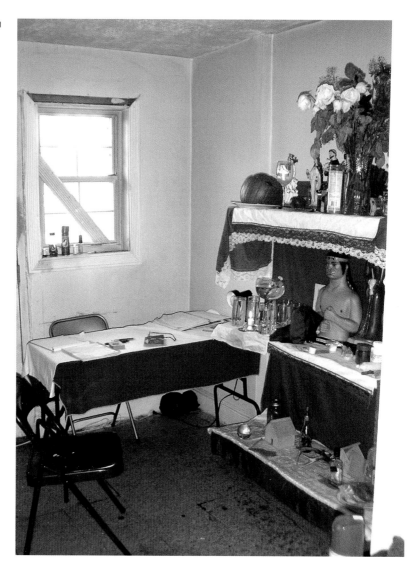

Consulting room, Botánica San Rafael, Washington, D.C.

The cards say there is trouble in the family. They say a young man. Do you have a son? No, then perhaps he is a companion of your daughter. He's no good. He'll leave her. The cards say that you have trouble sleeping. There's a burden on your shoulders. I can feel what you feel on my shoulders. You are going crazy writing this book? You have to be very careful. The cards say Oddi Meji, which is the sign of treason: *donde nació la traición* [where treason is born]. You can't trust anyone, but Ochún and Yemayá are going to help you with this project. Don't worry: Changó will protect you from the treachery.

I can see two spirits with you as well—Black people not whites. One is a black man, very intellectual and the other a very dark black woman, African. She's dressed all in white like an iyawo, I can only see her face. You need to go to the *boveda* to make offerings to them: candles and prayers to strengthen

them so that they can guide you. You can find out their names at a *misa espiritual* which will investigate your spiritual group.

After these and more observations, Maria told of the cards' prescription for the success of the book. "The main problem is tranquility. You need to make a bath of white flowers, *cascarilla* [dried egg whites], *rompe zaraguey* [an herb], honey, and rice water. You should also feed the orishas Eleggua, Ogun and Ochosi. If you don't feed them then instead of taking you forward they will take you backward."

As we have seen, Maria has known of her spiritual gifts since her childhood in Cuba and has developed them in obi, water, and card divination. Though she grew up with Cuban orisha veneration, she has only recently been initiated into the priesthood and invested with the diloggun cowries. I was struck by her combination of techniques in the reading as she supplemented the information from the cards with spiritual sight in the waters of the boveda. Even more striking was her parallel between the patterns of the cards and the signs, or letras, of diloggun,

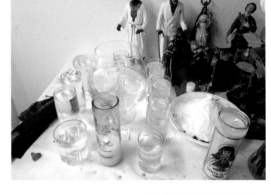

Boveda, Botánica San Rafael, Washington, D.C.

divination with sixteen cowries. Oddi Meji is a letra resulting from the double fall of seven shells and is usually considered a vehicle for the voice of the Yemayá, the orisha of the seas. Among the many verses associated with this letra is indeed the one of treachery: donde nació la traición.

I don't know if Maria's parallelism of card and shell divination is widespread or an innovation of her own, but it is a creative juxtaposition of divination techniques to arrive at the diagnosis of the spiritual problem

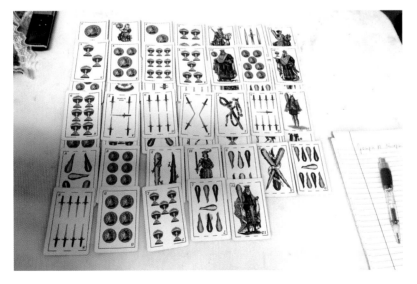

Layout of *cartas españolas*, Botánica San Rafael, Washington, D.C.

of her client. We can see this creativity in the ways botánica professionals offer prescriptions based on divination, "works" to address the problems people bring.

Trabajos, Despojos, Limpiezas, Obras

We have seen that divination entails prescription: Maggie prescribed candles for Ochún for women seeking to become pregnant; the cards told Maria to prescribe an herbal bath for me. The consultation determines the client's spiritual situation—both the problem and the solution—in which she or he is enmeshed. The underlying nature of the problem is revealed to lie in subtle spiritual forces, and the solution is found through addressing these forces by the symbolic energizing of ingredients in ritual action. Some work may be undertaken by the client him or herself with some instructions or suggestions from the botánica owner. Monica at Botánica Santa Barbara in suburban Maryland says she often prescribes for her clients herbal baths and teas in varying strengths, depending on the severity of the problem. The treatments, she says, can be with three herbs, seven herbs, or twenty-one herbs, and with these she'll recommend three baths to cleanse and three to attract good spirits.

Most works emanating from botánica consultations involve these self-administered treatments, but some work requires specialized knowledge and human resources that the botánica owner or other spiritual professional will put into action on behalf of the client. We have seen a variety of terms used for the work: trabajo (work, job), obra (work), despojo (stripping), limpieza (cleansing), rompimiento (breaking). The terms are often used loosely and sometimes interchangeably. A rough scheme can be constructed using the broad categories of the botanicals themselves. Carlos at Botánica Changó in Hartford says that the works of the botánica are seen in the two major kinds of herbs: bitter ones to repel and sweet ones to attract. This corresponds to works for the protection of the client and works to attract good fortune to him or her. These two categories of work might be further divided into those done *on* the client—on the body or the home—and work done *for* the client, effecting change in others.

Divination will often reveal that some spiritual force—either a negative disembodied spirit or a force sent by an enemy—has attached itself to the body or home of a person. This can come about through the active malice of another who is using sorcery (brujería or hechicería) or through someone's conscious, or even unconscious, feelings of envy (*envidia*, *mal de ojo*). Victims of this spiritual malice may fall sick, become accident prone, or suffer serious disappointments in their lives. To remove the attachment of the negative force, diviners will prescribe a trabajo that involves some kind of cleansing or breaking of the attachment. Work on the client begins with herbs, either in a bath to neutralize and wash away the negative force, or a despojo, a stripping away of the force through drawing the negativity

into objects and releasing it from the victim. A common despojo is done with a bundle of selected herbs, cinched at the stems, and used as a broom to wipe the body of the client. Based on her experience in Cuba and Miami, researcher Anahi Cortada characterized spiritual work in this way:

The person doing the *despojo* can spit *aguardiente* [raw rum] and the smoke of cigars, and as the person who is receiving the *despojo* turns, the other one hits him with the *yerbas* from head to toe, rubbing the *yerbas* throughout the whole body as a way to clean the person, to strip them of something bad. *Limpiezas* can follow the same procedure, only they can be done with animals, usually chickens or pigeons. A *rompimiento* is for a more severe case. The person do-

El Despojo, Félix González Sánchez.

ing it usually strips the other person of his clothes, breaking them as a way of breaking that bad spirit, or energy the person has.

The affecting and accurate painting by Cuban-born, Miami-based artist Félix González Sánchez shows a despojo in progress. The client stands in the center, exposed and receptive to the spiritual forces marshaled on her behalf. Three spiritual workers carefully attend her, censing the air with tobacco smoke and lighting the scene with candles. One attendant pours herb-infused water over her head and body as she is swept with an herbal bundle. Another shakes a rattle, likely chanting prayers in Spanish or Lucumi, the African-derived language of Santería/Ocha. The third spiritual worker wipes the client with a live dove, transferring the negativity that has become attached to her to the animal. The experience is full of powerful symbols of transformation: the "stripped down" state of the client open to change; the rich sights, sounds, smells, and feelings of the objects in play; and the multiple, simultaneously employed techniques of changing negativity through washing, sweeping, fumigation, and transference.

The despojo, whether a simple herbal bath or the elaborate ceremony shown above, is only one of the works that can be prescribed at the botánica. Researcher Anahi Cortada tells of the types of spiritual work familiar to her in Cuba and Miami:

You do *trabajos* and *obras* as an offering when you want the spirit to give you something you want. For example, women who want to get pregnant use pumpkins and honey to do a *trabajo* or *obra* to have a baby. The *trabajo* is something you do on the person: like to rub the belly of the woman with the pumpkins. The *obra* is more the offering. You put the pumpkins to Ochún directly. *Obras* are also used as a way of thanking the spirits for something that they have already given you.

These practices of working *on* the client lead us to consider the other direction of spiritual work: work done *for* a client in order to effect changes beyond the person, to make things happen in the world. These, of course, can be for good or ill; the line dividing them is not always clear, since the line between justice and vengeance is often in the eye of the beholder. Raquel Romberg's intimate study of Puerto Rican botánica owner and bruja Haydée taught her that there were *trabajos buenos* and *trabajos malos*. At one point, Haydee declared, "I am a mediumidad positiva of light, I don't harm . . . [my motive] is love. But I can make any *trabajo* you want; I have the instruments. I'm La Bruja de Villas de Loíza."[5]

It is true that there is prestige and respect in being thought capable of trabajos malos. In a hard world it may, at least sometimes, be better to be feared than to be loved. Romberg shows how Haydée embraces the word *bruja* (sorceress, witch) to describe herself and uses people's fear of it to enhance her social capital and hence power to work trabajos, both malos

and buenos. I can recall vividly the effect on me when a santera I had met deprecated her own powers but boasted in English that "my husband is one bad witch."

Once again malo and bueno is in the eye of the beholder. The "poor man's lawyer" seeks justice for those who employ him. On one occasion I observed a padlock placed on Maria's *nganga*, a large iron cauldron that acts as a "house" for the spirits of the dead in the Afro-Cuban tradition of Palo. Maria said it was part of a trabajo for a client who was being harassed by another, and the padlock was used to hold back the tormentor, to keep him from moving around. The trabajo was done with the lock, and the idea was that the person remains trapped by the lock.

Botánica owners can be reticent in speaking about their trabajos for other reasons as well. The combinations of objects, actions, and words are their professional secrets and the source of much of their livelihood. I didn't press workers to describe the specifics of their trabajos, they would often refer me to various published "spell books" to show how something is done. Migene Gonzalez-Wippler's *Rituals and Spells of Santería* provides procedures for a number of trabajos that invoke the power of the orishas. Here are two short examples:

• This ebbó [literally "work" in Lukumi] calls for the cleansing of an individual with four of the foods sacred to Changó during four consecutive days. The first day the cleansing is done by rubbing the body with four bananas. The second day four apples are used in the same manner. The cleansing is repeated on the third day with four pomegranates and the fourth day with *amalá* (cornmeal and okra. The amalá is placed in a plastic bag before rubbing it over the body. All four foods are gathered together on a piece of red cloth which is tied and brought to the woods with Changó's derecho, which is usually six cents.[6]
• To Make a Person Leave: The name of the person is written on a piece of brown paper and then reduced to ashes. It is placed in an empty can to which are added three grated roots of rompe zaraguey and three leaves of yerba buena. The can is left at Elegguá's feet for three days and then the ashes are sprinkled where the person will be sure to step on them.[7]

These "generic" trabajos however are not tailored to the individual situations of the clients. All the botánica owners that I have spoken to about this work were firm in saying that they do specific trabajos for specific clients and each is constructed with ingredients revealed by the spirit in divination. Michele of Botánica Santa Barbara told a story of a woman who came to her asking for help in finding her nephew who had been missing for four months. Michele read for her and said that it would take two weeks to find the young man and that he would come straight to the botánica. Michele would not speak of the ingredients of her trabajo for this situation, but the nephew appeared at the botánica as predicted and was reunited with his aunt.

Trabajos may involve appeal to spirits or orishas if the worker is versed in the religion of Santería/Ocha. These trabajos are based on reciprocal exchange: offerings to the spirit in exchange for help and success in the undertaking. Here, as Anahi Cortada says, the word *obra* is perhaps more appropriate and might still more specifically be referred to as an *ebo* (or *ebbó*) in Lucumi, the Yoruba-derived language of Santería/Ocha. An ebo can range from a simple offering of flowers at the altar of a spirit, to the presentation of elaborate foods prepared especially for the spirit's characteristic tastes, to grand ceremonies of invocation in which music and dance is used to appeal to the spirit's pleasure and entice its presence.

Manuela of Botánica Boricua once showed me how to make a small ebo to San Lázaro, the patron saint of the poor, the ill, and the disabled. The saint is imaged as an old man dressed in rags and supported by crutches. Dogs lick his open sores. From behind the counter, Manuela brought out items for the ebo: two miniature crutches and a length of purple ribbon. She said that in order to appeal to San Lazaro, I must write the name of the person that I am praying for on a slip of paper, place it between the crutches, and wrap them tightly with the ribbon. Then place this bundle before the image of the saint and pray in humility for the health of my loved one. The saint can do miracles.

Cures that astonish medical doctors inspire many conversations at botánicas. Diana told a wonderful story of a woman who came to her botánica having been diagnosed with cancer that was spreading over her whole body, and the doctors could not determine the source of the disease. "Death was coming for her," she told us, "but Orula didn't want death for her yet." Orula is the orisha of divination and the patron of babalawo diviners, a spirit who sees the past and the future. Diana gave the woman some remedies, and she got better but did not completely recover. Orula finally revealed that the source of the cancer was the rectum. The woman told her doctor, and he was able to prescribe a successful treatment to stop the spread of the disease so that she is alive today. Now, Diana said, her doctor wants to meet Orula!

We have noted the use of animals in trabajos and obras either as receptors of negative energy or as offerings to the spirits. This is one of the more controversial aspects of botánica work and led to a major confrontation in the late 1980s in Hialeah, Florida.[8] Concerned about the use of animals in religious rites in the city—and the growing presence of Black Cubans who practiced them—the Hialeah city council passed ordinances banning "animal sacrifice." A group of santeros who had incorporated their congregation as the Church of Lukumi Babalu Aye challenged the statute by publicly conducting sacrificial rites. They were arrested, tried, and convicted in the local courts, but they appealed the rulings all the way to the U.S. Supreme Court. In 1993, in a landmark "free exercise" of religion decision, the Court voted 9-0 in favor of the santeros. The Court determined that if the Hialeah council's concern was public health, there were ample enforce-

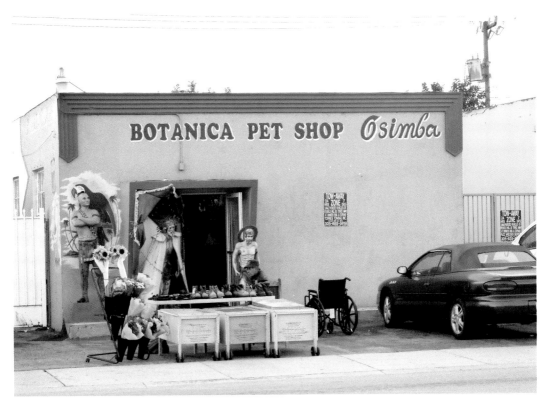

Botánica Pet Shop Osimba, Hialeah, Florida.

able health codes addressing animal storage, slaughter, and disposal. If the concern was the humane treatment of animals, there were laws concerning animal handling and humane slaughter. If the concern was "sacrifice," then the council was seeking a ban on religion and so was in violation of the Constitution. During the heated days at the time of the case I was speaking to a santero friend who sighed, "You can kill an animal in this country for any reason at all, as long as you don't pray over it."

Most devotees purchase these animals from live animal markets that can be found in any city. When the spirits request animal offerings—usually fowl but occasionally sheep and goats—trained priests and priestesses are required by ritual to slaughter the animals quickly and cleanly. Their blood is symbolically fed to the spirits by being poured on the sacred objects in the soperas. The carcass is then dressed and the meat is cooked into a variety of dishes sacred to the spirit and subsequently eaten by the congregation in a communal meal.

Not all botánica patrons are devotees of Santería/Ocha, of course, and some are as uncomfortable with ritual slaughter as the general public. Yet many immigrants to the United States from Latin America and the Caribbean grew up closer to the sources of their foods and have not been as insulated as the average American from the production and distribution of meat and poultry. Few botánicas in my research sold animals directly, though on several occasions I have heard clucking and rustling in the back

room, presumably fowl being readied for an ebo. In South Florida, however, a number of botánica owners have obtained licenses as "pet shops" and have legally sold poultry directly to clients.[9]

The heat of the controversy in Hialeah has abated somewhat, and there is a greater acceptance by the public regarding the legitimacy of Santería/Ocha and other Afro-Latin religions. Yet concerns on the part of animal rights organizations continue, and occasionally activists make headlines accusing devotees of animal abuse. The ASPCA has moved from active opposition to all forms of "animal sacrifice" to a position stated on their website that reads, "The ASPCA respects religious beliefs and traditions, but is opposed to any practice in which animals are made to suffer in the name of religion or tradition."[10]

We should not forget that the focus of all these practices—whether they are broadly accepted or not—is on healing, that is, on the reduction of human pain; on developing humility in the face of misfortune; and on the hope of a better, tranquil life. I will close this chapter with one of the few botánica trabajos that I was able to witness, a lovely candle preparation for a client at La Sirena Botánica in San Francisco in 2008. The owner is Mary Ehm, a woman of middle eastern ancestry who has received the orisha Ochún and dedicated the store to Ochún's avatar as the mermaid. She has been at the same location since 1999 at the intersection of the Latino neighborhoods of the Mission and the gentrifying districts of Noe Valley. When I was there on a late fall afternoon, Teresa, a young Latina woman, had just completed a consultation with Maria. I didn't know what had brought Teresa to the store, but she told me that Mary had helped her a lot. As a result of her consultation, Teresa was buying two candles. The first was yellow and marked with the name of the orisha Ochún, the spirit of beauty and cool water. Mary brought the candle over to the counter and from a shelf behind it brought out a variety of small sticks and bottles of fragrant oil. I was invited to listen, and Mary spoke about some of the ingredients she was placing at the top of the candle within the glass casing. She carefully grated five small palos, or herbal sticks, each for a different quality: *vencedora*, she said, for strength and *yerba dulce* for sweetness. She took her time with the grating and, bathed in the light of the low autumn sun, the effect was soothing, hypnotic. She then added five kinds of oils, again saying they were for things like courage and joy.

Mary said that she never prepares candles in the same way twice: it all depended on the person and what she or he needed at the time. Later, Teresa told me that Mary had prepared an Ochún candle for her in the past and that the ingredients were different.

At the end of the preparation, which took some twenty minutes, Mary and Theresa both held the candle and prayed silently for five minutes more. I didn't learn the purpose of the candle work, but it could be love-related, since Ochún was its patroness. For the second candle, however, Teresa told me that it was for her brother, who had passed away a few years earlier.

Since then she had been suffering from headaches and experienced trouble concentrating. Mary had read which spirit would be appropriate to sooth Teresa's brother and prescribed a white candle for Santa Clara. Again, she slowly put in the ingredients, grating eight palos and dropping in eight different oils. Again the women clasped the candle together silently and prayed. After several more minutes in this communion, Mary said to Teresa, "Place this candle by your *boveda* at home, let it burn for nine days, and speak to your brother."

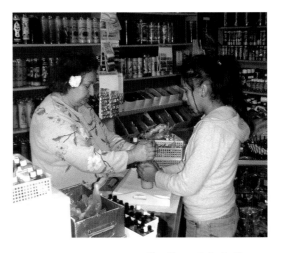

Mary Ehm and client with candle, Botánica La Sirena, San Francisco.

The two trabajos had taken at least forty minutes. A few customers had come into the store, but no one disturbed the candle blessing. I was touched by the care and the calm: the gentle, full attention that Mary offered and the faithful way that Teresa received it. While not every botánica interaction is as tender as this one, this kind of inspiring interaction is going on all the time at botánicas and, to me, is central to understanding the botánica and its importance to the people who patronize it.

Marta of Botánica Yemayá y Changó told us, "I consult with the shell and do limpiezas for people. Sometimes they cannot come until late at night and we finish at three or four o'clock in the morning. By that time, I don't even want to go home, so I sleep on a sofa I have in the back in the kitchen. . . . It's a tough job, you become a slave." One time her son told her that when he graduated from school and began his career, they would have enough money and she could close the *botánica*. She told him that she was not in business for money but as a way to stay in contact with her spirits. Her work is not a job, but rather a duty to use her gifts.

Maria of Botánica San Rafael echoes this conviction as she describes her mission:

I have received people in my religion and I have helped them so that they can have a good path. I wanted to show them that it is not necessary to steal, that drugs are not necessary, that it is not necessary to kill, that it is not necessary to abuse other people. People should be friends of others. We should all unite to be able to raise and prosper because one alone cannot do a lot of things.[11]

This, at least ideally, is the spirit of the botánica: a way to raise and prosper with the help of others. Rosa Chicas, wife of Otto Chicas, who had developed the first botánica with his uncle in El Barrio in Harlem, reflected on the store and the long history of service it has provided. At the end of our conversation she paused, and said rather quietly, "Otto has constructed something that I think is very nice."

4

Creole Devotions: The Spirituality of the Botánica

"My botánica is more than a store, it's like a temple. Many people don't know that. Others do know—they feel it—they see something is here."

Andrés, Botánica Yemayá y Changó

We have considered botánicas first as retail stores, selling remedies and shrineware in order to foster interactions between clients and the spiritual world. We then looked at them as sites of consultation where professional diviners can contact the other world, diagnose the sources of clients' problems, and discern the prescriptions for their solution. It remains for us to explore botánicas as shrines in and of themselves, as sacred sites where the faces of the spirits are present just off the streets of American cities.

We have seen that the cultural foundations of the botánica are Caribbean and grow out of encounters among Europeans, indigenous Americans, and Africans in the dreadful cauldron of conquest, enslavement, and genocide. If Fra. Bartolomé de las Casas, an eyewitness to the early Spanish forays, is to be trusted, nearly three million Native Taino, Arawak, and Carib peoples perished within the first decades of contact with Europeans in the brave new world.[1] Devastated by diseases for which they had no immunities and conscripted into murderous systems of forced labor, Native peoples were nearly erased from the cultural landscape of the islands. Las Casas tells the story of Hatuey, a *cacique*, or paramount chief, who led a guerrilla campaign against the Spanish in Hispañola. Fleeing to Cuba to try to rally resistance, there he was captured in 1512 and sentenced to burn at the stake. Las Casas reports on Hatuey's last moments:

When tied to the stake the cacique Hatuey was told by a Franciscan friar who was present, an artless rascal, something about the God of the Christians and of the articles of the Faith. And he was told what he could do in the brief time that remained to him, in order to be saved and go to Heaven. The cacique, who had never heard of any of this before, and he was told he would go to Inferno where, if he not adopt the Christian Faith, he would suffer eternal torment, asked the Franciscan friar if Christians all went to Heaven. When told that they did he said he would prefer to go to Hell. Such is the fame and honor that God and our Faith have earned through the Christians who have gone out to the Indies.[2]

Indian Spirits

Yet despite these attempts to destroy Taino and other Native Caribbean cultures, many of their traditions survived, driven underground or into the remote hills in the interiors of Hispañola, Cuba, Jamaica, and the other lands of the region. Aspects of Native traditions live on in Caribbean language; music; cuisine; herbalism; and, not the least, in religion.[3] Each of the nations of the Latin Caribbean venerate a creole advocation of the Virgin Mary, that is, a divine female figure with distinctly Native, African, and European traits and patterns of devotion. La Virgen de la Caridad del Cobre in Cuba, Notre Dame du Perpétuel Secours in Haiti, and Our Lady of Siparia in Trinidad all display cultural layers that reflect the peoples of the three continents who made up the early post-Columbian population of the Caribbean.[4] For example, according to a seventeenth-century account, the miraculous image of the Cuban Virgin was enshrined around 1612 after it was found floating on the waters off eastern Cuba by two *"indios naturales del pais"* (Indians native to the country) and *"un negro eslavo"* (a Black slave).[5] Today the Virgin is called *"morenita"* (a little dark)

Indio shrine, Botánica Tres Potencias, Falls Church, Virginia.

and is considered to represent all the races of the island. She is offered tobacco, honey, and candles, characteristics of Native, African, and European forms of veneration.

The Native heritage is remembered, venerated, and reenacted in a number of ways in the devotions of the botánica. It is brought alive in the beliefs and practices of Caribbean *Espiritismo*, and it often takes iconic form through the sentimentalized images of Plains Indians, made internationally recognizable through enterprises like Buffalo Bill's Wild West Show.[6] The Indios of the botánica represent particularly strong, protective, and natural forces among the vast spiritual population of *espiritismo*. They operate at the perimeters of a devotee's spiritual aura, a vanguard in protecting the devotee from harm, often from the malice of others. Brujo Luis, an

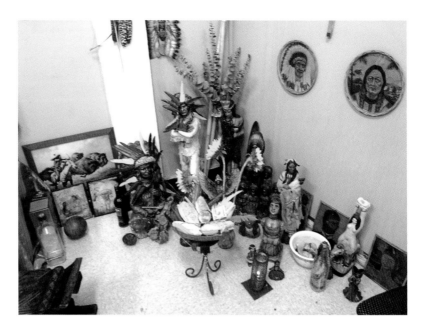

Indio shrine, Botánica San Miguel, New Britain, Connecticut.

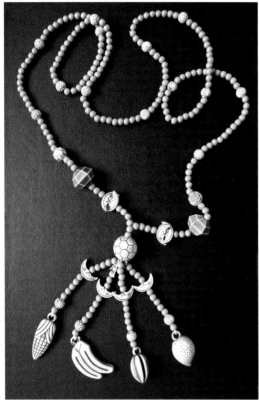

Indio necklace Botánica San Miguel, New Britain, Connecticut.

accomplished spiritist and blogger from Massachusetts, lists fifteen Indios that can be found at many botánicas, seven male warriors representing valiant qualities and eight princesses and female chieftains. His list contains el Indio de la Paz, el Indio de la Fuerza, el Indio Poderoso, el Indio de la Guerra, el Indio Bravo, el Indio Libertador, el Indio Valiente, two Taino princesses named Guanina and Alida, and the *caciquas* Anacaona, Casiguaya, Doña Ines, Doña María, Guanina, and Yuiza.[7] Each has his or her own prayers of devotion, iconographic representation, and characteristic gestures, movements, and healing practices when manifest in mediums in sacred trance. The Indios like to drink the bark-juice beverage called *mavi* (*mabi, mauby*), that is popular throughout the islands and associated with indigenous cultures. They come to spiritist ceremonies, Brujo Luis tells us, "to lift curses, remove a hex, and in matters of justice."

Lisa of Botánica San Miguel in New Britain, Connecticut, took me to the back of the store to see her altar for her Indian guides. There in a corner on the floor were statues and drawings of fifteen or more Native American figures surrounded by offerings of corn, flowers, feathers, mavi, and rum. She said that she had a special

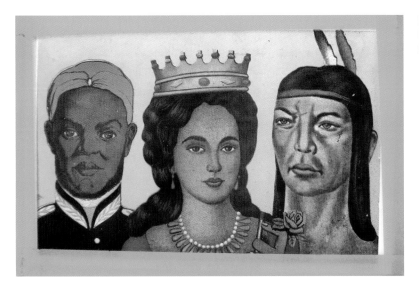

Las Tres Potencias: El Negro Felipe, La Reina Maria Lionza, El Cacique Guaicaipuro.

affinity for the Indians: "They are the spirits of the land; I love them very much." Lisa gave me an Indio necklace and explained that the spirits would protect me and open up pathways for my spiritual progress. "The beads come together at the Earth," she explained. "The four moons are the phases of the moon around the Earth and the beads at the end are the four products of the earth: corn, plantains, cacao, and avocado. If you need help, put the necklace on and you will feel strength from the Indian spirits."

Another Native spirit prominent at botánicas is Guaicaipuro, a Venezuelan cacique who battled the Spanish in the sixteenth century. In the Venezuelan tradition called Maria Lionza in honor of its preeminent divinity, Guaicaipuro is the head of the Indian *corte* (court) at the palace of the spirit queen. Together with Maria Lionza and the Afro-Venezuelan hero El Negro Felipe, Guaicaipuro is often venerated as part of a trinity, Las Tres Potencias. The trinitarian image elegantly both juxtaposes and integrates the Indian, European, and African roots of the Venezuelan people. Guaicaipuro represents the indigenous spirits of the land and the resistance to the invaders and oppressors of his devotees. A prayer shows his militancy on behalf of his devotees:

Guaicaipuro on Venezuelan currency.

Oh powerful spirit of the just, giver of force and courage, protector of the weak, humble and oppressed, brave Guaicaipuro, in the name of the Father of the Universe, our Creator, intercede before the All-Powerful to free me of deceit, traps, treason, bad influences, of the envy and jealousy of enemies visible and invisible, chance and free, known and unknown. Oh, great cacique, offer me your divine protection at this hour and for all time, for the centuries upon centuries. Amen.[8]

The cult of Guaicaipuro has been encouraged by the government of Hugo Chavez to underscore initiatives toward indigenous peoples' rights

Black Hawk statues, F & F Botánica, New Orleans.

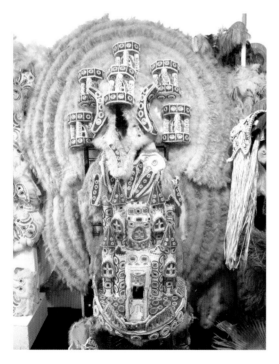

Carnival Indian regalia, Backstreet Cultural Museum, New Orleans.

as well as nationalist resistance against foreign imperialism. In 2007 Guaicaipuro's image was placed on the ten bolivar currency note.

A final example of the Native American presence at the botánica is a devotion specific to New Orleans. The Sauk warrior and statesman Black Hawk is a powerful spiritual presence in the African American Spiritual Churches of the city. The historical Black Hawk was born Ma-Ka-Tai-Me-She-Kia-Kiak in what is now Illinois in 1767.[9] He resisted the erosion of Native lands and the bad-faith treaties of the U.S. government. In the War of 1812 he sided with the British and wrote in his autobiography of 1834 that "I had not discovered one good trait in the character of the Americans that had come to the country! They made fair promises but never fulfilled them!"[10] In the early 1830s, Black Hawk led an armed resistance movement against Federal troops that came to be called the Black Hawk War. With the publication of his autobiography—dictated to translators and freely edited—he became a symbol of Indian dignity before the dreadful forces of Manifest Destiny.

According to the research of Jason Berry, the devotion to Black Hawk was founded in New Orleans in the 1920s by an African American spiritist named Mother Leafy Anderson, who herself was born in former Sauk lands in Wisconsin.[11] Berry quotes an older source transcribing the words of one of Mother Anderson's successors, Mother Dora Tyson: "When Mother Anderson first came down heah, she told us dat she wanted us to pray to Black Hawk, because he was a great saint for spiritualism only. She called Black Hawk to a special council for us. Ah know because Ah saw him."[12]

Mother Dyson's witness of Black Hawk is now an important part of the services of Spiritual churches throughout the city.[13] In sacred trance, Black Hawk may manifest himself in human devotees and heal and inspire the congregation. Berry met Jules Anderson, who was a renowned Black Hawk "demonstrator" at Spiritual churches in the 1990s. He regularly visited churches and,

in a flowing white robe, invoked the power and presence of Black Hawk in the ministers and congregations. He would chant, "Black Hawk is a watchman. He will fight your battles."

The connection between African Americans and Indians goes back before these Black Hawk devotions and now crosses over into a variety of New Orleans institutions. Just off Congo Square, where nineteenth-century Afro-New Orleanians danced to drum music, is the Backstreet Cultural Museum dedicated to the traditions of carnival Indian associations. As early as the 1880s, mutual aid societies of Black New Orleanians would dress as Indians to parade at Carnival, the feast of St. Joseph, and other celebrations. In 2012 we met curator Sylvester Francis, who has been an Fi-Yi-Yi Indian his whole long life. "We mask Indians," he said, "to honor their help to us during slavery." Jules Anderson told Jason Berry of the parallels between the Spiritual churches and the Indians:

I feel that Black Hawk has always been a part of the black spirit. We was took from Africa and that left us—we didn't hear any of those drums. It was the Indians that brought us back to the drums and the music. You could go on a Carnival day and see people full of Indian spirits. You wouldn't know if you was in a Black Hawk service or an Indian rehearsal. Those people experience a spirit take-over.[14]

Here in the devotion to Black Hawk and the traditions of carnival Indians, we can see a pairing and interpenetration of spiritual identities in resistance to enslavement and genocide. Black Hawk's principled stand against American racism and violence found resonance among black New Orleanians, and Indian regalia and spirituality became a medium to express a new and independent identity. By incarnating Indians in spiritist churches and carnival parades, people of color could embody the power of the indigenous world, felt to be older and deeper than that from Europe.

African Spirits

The African presence in the Caribbean is often said to have originated in Las Casas's suggestion that Africans be imported to labor in the mines and plantations of the region in order to forestall the extinction of the Indians. Las Casas lived to lament the growing trade as he saw that the colonists' treatment of the enslaved Africans was as reprehensible as that visited on the Indians.[15] Between the early sixteenth century and 1870 some 5.3 million Africans were enslaved and carried across the waters to Haiti, Cuba, Jamaica, and all the islands and littoral of the Caribbean basin.[16] This massive forced migration forever shaped the cultures of the region as enslaved men and women turned to traditions remembered from Africa in order to survive and grow in the New World. Religious traditions played a primary role in this process by sacralizing systems of healing, mutual aid, and ex-

pressions of hope and resistance. It is widely believed that devotion to African spirits emboldened Haitian slaves to fight for their freedom in the revolution of 1789–1804 and that the leaders of the Aponte and Escalera freedom movements in colonial Cuba were led by priests of African-derived religions.[17]

Two African traditions in particular have been remembered and developed in the devotional life of the botánica: those of the Congo, which came from the present-day nations of Congo and Angola, and those of the Yoruba which came from what is now Nigeria and Benin. With the success of the Haitian Revolution and the loss to European landlords of its large and lucrative plantations, sugar investors turned to the Spanish Caribbean and Brazil to rebuild the trade in the "white gold." Between 1790 and 1870, some 867,000 Africans were enslaved and taken to Cuba to labor on the new plantations, transforming the island's cultural mosaic and turning it into the primary producer of sugar in the world.[18] Congo and Yoruba men and women were caught up in this maelstrom and put to work planting, harvesting, and processing sugarcane and staffing the support industries to load and ship it to its European and American markets.

In the cities of Cuba, particularly Havana and Matanzas, enslaved and free people of color were able to gather in mutual aid organizations called *cabildos africanos* (African assemblies) that were organized by African ethnicity. Here *negros de nación* (Blacks from the same [African] nation) could gather to try to address the medical, legal, and spiritual needs of their fellow members. Funds were raised for burials and the purchase of members' freedom. As cabildo members were generally from the same African ethnicity, the old language could be spoken, old songs sung, and old spirits venerated.

Over one hundred distinct African ethnicities have been documented in Cuba, but the Congo and Yoruba traditions became the most prominent amid this diversity.[19] Of course, *Congo* and *Yoruba* (who were called Lucumi in Cuba) are themselves generic terms encompassing wide differences of language, thought, and practice. Cuban folklorist Lydia Cabrera lists twenty-seven different Congo "tribes or regions" that she encountered during her research in the mid-twentieth century.[20] Yet even in the later nineteenth century, the dyad "Congo" and "Lucumi" stood for the diversity of African heritage in Cuba. Esteban Montejo, in his *Autobiography of a Runaway Slave*, remembers the spiritualities of his fellow slaves at a large Cuban sugar plantation called Flor de Sagua:

I knew of two African religions in the *barracones* [slave quarters]: the Lucumí and the Congo. . . . The difference between the Congo and the Lucumi was that the Congo solved problems while the Lucumi told the future. This they would do with *diloggunes* which are shells from Africa with a mystery inside. . . .

The Congolese were more involved with witchcraft than the Lucumi, who had more to do with the saints and with God. . . . The Congo religion was the

more important one. It was well known at the Flor de Sagua because their *brujos* used to put spells on people and get possession of them, and their divination won them the confidence of all the slaves.

For the trabajos of their religion, the Congos used the dead and animals. They called the dead *nkise* and snakes *majases* or *emboba*. The Congos prepared pots and everything and the secret was there to make the trabajo. All the Congos had their *ngangas* for *mayombe* [Congo spirit work]. The *ngangas* worked with the sun. . . . When they had a problem with some person they followed that person along his path and got the dirt that he had stepped on. They saved it or put it in a little corner. As the sun went down so the life of the person would go too. And at the setting of the sun the person would be dead.[21]

The aggressiveness of Congo spirituality served enslaved Afro-Cubans well. Here again, Esteban Montejo gives us a glimpse of Congo ceremony and justice in the harsh world of the slave quarters:

In Mayombe they played the drums. The put an *nganga* or big pot in the center of the patio. In this pot were the powers, *los santos*. . . . They began to beat the drums and sing. They brought things for the *nganga*. Blacks asked for health and harmony among their brothers. They made *enkangues* which were *trabajos* with cemetery earth. They made four little piles with the earth to represent the points of the universe. Inside the pot they put *pata de gallina* [an herb] along with corn straw to protect them. When a master punished a slave, the others gathered a little of the earth and put it in the pot. With this earth they could get what they wanted. And the master would fall sick or it would happen that some danger would come to his family. Because as long as the earth was inside the pot the master was imprisoned there and the Devil couldn't get him out. This was the vengeance of the Congos on their masters.[22]

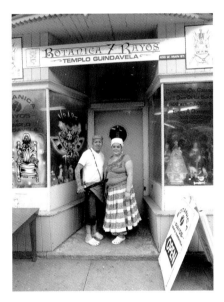

Paleros at Botánica Siete Rayos, New Britain, Connecticut.

Congo and Lucumi traditions come to the botánicas of the United States from a variety of Caribbean traditions which themselves have at times blended at other times overlapped both in the Caribbean and in the United States. The Congo practices that come from Cuba are usually called Palo (Palo Mayombe, Palo Monte) after the "sticks" that are prominent on altars and act as representatives of the natural world. Palo is built upon relationships with the forces of nature and the human dead. The natural forces are personified as *mpungu* with Congo and Spanish names: Nsasi (Siete Rayos, Lightning), Makengue (Tiembla Tierra, wisdom), Sarabanda (Rompe Monte, Iron). As Montejo observed from slavery times, Congo-influenced paleros construct altars to the dead that use a variety of natural ingredients including human bones. These are housed in a cauldron called

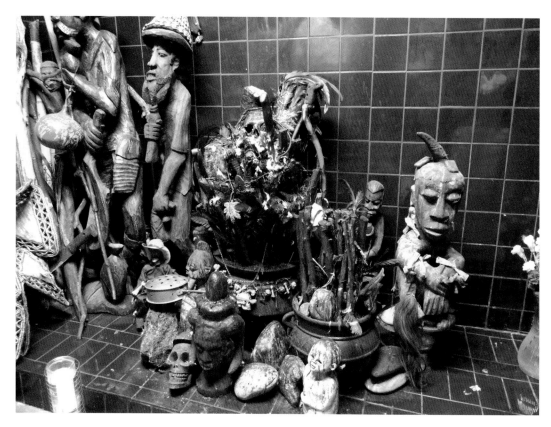

Prenda Sarabanda, Botánica Yemayá y Changó, Washington, D.C.

alternately *nkisi*, *nganga*, or *prenda*. Art historian Robert Farris Thompson says this about the Cuban Congo altar: "The *nkisi* itself is made according to Kongo recipes of earths and feathers, and forest wood, modified by contingency. Bristling at top with the feathers of heaven and weighted at bottom with cemetery earths, it is a cauldron, continuing the form and function of Old World medicines of God."[23]

The palero enters into a pact with the dead person (nfume) and can use its otherworldly power to heal or harm. The prenda is thus a living entity under the control of the palero, who must house, feed, placate, and admonish it. A Cuban palero told Lydia Cabrera, "A *prenda* is like the entire world in miniature and with it you dominate: for this reason you put in the cauldron all the spirits, those of the cemetery, the forest, the river, the sea, the lightning bolt, the whirlwind, the sun, the moon, the stars. A concentration of forces."[24] At Botánica Yemayá y Changó Andrés says:

An *nganga* is a compilation of objects that when separated you don't know what they are but when they're together they have power. The *nganga* comes from nature. All the elements are there: earth, stones, sticks, many sticks from different trees. Every *nganga* has a different name. I built a room at the botánica specifically for Sarabanda for my godchildren. You can't come to him unless you are initiated, unless he requires you to come.

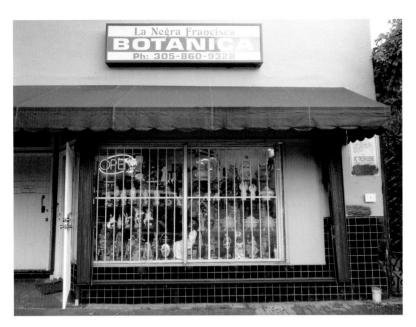

Botánica Negra Francisca, Miami.

In addition to the Palo traditions, Congo devotions are also represented at the botánica by means of espiritismo. The Congo spirits constitute a *línea* (line) or *corte* (court) or *comisión* (commission) of the spirit population much in the same way that the Indians do. Art historian Judith Bettelheim finds affinities between the two at Puerto Rican espiritismo centers. She concludes that

the confluence of the representation of the Congo and the representation of the Indian occurs on both the altar assemblages dedicated to espiritismo and those to Palo Monte. Yet, at times, the Congo and the Indian assert their presence in parallel positions, rather than confluent ones, as they exist side by side on the altars. Practitioners repeatedly underscore the notion of ancestor, land, and home that these images embody.[25]

Botánica shrines represent the Congos in statuary as elderly, dark-skinned agricultural laborers. The men usually wear white or sackcloth trousers rolled up above the calf and open-collared shirts with kerchiefs around their necks. The women wear long dresses and headties connoting workers of long ago. They bring to the botánica, and to the ceremonies that invoke them, the wisdom of the enslaved Black ancestors, who toiled and suffered, yet endured and triumphed by their patience and wits. "They survived slavery," says Andrés of Botánica Yemayá y Changó, "and we always honor them because they helped so much at that time."

Two of the most prominent of the Congo spirits are the old slaves Francisco and Francisca. They come to devotees in dreams, in the boveda water vessels, and in spiritist *misas* where they manifest in their mediums in sacred trance. In manifestation, Francisco and Francisca are bent with age

Francisco and Francisca,
Botánica Siete Rayos, New
Britain, Connecticut.

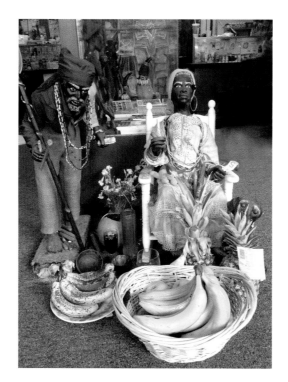

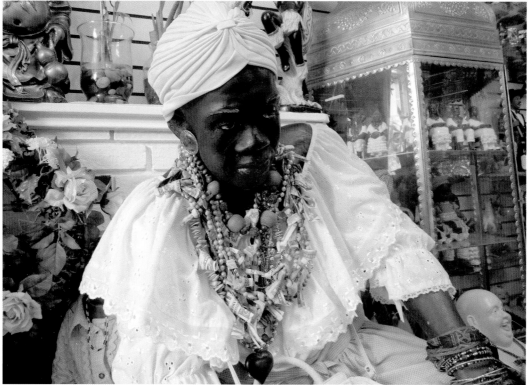

Francisca with votive jewelry, Botánica Yemayá y Changó, Washington, D.C.

and speak in creole Spanish. They dispense the wisdom of hard experience and resiliency. And, like the Indios, being from the edges of the industrialized world, their knowledge of herbs and nature make them powerful healers. Shrines for Francisco and Francisca at established botánicas are often dressed in lovely handmade clothing and bedecked with necklaces and bracelets. These are ways of thanking them for their aid and exalting them from the indignities they endured in life. Andrés speaks of his Congos:

My Conga is called Maria José though the male one is Francisco. They're all the same but sometimes have different names. I'm not Black anymore, maybe my ancestors were. The Congos are like your ancestors from the little town where you used to live. They help you, always have a remedy or medicine or an *ebo* for you. They like flowers, food . . . we do parties for them in August, just before our birthdays in Ocha [anniversary of initiation]. We dress them, make them look nice.

Here at the store Maria José is more popular than Francisco. He's quiet and doesn't do much, but she has a lot of women tending her. People come needing something and they promise her something and bring it back to her. She has a lot of gold—it's amazing—all the things people have brought to her, gold, chains, money, dresses.

Madama, Botánica San Lázaro, Oakland, California.

Another Congo-like spirit gracing many botánica altars is the Madama, "a generic term for the spirits of all non-Hispanic Afro-Caribbean women who communicate with the living," in Angela Jorge's phrase.[26] Jorge writes of a particular Madama who is popular at Puerto Rican botánicas—*la madama francescita*—who is considered a spirit of a French-speaking Black woman from Martinique. Her symbols used in healings include a fan, a piece of red cloth, a large cowrie shell or shells, nine colored kerchiefs tied together, a broom, tobacco leaves and medicinal plants, cigars, overproof rum, honey, coconuts, baked sweets, and cards.[27] As the Congos are usually associated with rural, agricultural labor and life, the Madama wears the clothes and carries the broom of a domestic worker. Madamas are thought to be the spirits of house slaves or freedwomen who raised the children of their white employers and thus lived in the two worlds of segregated society. Madamas wrap their heads in a distinctive head scarf with a prominent knot in the front, and when they "descend" on their mediums in sacred trance the mediums wrap their heads in the same way.[28] Brujo Luis says that

when the Madamas come down in Fiestas Espirituales they come down as stern wise women. Often scolding and reprimanding those who do or are in the wrong, they are over-opinioned, witty and quick with their tongue. They represent a strong matriarch figure who is stern and strong willed. When they are happy they love to laugh which is a deep hoarse laughter, and quickly ask those attending the Fiesta for her offering of cigars, black coffee sweetened with brown sugar or molasses.[29]

Esteban Montejo's distinction between Congo brujeria and Lucumi santos in the nineteenth-century slave quarters still holds true among many practitioners today. When asked, many botánica owners denied being involved with Palo and several referred to it as the "dark side" of Afro-Caribbean religion. The use of human bones in the prendas and the rituals of control of the dead strike many as a sinister ethic of domination rather than spiritual growth. Lauro, a Miami santero, told me that he could never be a palero because he can't stand slavery. "You work *with* the *santos*," he said. "You can negotiate with them. The Palo *muertos* are simply slaves."

Yet many santeros are paleros as well. Greta at Botanica Ochún in New York said that Palo is indeed the "other side of Ocha," (i.e., Lucumi, Santería) but that "they balance each other. You should learn about it." Andrés says that

without Palo there is no Ocha. The tradition of Palo is honor. It all depends on how you carry yourself. To be initiated into Palo you can't just come and tell me, "I want to be initiated into Palo." No, you have to go through a process. We need to see how you are, how you behave yourself. What kind of man you are. Are you married? Do you have kids? Are you a good father?

Historian Stephan Palmié characterizes the Palo/Ocha dyad as "two conceptually distinct but practically intertwined ritual idioms: one foregrounding reciprocal interchange and divine initiative (*regla ocha*), the other cast in terms of wage labor and payment, dominance, and potential revolt (*palo monte*)." He sees the critique of Palo by santeros as "ideologically purifying their own practices of moral ambiguity," whereas Palo's spiritual aggression lies in the "militarization of social arrangements in which healing could proceed only by counterattack."[30] As we have seen, militancy and aggression can be appropriate responses to the challenges of life in urban America. The frequent impossibility of satisfying the most basic needs by "going through channels" makes the expediency of Palo spirituality a viable option. "The Lucumi *santos* will get you what you need eventually," said botanica patron Hector, "but the Palo *muertos* will get it right away."

In this review of the Afro-Caribbean devotions of the botánica, it remains to mention the most widely recognized African spirits venerated there: the Yoruba (Lucumi) orishas. At some time during their experience

in the colonial Caribbean, enslaved Yoruba called the orisha spirits of their homeland "santos" in Spanish and so their devotions were popularly called Santería, the way of the santos. They made narrative and iconographic parallels between their African santos and those of Catholic folk piety, thus forging an elegant system of spiritual representation wherein the Catholic saints could "stand for" the orishas in altar displays and public festivals.

Many botánicas are named for Catholic saints but continue to be understood by devotees as representations of the orishas who are the patrons of the owners and their stores. Shrines to Catholic saints are prominent throughout most botánicas, and are approached with this same understanding, that the saint is an avatar of the orisha being venerated. In referring to a santo, owners and patrons slide easily, for example, between calling her La Virgen de la Caridad and Ochún. If the name switches can be seen as coded, it seems that the Catholic name is the more public one and the Lucumi name the more private. This bilingualism has caused many observers to believe that devotees are concealing their devotion to the orishas behind a camouflage of Catholic imagery. While deception may be intended when devotees fear disapproval or persecution because of their loyalty to an African and non-Christian faith, I have seen little concealment or dissimilation on the part of devotees throughout my long experience with Lucumi religion. Rather, devotees have tried to explain a complex parallelism between the orisha and the Catholic santo, that they embody the same powers at different levels of personal and social experience. Michele of Botánica Santa Barbara says, "The slaves did it to hide their *orishas* but let me tell you, Changó and Santa Barbara are the same. . . . People say there's a difference but to me it doesn't really matter. There are two different stories. To me it's the same. In the religion it's what the slaves did to cover up, so it has to be the same."

I interpret Michele to mean that when the slaves and freedmen created the correspondences, they made a thoughtful and spiritual connection between the saint and the orisha. The correspondences were not simply strategic but also recognitions of the same powers. The correspondences between orisha and Catholic saints recognized at the botánica have remained remarkably stable for at least a century and possibly two.[31] On some occasions devotees have offered different pairings, but the most prominent orishas continue to be identified with the same saints. While the number of orishas is theoretically infinite, there are some twenty recognized at botánicas. Here are nine of the best known, with their Catholic correspondent, qualities, and fragment of praise poetry translated from the Lucumi by orisha priest John Mason.[32]

- Eleggua/La Niño de Atocha or San Benito el Moro
 - *messenger, trickster, ambivalence
 - *"the one who owns the road"

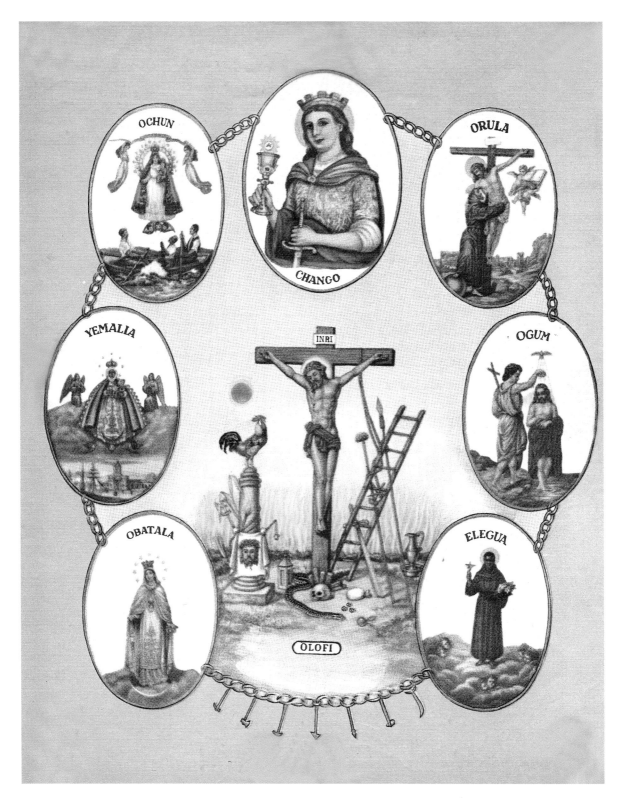

Seven African Powers chromolithograph.

- Oggun/San Juan Bautista or San Pedro
 * iron, craft, militancy
 * "clears the land . . . clears the roads"
- Ochosi/San Norberto
 * protector, champion
 * "hunter who shoots and does not miss"
- Obatala/La Virgen de Las Mercedes
 * royalty, seniority, clarity, rebirth
 * "first born, self-existent chief"
- Chango/Santa Barbara
 * owner of the palace, thunder, lightning, justice
 * "chief of dazzling lightning"
- Yemaya/La Virgen de Regla
 * maternity, protection
 * "mother of the house of bottommost water"
- Ochún/La Virgen de la Caridad del Cobre
 * crowned woman, elegance
 * "give birth to the world, River"
- Babalu Ayé/San Lázaro
 * transformative power of disease
 * "who chooses to scrub the child healthy"
- Oya/Santa Teresa or La Virgen del Candelaria
 * warrior woman, hurricane, owner of Death
 * "the Tearer arrives noisily . . . the harmatten cleanses you"

While the iconographic symbolism of orisha and Catholic santo is frequently brought together throughout the stores, I have often been invited to a back room where the orishas are displayed in their fundamental glory.

Orishas in state, Church of Lukumi Babalú Ayé, Hialeah, Florida, 2000.

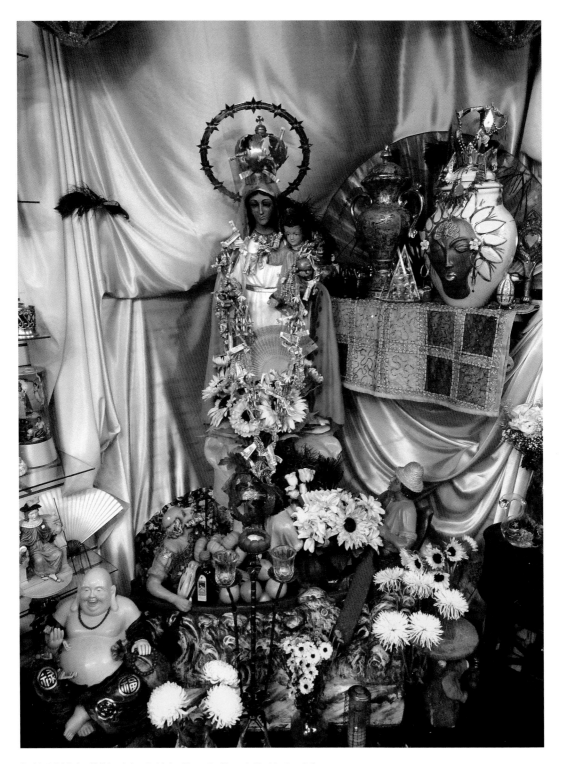

Caridad del Cobre/Ochún shrine, Botánica Yemayá y Changó, Washington, D.C.

This essential presence of the orisha—"*el fundamento*"—is the collection of objects housed in the sopera tureen, principally stones and other objects consecrated to embody the orisha through herbal and sacrificial treatments. Orisha altars are usually bright, baroque assemblages, the soperas set on pedestals or tiered planes and often draped in rich cloths and finery. Though the Catholic images can have their place in the displays, it is the soperas that command pride of place and ritual attention. With the invitation to see "*mis santos*," some owners have asked that I not take photographs as the objects have a heightened sacrality. Other owners have been happy to have their santos photographed and doubly pleased when I brought a print as a gift on my next visit.

It is rare that these active embodiments of the orishas are placed in the public rooms of the botánica. On a couple of occasions, I've been asked not to photograph this *sopera* or that *sopera*, with the understanding that its contents were fundamento. I have never asked to photograph the contents of a sopera, but I have seen the objects within when they have been opened at ceremonies to receive the sacrificial offerings due them.

In the public rooms of the botánica, the Catholic images anchor the major shrines though they are peppered with references to their orisha counterparts. Here is a shrine to Ochún/Caridad at Botánica Yemayá y Changó in Washington. She holds a cross in her right hand and cradles her child in her left. She wears a fine metal crown encircled by a star-studded nimbus as befits the queen of heaven and woman of the apocalypse (Revelation 12:1). As told in her official story from seventeenth-century Cuba, she stands atop the waves as the three Juans in the rowboat below her gaze upward in awe. The figure is nearly half-sized, set above eye level, and dominates a corner niche and much of the store. Any Cuban would recognize her as La Virgen de la Caridad del Cobre, but here at the botánica she is overbrimming with symbols of Ochún, the orisha of royalty, cool water, and riches. First the color of the golden-yellow canopy is a "primary signifier" of Ochún.[33] It is gathered in elegant folds, creating an intimate, warm space for the santo. The niche is decorated with fans for the cool breezes and elegant airs of the orisha. Peacock feathers suggest the hauteur and extravagance of the orisha of riches. She wears around her neck a massive *collar de mazo*, a huge, beaded necklace worn by those initiated into Ochún's mysteries. Thousands of yellow and gold beads in hundreds of strands have been strung by an artisan beadworker to signify the highest level of commitment to Ochún's devotion. Climbing the sculpture are bunches of yellow sunflowers, mums and roses, brought by devotees to thank Ochún for blessings. The offerings are specifically appropriate to Ochún, including honey (golden and sweet), pumpkins (yellow and full of life-bearing seeds), and oranges (ripe and round, like full bellies and wombs). Finally the anthropomorphic Catholic image is flanked by two soperas for Ochún, recognized by their yellow and gold colors, coral beads, and brass crown. All is golden, rich, fertile.

The shrine is maintained by the owner, but the offerings of money, flowers, foods, and candles are often brought by devotees. It is important that each offering be suitable to the specific santo being approached. All the santos, especially those with Ocha identities, have symbolically appropriate numbers, colors, plants, foods, drinks, songs, and rhythms. Knowledge of these codes—not simply humility of heart—is a key to the exchange, and in the specificity of the material offering lies the efficacy of the exchange. As José at Botanica El Salvador del Mundo said, "You can offer San Simón anything and he will accept it, but he *likes* tortillas, white rum and *puro* tobacco." Each part of the offering display is a wish and a vow, an *ex voto*, an exchange between the santo and the devotee to effect some change in circumstances or give thanks for favors granted. This relationship of reciprocal exchange is at the heart of botánica spirituality and is the devotional basis for the folk Catholicism that permeates the lives of so many Latinos patrons.[34]

European Spirits

It might be said that the European influence on the botánica lies less with the origins of the spirits venerated and more with an overarching ethos and an underlying pattern of devotion. The baroque aesthetic of the shrine and transactional basis of its maintenance have their roots in Iberian art and devotionalism. Many of the saints venerated at the botánica are of European or Mediterranean origin, canonized by the Roman Church, and brought to the Americas by Spanish and other Europeans. Among the most popular of these presences at the stores are Sta. Barbara, S. Miguel, S. Antonio, S. Francisco; el Niño de Atocha, Sta. Teresa, Sta. Clara, S. Pedro, and a number of advocations of the Virgin such as N.S. de la Regla and N.S. de las Mercedes. The devotions to these santos, like that to all the others, were transformed by the heterogeneous cultural experience of Latin American peoples, so that their veneration reflects diverse, layered, and juxtaposed religious influences. The European elements of these creole reconstructions of religious experience can be seen in the pervasive influence of the metropolitan Big Tradition of Roman Catholicism on the local Little Traditions of the Spanish Americas. Catholicism formed what sociologist Peter Berger called a "sacred canopy" of legitimation of Spanish colonial social institutions, infusing them with transcendent meaning and power.[35] A glance at a map of Latin America shows the veneration of the saints imprinted on the landscape: San Juan; San Cristobal de la Habana; Santo Domingo; and, of course, Saint Augustine, San Francisco, and (Nuestra Señora de) Los Angeles. Each naming expresses a dedication to the transcendent powers of the city's saintly patron and to the worldly powers of the Church to arbitrate them. The Catholicism practiced in the Spanish Americas was thus hagiocentric, saint-centered, focused on the cults to the saints and the conventions of devotion to them.

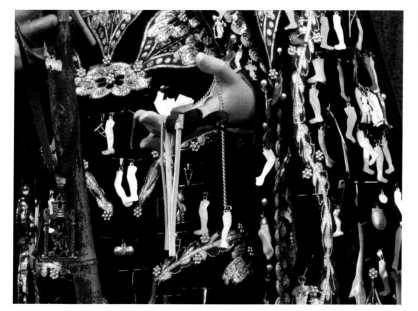

Milagros on San Lázaro statue, San Lázaro Roman Catholic Church, Hialeah, Florida.

Pilgrim to the shrine of San Lazáro," Hialeah, Florida.

We have already mentioned the promesa, the vow to the santo, as the underlying devotional dynamic of the botánica. In this spirituality of exchange, the devotee enters into a reciprocal relationship with the santo, agreeing to perform specific actions in exchange for the supernatural intervention of the santo on the devotee's behalf. The terms of the exchange are to be clear and declared to the santo. A devotee of San Lázaro told me that she had made a promesa that if the santo would cure her father of stomach cancer, she would walk barefoot in the four-mile street procession around his shrine in Miami on his feast day. And she would do it for three years. Alas, her father died but when we spoke she was in her third year of keeping her promesa.

One of the most common exchanges of a promesa is the vow to adorn the shrine of the santo, either at his or her public site or at the home altar of the devotee. Devotees bring flowers, fresh water, candles, perfume, incense, and money. They bring small charms to affix to the image of the santo called *milagros*, tokens of miracles that the saint has worked for the devotee. Milagros are often beautifully wrought miniature sculptures of a human arm or leg or heart, signifying the cure that the saint has performed. Shrines are often adorned with other mementos of petitions granted. A santera friend once showed me her home altar for Yemayá, which contained a miniature boat. She had participated in the Mariel boatlift and was caught in a terrible storm in the Florida Straits. She made a promesa to Yemayá that should she survive, she would make her a beauti-

Offerings for San Lázaro with crutches, Botánica Yemayá y Changó, Washington, D.C.

ful altar. Amid the blue satin hangings and fresh flowers the boat was a reminder of her ordeal at sea and the santo's saving intervention.

Large public shrines for the santos are places of pilgrimage, and devotees fulfill promesas by traveling long distances, often augmenting the difficulties with painful penitential practices to demonstrate their faith and show their courageous resolve to fulfill their end of the exchange. Altars at the shrines are covered in milagros, mementos, and *retablos*, plaques to praise the santo for his or her help and fulfillment of the pact. The great public shrines like that for the Virgin of Charity in Cobre, Cuba, or the Niño de Atocha in Fresnillo, Mexico, receive many thousands of pilgrims every year.

This pattern holds true on a small scale at the botánica. In these relatively intimate spaces, more direct offerings are possible, and the shrines of the santos have food, tobacco, coffee, and rum before them. Devotees fold dollar bills lengthwise and tie them to the clothing or regalia of the santos. Andrés says that he periodically gathers the money and uses it to enhance the shrines, buying fresh flowers and more elaborate adornments. One time when I visited Botánica Tres Potencias, owner Terry told me that it was time to "de-dollar" some of his shrines. He and his partner Erich donate the money to a favorite charity, sponsoring a child at the local children's hospital. As we saw with the Conga Maria José, people come to the botánica shrines to fulfill promesas. Andrés told of a woman who came to

the botánica with a medical problem which was so serious that the doctors said her legs might have to be amputated. She prayed to San Lázaro for a cure. "Three or four days before her surgery she came in walking fine and gave her crutches to the santo because that's what she told him" in her promesa. Andrés has fitted the real crutches into the statue of the santo to proclaim the miracle.

We have seen that santos of European origin are prominently venerated at the botánica, though often with the understanding of their dual signification. It would be the rare patron who practices Roman Catholicism to the exclusion of nonorthodox devotions. I have not met such a patron in my visits to the stores, but I've been told that they sometimes come to buy statues or candles for home altars. More common are patrons who see no contradiction between orthodox and spiritualist devotions to the saints. On several occasions, I have spoken to people who didn't know that the San Lázaro "*con muletas y perros*" (with crutches and dogs, that is, the poor Lazarus of parable) was not a canonical Catholic saint and that offerings of cigars, wine, seeds, and burlap were not authorized practices. Many santeros, of course, are well aware of the differences between orthodox and nonorthodox santos and practices, with opinions ranging from seeing an essential identity of spirit with differences of practice, to honoring parallel santos, each to be venerated in its appropriate liturgical setting. With a few exceptions, nearly everyone to whom I spoke who were making offerings at botánicas claimed to Catholic but recognized that some of their devotions would be frowned upon by the orthodox. "*Soy catolico,*" I was told often, "*en mi manera.*" ("I'm Catholic, in my own way.")

The avowed non-Catholics at botánicas are often what might be called Yorubaists, devotees of the Yoruba orishas who are seeking a pure African faith, unmixed with Catholic or Spiritist accretions.[36] They seek to practice Yoruba traditions exclusively, as a distinct religion to be considered in the same manner as the more-recognized religions such as Judaism or Christianity. Yoruba religion thus might take its place alongside them in the American public sphere, with its ministers recognized by secular institutions such as schools, prisons, and the military.[37] The statues of the Catholic saints and the shrines and services dedicated to the host of non-Yoruba spirits are superfluous to these patrons, but the herbs necessary for making the fundamento preparations for the orishas are important reasons for patronage.

The botánica is also a site for devotions to santos who are neither Indian African, nor European, nor officially canonized or corresponded to orishas. They might fall into the broad category of "folk saints" as described by Frank Graziano: "Folk saint devotees are almost exclusively Catholic, and have access to a multitude of canonized saints, all of whom are recognized as miraculous. Rather than contenting themselves with these diverse options, however, they supplement the canon by creating new saints—folk saints—despite the explicit disapproval of the Church."[38]

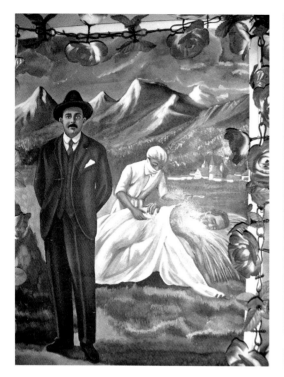

Altar painting of José Gregorio Hernández, Botánica Todopoderoso, Washington, D.C.

Jesus Malverde statue, Botánica Santa Barbara, Bladensburg, Maryland.

Graziano develops a set of criteria for recognizing a folk saint that usually involves a tragic and unjust death, often at the hands of corrupt authorities. The saints can be "pure" victims who were violated by the police or military or "noble outlaws" who generously gave away their ill-gotten goods and who were cruelly slain by officials. As fellow victims of corrupt authority, the folk saint is seen as *lo nuestro*, one of us, and not a supernatural being co-opted by the powerful. As Graziano puts it, "One can negotiate religion through the bureaucratic Church—with its dogmatic priests, foreign saints, prescribed rituals, and expensive fees—or one can appeal to 'one of us' who is close to God."[39]

The principles of devotion to folk saints reveal much about the spirituality of the botánica. Folk saints reflect a disillusion with official institutions wherein, in Graziano's phrase, Catholicism "is not so much abandoned as expanded." These devotions are open to a variety of indigenous and creole influences, and devotees are free to improvise and hold positions of authority. Like canonized saints, folk saints can be petitioned and contracted with in order to perform miracles for their devotees. They can also work for their devotees' gain or vengeance, motives at least theoretically unacceptable to the official Church.

Figures at the botánica who fit well the criteria of folk saint are Venezuela's José Gregorio Hernández and Mexico's Jesús Malverde. José

Gregorio was a physician at the beginning of the twentieth century who worked among the poor of Caracas. Among the many miraculous cures attributed to him, he is said to have raised a patient from the dead. In 1919 he was killed tragically after being struck by a car as he was on his way to deliver medicines to one of his patients. Healers can receive the spirit of José Gregorio and perform spiritual operations on their clients, who attest to miraculous cures.[40] José Gregorio shows all that is good and pure in folk saints, unjustly taken from the poor who need him by an automobile, the industrial machine of the wealthy. Jesús Malverde was a Mexican outlaw brutally executed by soldiers at the command of a tyrannical local authority. A printed novena available at his shrine in his home state of Sinaloa tells his story:

If a woman was about to give birth and had no clothing for her infant, Malverde would be there anonymously, or send money or do whatever to overcome problems. What if someone was sick, had given up hope, was a prisoner, a lonely person or a widow, anyone who was isolated, whenever Malverde knew about pain or anguish of his brothers, he always undertook action to help them.[41]

Betrayed by a false friend for the price on his head, Malverde is led to the gallows by his enemy: "'Tell me Malverde, speak your last wish.' 'Help my people, in the name of God,' answered Jesús."

The pamphlet goes on to say that the Vatican came to Sinaloa to investigate Malverde's case for sainthood but rejected it. "The Vatican didn't recognize him, but Jesús continued caring for his people."

Malverde's story, like that of the Jesus of his namesake, exemplifies the anti-authoritarian dimensions of the folk saint. This outlaw stand is taken still further by contemporary Mexican drug dealers, smugglers, and other border crossers who have turned to Malverde for protection and success. He has been labeled a "narco-saint" in many police accounts, and his image on vehicles may constitute a kind of probable cause for search by law enforcement officials.[42]

José Gregorio's saintly life has inspired the Venezuelan hierarchy to work toward his official canonization, though his cult among unorthodox Catholics may be an impediment. Malverde's sketchy history and association with genuine outlaws makes him an unlikely candidate for official recognition. Yet despite its history of repression of unoffical ideas and practices, the Catholic Church has, of course, canonized local and indigenous spiritual beings from its very inception. St. Brigid in Ireland, St. Nicholas in Holland, and Sts. Cosmas and Damien in Rome all were in some way christianizations of indigenous figures. So, too, Christian relics and qualities were personified in narratives as cults grew around them, witness St. Veronica (vera icon, true image) or St. Christopher, (Christ bearer). The cults of the Virgin Mary in particular are famed for absorbing iconographic and cultic features of local female spiritual figures, be they Ishtar, Isis, or

Nuestra Señora de Guadalupe, Botánica Comanche, Atlanta.

the Black Madonnas of pre-Christian times.[43] We have spoken of the indigenous roots of the Caribbean Virgins and must note here the most famous christianization of an indigenous figure, the patroness of all the Americas, Our Lady of Guadalupe. In the earliest narrative, written in 1649, it is told that in 1531, barely ten years after the Spanish conquest of Mexico, a mysterious lady appears to a Mexica elder christened Juan Diego Cuauhtlatoatzin.[44] The scene is one of "superhuman grandeur" in which "the mesquites, cactus and other little plants growing there were like emeralds, their foliage beautiful turquoise, and their branches and thorns gleamed like gold." The lady commissions the awestruck Juan Diego to go to the bishop in Mexico City and tell him that "on this spot a temple be erected to me." The spot is the hill of Tepeyacac, a site of veneration of an indigenous goddess of many manifestations called Tonantzin, Our Mother. The mysterious lady's features, clothing, and aura all suggest Mexica origins. Though the narrator says "it was apparent that she was the ever Virgin Blessed Mother of the Savior, Our Lord, Jesus Christ," it is interesting that at no point in the narrative does she identify herself as such nor does Juan Diego. It is the Spanish who call her Our Lady of Guadalupe after a miraculous Virgin in Spain. There is speculation that Juan Diego might have called her Tequatlanopeuh, an appellation of Tonantzin, She Whose Origins Were in the Rocky Summit, and that the Native word was interpreted by the Spanish as Guadalupe.[45]

Many Mexicans today are proud to call her "*mestiza*" (mixed) with the connotations of mixed Spanish and Indian ancestry.[46] In one way or another, all the spirits of the botánica are mixed. They are constructions of power from a variety of historical sources, brought together, often under stress, by historically oppressed and marginalized peoples. Through conquest, entrenched caste systems, and exploitive systems of labor, many Latin American peoples have been forced into mixture and have created subtle, beautiful, and powerful ways to make use of it. There are several analytical terms to describe this process, each with its own etymology and connotation, among them being syncretism, symbiosis, hybridization, and creolization. A brief word about each of these.

Syncretism, in its modern usage, grows out of religious controversies in Reformation Europe. Theological positions that tried to harmonize hardening differences among Protestant and Catholic doctrines were condemned by their opponents with the word *syncretism*, untenable mixtures of important distinctions. This word continued in use among Christian missionaries to describe, and usually condemn, indigenous appropriations of Christian symbols that were considered unacceptably mixed with Native religions or "superstitions." The term was recently used in a related way by Pope Benedict XVI to warn against relativist theologies which might suggest all religions have equal claims to divine truth.[47] Anthropologists and historians of religion have been ambivalent about the use of the word,

freighted as it is with pejorative connotations.[48] Robert Baird has advocated abandoning the term altogether because it implies either a normative judgment that a religious tradition is impure or a historical truism, since every religious belief and practice has multiple and diverse historical antecedents.[49]

Symbiosis is a term derived from biology that stresses the mutual living together and interdependence of organisms. It has been developed by Leslie Desmangles, a Haitian American historian of religion, to describe the relationship of Roman Catholic and African elements in Vodou. He writes

symbiosis refers to the spatial juxtaposition of diverse religious traditions from two continents, which co-exist without fusing with one another. Just as tiny parts of a stained glass window are juxtaposed to form a whole, so too parts of the Vodou and Catholic traditions are juxtaposed in space and time to constitute the whole of Vodou.[50]

Hybridity has its origins in genetics and has been adopted by cultural theorists to describe colonial and post-colonial performances of contestation and resistance by the colonized. Homi Bhabha writes of the cultural in-between:

The interstitial passage between fixed identifications opens up the possibility of a cultural hybridity that entertains difference without an assumed or imposed hierarchy. . . . Hybridity is the sign of the productivity of colonial power, its shifting forces and fixities; it is the name for the strategic reversal of the process of domination through disavowal (that is, the production of discriminatory identities that secure the "pure" and original identity of authority). . . . Colonial hybridity is not a *problem* of genealogy or identity between two *different* cultures which can then be resolved as an issue of cultural relativism. Hybridity is a problematic of colonial representation and individuation that reverses the effects of the colonialist disavowal, so that other "denied" knowledges enter upon the dominant discourse and estrange the basis of its authority—its rules of recognition.[51]

Finally, creolization is a term arising out of linguistics that likens the production of culture and the arrangement of its structural features to the development of languages in contact. In a much-quoted passage, linguist Suzanne Comhaire-Sylvain says of Haitian créole "we are in the presence of French poured into the mould of African grammar or, since languages are generally classified according to their grammatical parentage, of a Ewe language with French vocabulary."[52]

A creole religion, therefore, is a reconstruction of the grammar and vocabulary of religious symbols from different sources: a structured, meaningful arrangement of elements that communicates in multiple and shifting cultural milieux.

Each of these formulations has applicability to the religions of the botánica. Syncretism is the most recognized term for religious mixture, though it so burdened with normative ideas of essence and purity that I use it sparingly. Anthropologists Charles Stewart and Rosalind Shaw have worked to revive the idea of syncretism not so much as a description of a religion but rather a discourse *about* religion and the contestations of boundaries that the use of the word syncretism provokes.[53] Symbiosis refines the broader notion of syncretism by focusing on the distinctions recognized by devotees in their mixing of religious symbols. Rather than fused or homogenized, elements are juxtaposed and mutually enhanced. The placement of objects on botánica altars suggests a "science of the concrete" where symbols in proximity are in dialogue with each other, commenting on each other, and revealing deepening layers of similarity and difference. Hybridity highlights precisely those areas of contestation that the idea of syncretism evokes. Botánica devotees are indeed engaged in a struggle to maintain and adapt identities in a difficult and often hostile environment. The hybridities of the botánica are strategic tools of power in that struggle. By appropriating and reworking the meanings of symbols, botánica devotees create their own identities and systems of power, subverting the places assigned to them by the official channels of power in colonial and postcolonial societies. Rachel Romberg writes of Puerto Rican brujeria,

choices are not only the result of individual, subjective perceptions of reality but also are constrained by specific social and institutional alternatives for action—already enmeshed in dynamic of power and inequality—that delimit the possible choices that can be made. . . . Brujeria as practiced in urban Puerto Rico shows the vernacular co-optation of discourses of interest and passions, of consumerism and spirituality, commodity fetishism and morality, and welfare capitalism and magic.[54]

Finally, creolization foregrounds the dynamic of botánica mixtures to show that they are *doing* something, speaking and communicating at several levels at once. By placing disparate sacred objects into spatial and temporal relationships, effective medicines are created. Recall the nganga, where earth and feathers, sticks and bones are brought together to "have its own power." Or the Ochún altar where the anthropomorphic image is juxtaposed with the soperas to speak on several levels at once. The creole grammar of the botánica speaks the language of its devotees and, with its vocabulary from Europe, Africa, and the Americas, it works to empower and heal. We can now look at the devotions to three creole santos and the ways that the botánica makes them present and effective to those who need them.

5

Three Santos

"The religion is very beautiful. . . . You are blind before and then you start practicing the
religion and the saints open your eyes to all you have in front of you."
Jorge, Botánica Chango, Baltimore

Eleggua: At the Threshold

Though the eye is drawn to the bright and colorful at the botánica, perhaps
the most important spiritual presence lies on the floor, small and gray,
guarding the threshold. This is the orisha Eleggua, also known as Echú,[1]
whose devotion was brought to the Americas by enslaved Yoruba men and
women and integrated into the complex mosaic of creole spirituality in the
nineteenth century. "Echú is the most important of the Orishas," says Oba
Ecun. "He is number one. He is the foundation of our religion. He is the
first."[2]

These praises to Eleggua were recorded in West Africa in the mid-twen-
tieth century and translated from the Yoruba:

> First born
> Known to everyone
> Anger prompting retaliation all out of proportion.
> Sharer in sacrifice
> Turner of right into wrong, who makes the innocent guilty.
> Standing alone in the entryway, like a stranger's son.[3]

The verses highlight several of Eleggua's traits: his primacy among the
orishas; his role as mediator in the sacrificial relationship between humans
and the divine; his capacity to overturn expectation and visit terrible con-
sequences on those who heedlessly neglect him; and, finally, his position at
the gateway, the liminal space between our world and that of the gods.

It is Eleggua who brings the offerings made by humans to the other ori-
shas and returns with their healing power, or in Lucumi, aché. All commu-
nication with God and the orishas goes through the gate of Eleggua, and
so he must be honored and propitiated for all the heavenly exchanges to be
successful. Andrés at Botánica Yemayá y Changó says that "Eleggua is like
the press secretary of the orishas, the messenger who goes between the
people and the power. But you have to be careful because he's very tricky.
You don't want to offend Eleggua: he owns life and he owns death."

There is a famous story of Eleggua told both in Africa and the

Eleggua at the door, Botánica La Esperanza, Miami.

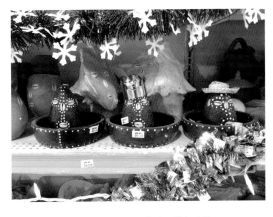

Red and black Elegguas, Botánica Riviera, Miami.

Americas of a time when two friends boasted that nothing would ever part them. They had been advised by the oracle to sacrifice to Eleggua but had refused. One day, while the friends were working on their farm, Eleggua walked between them, wearing a cap that was red on one side and black on the other. The friend who saw one side of Eleggua said, "Who was that man in the red cap?" The other friend said, "I saw him, but his cap was black." An argument ensued and just as things were calming down, Eleggua walked back between them in the other direction. The first friend tried to apologize for the disagreement: "no indeed the cap was black." But the second friend insisted that it was in fact red. Again the argument escalated till they began to fight in earnest and injure each other. Later they remembered their refusal to sacrifice to Eleggua, and belatedly they did so and reconciled.[4]

The story shows the fundamental two-sidedness of Eleggua and expresses two related principles in Yoruba spirituality. First, that every view is one-sided, self-interested, and relative. We usually see only the partial truth and not the whole, and we judge the world at our peril based on this incomplete picture. Eleggua is there to trick us when we are most self-satisfied. And second, that this twoness is liminal, it partakes of both sides, both worlds, and neither. Eleggua's power arises out of the point between dualisms. It is a place, as anthropologist Victor Turner writes, of power, creativity, and danger: "Liminality may perhaps be regarded as the Nay to all possible structural assertions, but as in some sense the source of them all, and, more than that, as a realm of pure possibility whence novel configurations of ideas and relations may arise."[5]

Eleggua, Botánica Orula, Hartford, Connecticut.

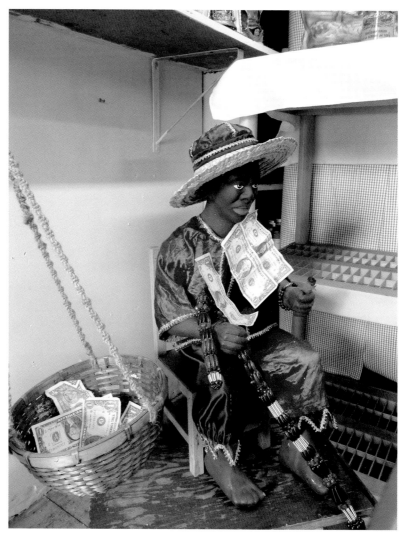

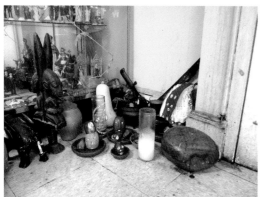

Elegguas at the door, Botánica San Rafael, Washington, D.C.

It is appropriate then, that the shrine of Eleggua occupies the liminal space of the botánica, at the doorway between the harsh, secular world of the street and the calm and healing precincts within. He is placed by the doorways of homes and businesses to preside over transitions across the threshold, and so monitor what comes in and what goes out.

Perhaps more than any other orisha, Eleggua takes on a variety of personalities and guises. He can be imaged as an old man at the gates of the city or a young boy in the palace of the king. Eleggua's unpredictability and penchant for challenging and upsetting order have caused some devotees to liken him to the biblical Satan, who is both

antagonist and partner to the divine at the court of the Almighty. These trickster traits also correspond to his image as a mischievous child. Many devotees refer to him familiarly as *el negrito*, the little black one, and accord him the wary respect due a supernaturally powerful little boy. Referring to this child persona, orisha priest John Mason calls him "cruel shorty who talks real jive" and "the virtual, wish-to-be artistic self of the id."[6]

As with the other orishas, the Cuban Lucumi found correspondences between Eleggua and the Catholic communion of saints, particularly with San Benito el Moro, San Antonio de Padua, and El Niño de Atocha. San Benito was born in sixteenth-century Sicily, the child of African slaves who achieved their freedom.[7] His dignity in confronting racial slurs won him the respect of the Franciscans, and he became a novice master and famous counselor of the order. He worked many miracles and people came from all over the island for healing. San Benito is often imaged as a diminutive Black man holding out a large cross. The correspondence with Eleggua may lie in these iconographic conventions of small size, dark complexion, and cross as the symbol of the liminal crossroads where Eleggua dwells.

San Benito, Saint Benedict the Moor Church, Washington, D.C.

San Antonio was a charismatic preacher in thirteenth-century Italy and is now one of the most popular saints in the Latin world. He is often invoked as the patron saint of lost articles, stemming from a story in which a novice at his monastery took a valuable book that Antonio was using. The saint prayed for its return and the novice was visited with a dreadful vision of Antonio and returned the book. As a theologian and mystic, Antonio himself received a vision of the Christ child as he studied the Bible and is now often imaged cradling the divine infant.[8] The Eleggua connection may lie in a remarkable folk Catholic tradition of interaction with the saint. Valeria of Botánica Todopoderoso brought me to her backroom shrine to show me her statue of San Antonio. She demonstrated how the child was detachable from the saint and said that when you want something from San Antonio, you take the child and hide it, refusing to return it until the saint grants your request. Extortion can go both ways with Eleggua, of course. An American santera friend once told me that San Antonio was Eleggua and that the reason why Catholics prayed to Saint Anthony for lost articles was because it was he who hid them in the first place.

San Antonio, Botánica Todopoderoso, Washington, D.C.

Perhaps the most popular Catholic avatar of Eleggua is a Spanish devotion to Jesus called El Niño de Atocha. The Niño is depicted as a medieval pilgrim with broad hat, staff, and drinking gourd. Like Eleggua, El Niño

Niño de Atocha/Eleggua shrine, Botánica Green and White, Austin, Texas.

is a child and a wayfarer with miraculous powers. The story goes that during the battles for the Christian reconquest of Spain, many Christian soldiers were imprisoned without food or water. Their relatives prayed to Our Lady of Atocha, the patroness of a Madrid suburb, and it happened that the imprisoned men were visited in the night by a mysterious child who brought them food. When the relatives went to the shrine of the Virgin to thank her for the miracle, they noticed that the shoes of the Christ child she carries were dirty, and they realized that the child savior of the imprisoned men was none other than the statue of the boy Christ come to life in the night.[9] There is a parallel story of El Niño from Mexico where the child appeared among trapped miners

Niño de Atocha/Eleggua shrine at door, Botánica Santa Barbara, Bladensburg, Maryland.

far below ground. A shrine was erected to commemorate this miracle in Plateros, Zacatecas, and it is now a major pilgrimage site. In the stories of El Niño, we have a miraculous and tricky child passing through the seemingly impassible gates of prison or fallen walls of the mine. This ability of a

Eleggua, Botánica Yemayá y Changó, Washington, D.C.

Echu/Eleggua, Botánica
Boricua, Wheaton, Maryland.

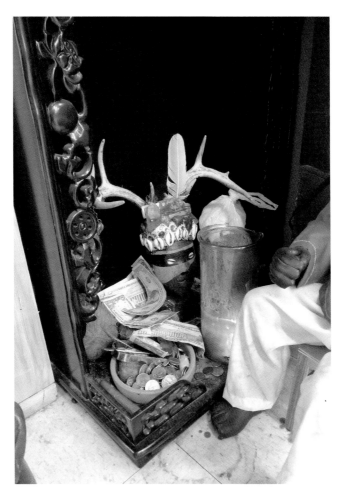

Red and black Eleggua in
shell, Botánica Los Sueños,
San Francisco.

divine child to do the impossible by opening blocked ways is precisely the special aché or divine potency of Eleggua.

Eleggua's shrine at the threshold of the botánica can be fashioned in a variety of ways, depending on the particular road that has been divined to be a protector of the store. Andrés at Botánica Yemayá y Changó says that "there are 101 paths of Eleggua, for each type of work that you want. There's an Eleggua for police, to control revolution, to open the road for work, for business. The one here at the botánica I had specially made for the store."

Andrés's botánica Eleggua exemplifies the most common icon of Eleggua as a concrete cone or cylinder some five inches high, with cowrie shell eyes and nose and a metal blade protruding from the crown of his head. This "wonderous knife" cuts things in two and sits atop Eleggua's head to demonstrate his aché and show his independence.[10] Another praise poem from West Africa goes,

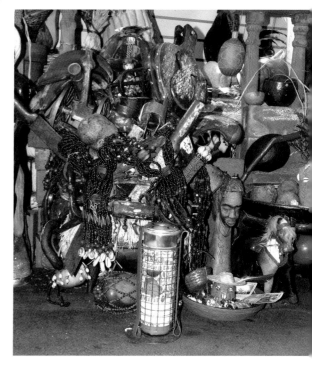

I salute Esu, I bow
The little child, I salute Esu
Elegba Esu on the road
Esu does not have a head to carry burdens
His head is pointed, Esu does not have a head to
carry burdens.[11]

Guerreros Eleggua, Ogun, and Ochosi, Botánica Yemayá y Changó, Washington, D.C.

Some roads of Eleggua display two and even four cowrie shell faces, reinforcing the experience of the multi-sidedness of the orisha. Other roads set the concrete head within a conch shell or crown it with antlers or other horns. Each has its own application and is constructed solely for its human devotee's needs.

Amassing the ingredients and combining them to make a sacred image of Eleggua require great knowledge and skill. Only advanced priests in orisha traditions are sanctioned to make an Eleggua. Oba Ecun provides an impressive list of twenty-eight materials that are needed to construct a basic empowered statue of Eleggua, not counting the additional materials for each of his 101 roads. A partial list includes red cloth, turtle shell, coins, guinea peppers, palm oil, honey, rum, and dirt from a crossroad, riverside, woods, jail, hospital, cemetery, royal palm, a dry tree, and from the house of the person who is receiving Eleggua.[12]

Eleggua often shares offerings with two companions, Ogun, the orisha of iron, and Ochosi the orisha of the hunt. Both are dwellers of the forest and share a similar role with Eleggua as outliers of civilization. Ogun's icon is the iron cauldron filled with tools and weapons of the forge. Ochosi's is

Eleggua with toys, Botánica Ashé, Hialeah, Florida.

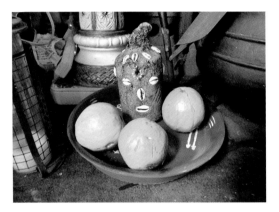

Eleggua with three guavas, Botánica Yemayá y Changó, Washington, D.C.

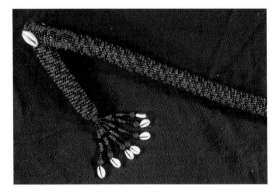

Garabato sheathed in red and black beads, Botánica Yemayá y Changó, Washington, D.C.

the *odé*, a stylized iron bow and arrow. Together Eleggua, Ogun, and Ochosi are called *los guerreros*, the warriors, and they are often petitioned and fed together. If divination should require it, these icons receive the sacrificial blood and herbal baths of Lucumi tradition. At the botánica one might see less sanguine offerings of tobacco, rum, and fruits. Eleggua, child that he can be, likes toys and candies at his shrine. But he enjoys the grown-up pleasures of rum and cigars as well. Other favorite offerings are toasted corn, rooster, and smoked possum. Orisha priestess Oggun Gbemi writes of an offering (ebo) for Eleggua:

One of my favorite ebbos is to take three guavas and cut them in half, placing them in an *igba* (gourd). I sprinkle them with *awado* (toasted corn), *eya* (dried smoked fish), and *eku* (dried smoked bush rat). Then I pour some honey on them, place them in front of Eleggua and light two candles on a white plate. I leave the offering for three days and each day I write one desire on brown paper and fold it up and put it on one of the guava halves. After the three days I reunite the guavas with the desires, now in the middle, wrap each one separately in a brown paper bag, and bring each to one of Eleggua's favorite places (ie: manigua [woods], four corners, etc.). I always ask Eleggua to allow me to have ONE of my wishes and let him pick which one. He never lets me down and always comes through with the one I needed the most, not necessarily the one I wanted the most.[13]

Andrés places three fresh guavas before Eleggua weekly:

His favorite tree is the guava tree. Having the secret we always put [out] guava to make him happy, to keep him always willing to do things for you when you ask him. Eleggua's hooked stick, the *garabato*, is from the guava tree. The reason why he has the *garabato*, the hook, is because that's how he tricks you. He grabs you or opens the roads for you. So every time a person who is crowned with Eleggua is dancing, as soon as the possession

takes over, right away he looks for the *garabato* because that is one of the tools that he uses all the time.

Not many santeros are called to be crowned, that is, to be initiated into Eleggua's priesthood and so act as mediums for the orisha in trance. When he does "come down" (*bajar*) to "mount" (*montar*) a medium-priest, he will often act mischievously. I remember well one occasion when an American colleague and I were attending a ceremony for Eleggua in Matanzas, Cuba. As the drummers played his rhythms and the lead singer sang his praises, the orisha mounted a man in the congregation and proceeded to dance, whirling and crossing his arms and legs. At one point, he took the money that had been left in a bowl for the drummers and threw all the coins out the door and into the street, much to the delight of the children who had gathered there, no doubt anticipating such a gesture. Eleggua then moved toward the two American visitors who were leaning against a wall, arms crossed. He took my companion's cigar and put it in his own mouth and then leaned back against the wall and crossed his arms in a perfect parody of us.

The Elegguas at botánicas are capable of effecting all of these tricks and so are carefully nurtured by the owners to work for the benefit of the businesses. Andrés says:

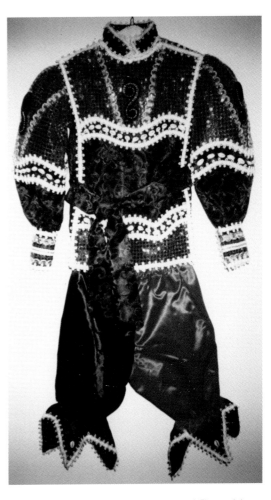

Red and black Eleggua initiation garment by Rolando Vasallo, photo courtesy of HistoryMiami.

I have ten Elegguas. I have one for the store—specifically for the store—to open the doors, to bring customers, and for customers to find what they need. I specifically had this Eleggua for the customers, for them to find what they need, for when they come to me to get the help that they need for whatever issues they have.

I've been here many years, and I have many godchildren. Many godchildren don't have the opportunity to receive Eleggua, but they need him for different reasons, like for a job. Some can't have Eleggua in their house. So they come here and they bring a fruit, they bring candles, flowers, whatever need they have they come to Eleggua with a problem and are welcomed.

One will often see a mousetrap among the offerings at an Eleggua shrine and it is there for Eleggua to catch things one wants and things one doesn't. Andrés says,

Mariwó over doorway, Botánica Santa Barbara, Alexandria, Virginia.

You put [out] things like a mousetrap, things like that because he's very tricky. You put items that basically belong to him, whatever he uses to catch whatever it is that is impossible to you. If you have a person who is a thief and you're trying to catch the thief, you put the mousetrap in there. Sooner or later, Eleggua will make it happen.

Michele at Botánica Santa Barbara says of the gatekeeping power of Eleggua, "When you have an Eleggua at the door it's for him not to allow people who don't need to come in, period. Let's say there's five people together who want to come in to the store. And one of them says, 'No, it's OK, I'll stay outside.' That's my sign right there."

All this attention to the threshold demonstrates the importance of marking the botánica as a sacred space. Eleggua serves the practical role of protecting the store from ordinary threats like thieves and hostile people, but the orisha also delimits from the profane world the ritual space of the temple, to use Andrés's word. Many botánicas hang a fringed band of dried palm leaves called *mariwó* from their doorways to show that the precincts within are sacred. "Anyone outside seeing *mariwó* at the door," says santero Isadoro, "should know that a secret is present inside, a mystery that must be respected." Eleggua lies at the place of mystery, marking the botánica as a sacred site amid the mean streets of America.

Changó: Welcome Home Your Majesty

Changó is a royal orisha whose veneration was also brought to Cuba and other American plantation societies by enslaved Yoruba men and women in the late eighteenth and early nineteenth centuries. In the misty times of Yoruba origins, Changó was a charismatic king, the *alafin*, or owner of the palace, at the imperial capital of Oyo.[14] He was famed as a warrior and

horseman with a thirst for conquest and glory. Yet amid all the admiration for Changó's virility and prowess, there is a persistent strain of ambivalence and tragedy in his story. Impetuous and impulsive, Changó was said to have mastered the mysteries of fire and could rain it from the sky on his enemies.[15] But one time he set his own palace ablaze and burned to death his wives, children, and courtiers. In despair he withdrew to the forests where he underwent an apotheosis. Some say he hanged himself, others that he ascended into heaven on a golden chain. From heaven he now reigns as the lord of thunder and lightning, where he continues to visit fire on evildoers. He splits the sky with his double-headed ax, announcing his presence with mighty peals of thunder. His followers sang these praise-verses to him in West Africa in the mid-twentieth century:

He dances savagely in the courtyard of the impertinent
He sets fire to the house of the man who lies.
Owner of the destroying ax,
He sounds his maracas like iron handbells.[16]

Changó is probably the most popular orisha in the Americas, and his patterns of worship have become the model for orisha religions from Brazil to the United States. Orisha priest and scholar David Brown once said that Yoruba religion underwent a "changoization" in the Americas, collapsing many disparate orisha traditions from Africa onto the template of Changó worship.[17] Willie Ramos, a historian and himself a priest of Changó, sees this assertion of Changó's preeminence as a continuation of the royal house of Oyo's claim to authority transplanted to the New World.[18] Ramos documents the initiatives of a number of orisha priests in Havana around the turn of the last century who worked to regularize orisha worship by creating a "Havana ordination mandate" that sanctioned initiations according to the rites of Changó. As a result of this collaboration of influential priests, new initiates into all the major orishas are properly crowned on Changó's mortar stool, presented to his sacred *batá* drums, and become mediums for their patron orisha in sacred trance as Changó's mediums have done for centuries. An echo of Oyo triumphalism can be heard when Andrés, who is also a Changó priest, says,

Changó owns the religion. He brings everybody together, all the powers and mysteries of all the *orishas* are owned by Changó. The other *orishas* give their secrets to Changó in exchange for him fighting for them. When Changó has all the powers he ends the fighting among the *orishas*. His colors are the colors of all the orishas: red and white, war and peace, both together.

It often strikes botánica visitors as odd that the macho African Changó is corresponded to the pale virgin martyr Santa Barbara among the Catholic saints. Santa Barbara's legend goes back to Asia Minor at the time of

the Diocletian persecution of Christians in the third century. Barbara was the daughter of a wealthy pagan who imprisoned her in a tower to keep her from the seditious teachings of Christianity. In spite of these efforts, Barbara converted to the Christian faith and her father denounced her to

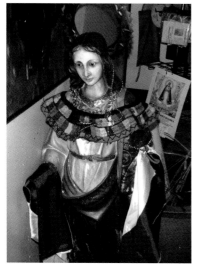

the local authorities. She resisted all attempts to persuade her to recant, including torture and a sentence of death. In a fury, Barbara's father carried out her execution himself and beheaded her. At the moment of this outrage, a bolt of lightning came out of the sky and consumed him in fire. Church scholar J. P. Kirsch writes, "The legend that her father was struck by lightning caused her, probably, to be regarded by the common people as the patron saint in times of danger from thunderstorms and fire, and later by analogy, as the protector of artillerymen and miners."[19]

One can easily see the parallels that might have inspired the Cuban Lucumi to correspond Changó and Santa Barbara. Each dies an ignominious death and brings death to their families by lightning. Each story associates lightning, retribution, and rough justice. And each is connected with the militancy of fire. In statuary and lithography, Santa Barbara wears a white tunic and the scarlet cape of the martyr. She carries a sword that

Santa Barbara, Botánica Santa Barbara, Washington, D.C.

identifies the instrument of her martyrdom and a chalice that signifies that those who pray to her at the hour of their death will receive the Eucharist and, so, salvation. The tower of her imprisonment is often depicted with her, and her crown is often crenellated like tower battlements. Each of these symbols has parallels in the Changó story. Changó is the alafin, the lord of the palace at Oyo, and thus the crenellated tower recalls him. His colors are red and white and he fights with a sword.

Both Juana and Michele have named their botánicas after Santa Barbara. And each has a story of fire. When I first visited Juana at Botánica Santa Barbara, it was clear that her basement shop had recently experienced a fire. Everything was scorched and dingy, the merchandise covered with a film of soot. Amid this depressing scene was a bright, beautiful shrine with a Santa Barbara statue cloaked in a woven mantle given to her by a Central American devotee. Juana told us that she had dreamed of the fire the night that it had broken out and that Santa Barbara assured her that it would be contained. When she got to the store in the middle of the night, the smoke was clearing and everything was singed and damp from the sprinklers: everything except the untouched statue of Santa Barbara.

Michele also had a dream of fire. She told us that her first business was selling botánica items like candles, oils, and statues from a booth that she would set up at a weekly flea market. She was hoping one day to open a real store but with a full-time job and young children she couldn't get started. Every day she would light a candle to Santa Barbara in the corner of her room. One night she dreamed of fire and a blue door. The next day

Santa Barbara/Changó shrine, Botánica Yemayá y Changó, Washington, D.C.

she was called from work—her apartment was on fire! When she returned, she found all her belongings destroyed except the wares for the botánica. Shortly afterward she saw a small space for rent with a blue door. The landlady inexplicably lowered the price so that she could afford it. And so Botánica Santa Barbara was begun. "As a daughter of Changó I'm dedicated to justice," Michele says. "My justice is to comfort and to care for people." Still, a life with Changó has its challenges. She concludes that "All my life I knew I was a daughter of Changó. One time my godfather was lighting a candle and all of the sudden he started a fire. He said 'My God! You're definitely the daughter of Changó!' We almost burned the place down!"

At Botánica Yemayá y Changó in Washington, Andrés and Marta have constructed a magnificent shrine for Changó/Santa Barbara. The backing drapery is gleaming white and overhung with bright red filigree, giving the enclosure a dynamic pulse. Red and white string lights illuminate the drapery from within. Offerings of flowers, foods, and red wine are placed before the santo atop a platform supported by fluted pedestals. Various statues of courtiers are in attendance, the gifts of patrons in thanksgiving for Changó's intercession. Two of Changó's double-headed axes can be seen flanking the central figure, the one on the right encrusted with red and white beads, showing shining metal blades. The one on the left is in more traditional wood, adorned at the handle with a sleeve of red beads. The statue depicts Santa Barbara mounted on a white horse. The sculpture is half-sized, set above eye level, gazing out beyond her visitors. She wears a red cloak inscribed in white with a scene of the crucifixion of Jesus. She carries in her right hand the eucharistic chalice, now filled with money offerings. In her left is a great drawn sword, ready for battle. Hanging from her right wrist are red and white maracas inscribed for Changó.

I asked Andrés about the statue, and he told me that he commissioned it from a sculptor in Miami named Ernesto Flores, who had since passed away. Andrés said that it was his idea to portray Santa Barbara sidesaddle. The other images that he'd seen had shown her mounted astride "like a man" and he wanted her to be "gentle, to look more like a gentle woman, more of a woman saint." The sculptor didn't know how to do it and they spent a long time designing it so that her legs would look natural. For the horse, they got an old carousel horse. Andrés told me an apocryphal story of Santa Barbara:

Santa Barbara was from France and was a soldier. She hid as a man and fought many battles. She had the same job as Changó. She lived in the castle as a soldier and left from it to fight her wars. Her father was very oppressive; he took food from the poor as taxes. Barbara fought against him but was betrayed by friends. He captured her and put her in the tower and tried to make her marry another king. Lightning struck the tower and Barbara was nowhere to be found. She became a saint for the army in the Catholic religion. She carries the chalice because she was a good Christian and went to church every day.

The statue, like the story, presents a wonderful example of creolization, where a Changó grammar is filled with a Santa Barbara vocabulary to express a new and dynamic religious experience. Nowhere in European iconography is Santa Barbara depicted on a horse. The substrate of Changó worship has shaped the image and story of Santa Barbara to reflect and amplify Changó's symbolic array. And Changó's militancy enhances Santa Barbara's capacities with lightning, gunpowder, and fire. The equestrian Santa Barbara is also a visual pun. Changó is a divine horseman who mounts his medium-priests in ceremonial trance. By depicting Sta. Barbara mounted, the relationship between horse and rider, and thus human and divine, is visually presented.

This pun may illuminate that problem encountered by the new visitor to the botánica: the depiction of a male santo through the iconography of a female one. I will offer three brief interlocking explanations. First, that the orishas are neither male nor female, they are *potencias*, powers, forms of aché. They can become persons but are not fundamentally persons, and so they manifest in men or women as they please. Second, human priests who are consecrated to become mediums for the orishas can be male or female. In the language of Changó's priesthood in Africa, mediums, regardless of their sex, were wives of the orisha, receiving him into their bodies. When priests are initiated in orisha traditions in the Americas, they are called iyawo, new wives or brides of the spirit. In this way Sta. Barbara can be understood as a medium of Changó, manifesting him in men and women with characteristic regalia. Finally, among all the orishas, Changó's gender in particular can be ambivalent. Andrés told me a story:

Changó always has problems with Ogun, always fighting. One day Ogun has him surrounded after he had fled to Oya's country. His enemies see his white horse and search for him and surround Oya's house. They demand a search. She says all right but she needs a little time to get ready. Oya cuts off some of her hair and makes a wig for Changó. She sends out a group of women messengers and Changó is among them and escapes through the lines because Ogun's soldiers think they're just women. Changó is grateful to Oya because she gave him the power of lightning. There is a belief in the religion that Changó is six months a woman and six months a man after that.

Andrés goes on to explain that this ambivalence is often contested at drum ceremonies, *bembés*, when Changó manifests himself in his human mediums:

So Changó always has to prove he is a man. When he dances at the *bembé* he does that. The *akpon* [songmaster] sings "prove you are a man!" When women are possessed by Changó they always have a second set of clothing under their first because Changó will rip them off to prove he is man. Women don't want

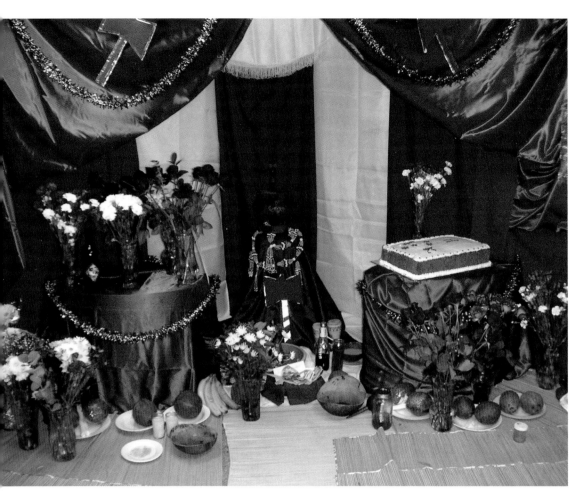

Changó throne, Botánica Santa
Barbara, Alexandria, Virginia.

to be naked when possessed. They will wear men's trousers under their ordinary women's clothing.

On December 4, the feast of Santa Barbara, Botánica Santa Barbara hosts a bembé for Changó.[20] Owner Michele is godmother to a large community of orisha devotees and celebrates an annual cycle of ceremonies for her patron spirits in the basement rooms of the store. On some occasions, she rents a somewhat larger space in a building adjacent to the botánica, but at that location, too, there always seems to be a crush of people paying homage to the santos. This time we are packed into the basement, some fifty people representing Michele's wide circle of godchildren and friends. Most are Latino from the Caribbean and Central America, with a few African Americans and a couple of white Americans attending. The conversations are mostly in Spanish, but many people welcome me in English. There is a larger room, perhaps twelve by fifteen feet, with a couch and a few chairs. But now the room is overflowing with standing people, spilling out into the stairwell to the street outside. Next to this space is a smaller

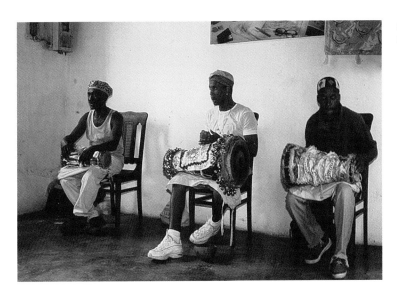

Batá drummers, Matanzas, Cuba, 2001.

room, converted into a shrine for Changó. As each person enters, he or she is pushed along through the crowd into the shrine room to pay respects to the Alafin. Most bring red and white flowers and baskets of fruit. Michele and her senior godchildren greet them at the shrine, place their offerings before the divine throne, and bless the devotees as they prostrate before the royal presence. The throne is a sumptuous composition in red and white satin. Amid flowers, candles, fruits, and drinks, Changó sits in state on his mortar stool, his sopera draped in elegant cloth, wrapped with his beaded mazo necklace, and topped by a wooden crown. *Oché* double-headed axes hang in the drapery and lie before the sopera. A great cake sits before the king, inscribed "Felicidades Changó/Santa Barbara." The two rooms constitute the architecture of the bembé, as the ceremony will move from the shrine space, known in Lucumi as the *igbodu*, to what will be the dance space, the *eyá aranla*.

At last the drummers arrive and set themselves up on chairs before the shrine in the igbodu. They are three Afro-Cuban men, and each carries a batá drum of a different size. The largest is the Iyá or mother drum, which is placed in the middle, flanked by the mid-sized Itótele on the left and the small Okónkolo on the right. Each drum is hourglass-shaped, with a skin drumhead at each end. Each is covered with a richly beaded drape called a *banté*, which honors the orisha to whom the drum is dedicated. The drums are played on the knees of the seated drummers, each hand producing a rhythm and together creating a complex polyrhythmic wall of sound. The high crack of the Okónkolo and the deep bass of the Iyá reverberate in the small space, but the effect is tight and disciplined, like a Bach fugue. This is the *oro del igbodu*, or rite of the shrine, where the drummers cycle through the praises of each of the orishas without accompaniment. For many drummers, this is the most important part of the bembé, where their playing must be precise and acceptable to each orisha invoked. But the congre-

gation is eager for the second phase of the evening, when the drummers move into the eyá aranla and the singing and dancing begin.

After some thirty minutes of playing before the throne, the drummers squeeze their chairs into the larger room and begin the awaited party. Once again the rhythmic praises of each orisha is played on the bátá ensemble, but now a burly Cuban man, the akpon songmaster, steps forward and begins singing the Lucumi praises of Eleggua, the opener of the ways.

Íbarago-o moyubá
Íbarago-o Agó moyuba'ra
O-o-modé koni ko'si baragó-o
Agó moyúbara Eleguá Echú lo-na.[21]

It is difficult to translate Lucumi songs, because the crucial tones of the original Yoruba have been obscured in the centuries of development of the orisha traditions in Cuba. Lydia Cabrera offers this free translation:

Con el permiso de los que están aqui (los orishas) me inclino, pido permiso a Eleguara y a Eshu, dueño del camino. [With the permission of those that are here, I bow and ask permission of Eleggua and of Eshu, lord of the road.][22]

The Lucumi songs for the orishas are known by many people at the bembé and the congregation complements the akpon in energetic response to his calls. Sometimes he will gesture and demand a more vigorous response like a preacher in a Black church seeking witness. As each orisha is called by the drums and songs, people who are initiated into its service come forward and place their heads on the Iyá as it plays for their patron. At times people will stagger and begin to seem dissociated but they are quickly attended to by Michele's senior godchildren and gently brought back to ordinary consciousness. I ask one of the godchildren later why they were not encouraged to go into trance, and she said, "This is Changó's party and he's the only *orisha* invited to attend." Indeed, Changó's songs are saved for last and it seems that the drummers and singer have stepped up the energy. Michele is persuaded to dance before the drums and comes forward, somewhat reluctantly, it seems. Andrés once told me that he resists being "mounted" by Changó. He'll feel a sudden heat flash and he'll back away saying "No! No!" Changó is "very jumpy," he said, and the next day after a *bembé*, his muscles ache from the santo's powerful dancing.

Michele begins to dance more and more vigorously, and the singer and drummers are more focused upon her. Everyone is dancing in place and the room is hot and heavy with expectation. The akpon demands loud and heartfelt responses from the congregation and forcefully calls upon Changó to descend, "praying up a storm," in master drummer David Font's apt phrase.[23] After twenty minutes of focused hard rhythms, singing, and dancing, the gathering storm breaks and Michele staggers as she receives

Oché Changó, double-headed ax, by Baba Ade Cola.

Changó priestess Barbarita de Leon in characteristic gesture, Matanzas, Cuba, 2001.

the Alafin. Her eyes bulge with the power within her, and the affect of her face changes from that of an ordinary person into a mask of open-eyed might. She raises each leg high and stamps the floor hard. Her arms circle downward from her chest to the groin and radiate outward again. Then, left hand on hip, Changó raises his right to the sky, holding and poised to release thunder. As the drums roar, the akpon leads the most famous of songs for the arrival of Changó:

Kawo é! (Welcome!)
Kawo é! (Welcome!)
Kawo é, Kabiesilé ó! (Welcome home Your Majesty!)

Changó dances in the crowded room for some twenty more minutes as the musicians finish the song cycle in his honor. The akpon then leads the drummers to a rousing conclusion. As the drums reverberate in the suddenly silent room, Changó hurls himself to the floor in prostration before the Iyá and the whole community exhales as one. Michele's godchildren now help Changó to his feet and bring him into the igbodu, where he is shown his magnificent throne and offered some of the foods displayed

around it. A line forms at the door of the throne room and one by one people are admitted to consult the orisha in manifestation. People ask for help and blessings and Changó will sometimes dictate remedies for problems or prophecy outcomes. When my turn comes, I ask simply for his blessing, and he gently pushes me to prostrate before the throne and touches my shoulders with a light tap as I lie prone on the floor.

While Changó is seeing petitioners, the rest of the congregation relaxes and enjoys a catered meal from hot steam trays wedged into the hallway that leads to the upper floors. Changó cake, now that he has sampled it, is there for all to have for dessert. The drummers relax with paper cups of rum and tell stories. When Changó sees the last supplicant, they take one last swallow and hoist the drums to their knees. The akpon sets the time and they begin a fresh cycle of songs to Changó. The Alafin returns to the larger room, the eyá aranla, and dances in acknowledgement of the fine party in his honor. He now carries his oché ax, whirling it aloft and bringing down thunder and blessings on the congregation that dances with him. Amid these displays of power he will go up to some people and gently touch them with the oché, moving the wand over them in healing strokes. He breaks off at times to dance and then returns to other people, dispensing favor like the royal personage that he is.

After another thirty minutes of dance and song the time comes for the Alafin to depart. He slows, begins to slump, and eventually falls limp into the arms of Michele's godchildren. They help her back to the privacy of the igbodu and the drummers stop for good. Everyone is tired, happy, purged.

With these and other dramatic ceremonies, Botánica Santa Barbara is not only a space of commerce and consultation but a ritual space where the living gods are brought down from heaven to incarnate themselves among their human devotees. Changó, as the preeminent divine horseman, did not die in Africa but lives on in rhythm song and dance at the botánica.

Maximón/San Simón: Maya Lord of Wealth and Changes

The origin of Maximón, or San Simón, was in a different cultural dynamic than the Caribbean, one that brought Eleggua and Changó to the botánica. His oldest shines are in the highlands of Guatemala among the Tz'utujil Maya peoples who inhabited the region long before the arrival of the Spanish and Christianity. Pre-Columbian Maya religions were based on a series of calendrical observances that worked to ensure the continual processes of the cosmos: the cycles of the seasons, the rhythms of agriculture, the fertility of men and women. The annual obligations to perform these ceremonies, and the local fraternities entrusted to this task, lived on after the introduction of Christianity in the sixteenth century. *Costumbre*, the "old inherited ways of knowing and doing," were maintained by locally administrated *cofradias* alongside and within the Christian devotions brought by the conquerors.[24] Robert Carlson writes that

evading the scrutiny of their pious overlords living in distant towns, many communities have used the *cofradía* system to transfer aspects of pre-Conquest religious ritual, refabricating the institution in the process. . . . Whereas enough of the accoutrements of Catholicism are generally present in the *cofradías* to deflect direct intervention, at the same time the system can constitute a "barrier," the occult side of which offers a venue for the celebrations of characteristically indigenous religious expressions.[25]

Into this Mayan grammar, the vocabulary of the fiestas and santos of Roman Catholic devotion were integrated. The Catholic fiestas became opportunities to carry out the vital regeneration rites for the cosmic cycles, and the santos came to stand for indigenous ancestors and divinities crucial to this task. In the town of Santiago Atitlán, Guatemala, for example, St. John is associated with the local lord of wild animals, while Judas Iscariot, the villain of the Gospel narratives, is identified with Maximón and revered as a creation of the local rain gods who acts as a central oppositional figure to the "good" santos canonized by the Catholic hierarchy.

It is in this environment of cultural blending and resistance that Maximón/San Simón makes his appearance. He is known by a number of names, as the slash above might indicate. Carlsen says that the name Maximón is itself a conflation of a Mayan honorific Mam, meaning Ancestor, or Grandfather, and the Spanish name Simón. He is often called simply Mam by devotees. Art historian Jim Pieper says that when the deity is addressed in Mayan he is called Maximón and when venerated in Spanish he is San Simón.[26] One of his foremost devotees derives the name from the Mayan *Ximon* or *shum*, meaning "bundle" or "tied up." Apolinario Chile Pixtun explains

in the classic epoch of the Mayans . . . the forms of ancestors were made of tied-up leaves, wood, or bark. . . . The original Maximón was not in this [current anthropomorphic] form, but in the energy of the first bundles that were here among the Mayans. . . . The Catholic missionaries came, and they gave him blue eyes, and a big mustache, another form, because they had burned the original. Maximón was originally a Mayan. The Spanish burned him three times . . . so they [the Maya] made him different each time so that the missionaries wouldn't recognize him and burn him . . . to look like a Catholic saint instead of an Indian.[27]

For Tata Apolinario, Maximón is a representation of the lineage of ancient Maya kings. He says

for us, these Mayans are not dead, but in actuality the energy of our *Aipop* [king] vibrates within the Mayan sons and grandsons, with the people, the Mayan people.

The aesthetics of the wisdom to understand the images of the forms of

[kings] Axmon, Axuan, Ajpop, etc contains the great philosophy of the Mayan calendar and the grand roots of the origins of the Mayan people. It [Maximón] is then the image of the great Mayan men and ancestors. The great spirits of our people, the names are the names of the sacred days of the Mayan calendar, which is our measure of time and space.[28]

Maximón shares a number of characteristics with the ancient Maya divinity known as God L., who is depicted in pre-Columbian glyphs as seated with a scepter and who was associated with commerce, wealth, and sexuality. In Santiago Atitlán, they say that Maximón was created by the ancient rain deities as a guardian of traveling merchants, but that he betrayed them by sleeping with their wives when they were on their journeys. The rain gods thus broke him up into his current image at the town shrine, with its turned-around head and short legs.

The association of the indigenous Mam with the biblical San Simón may lie, like the connection with Judas, in betrayal. At a crucial moment in the passion story, Simon Peter denies his association with Jesus and curses his master. The most important festival for Maximón is celebrated at his oldest shrine at Santiago Atitlán on Good Friday, when a great transition in the Maya calendar is enacted. The days of the Christian Holy Week are "delicate days" in the Maya calendar in which the passage of the dry season into the wet is in a dangerous liminal state. Maximón's cofradia must perform the necessary rites to bring about the all-important change.

During Holy Week, Maximón's effigy is hanged from a symbolic tree in his chapel across the central plaza from the church. On Good Friday, he is paraded around the square as the sun is moved across the sky. In midafternoon, when the young Catholic catechists bear the image of the dead Christ from the church into the square, Maximón's cofradia carries out Maximón for a confrontation. The two corteges meet and Maximón is said to inseminate the dead Christ and so ensure the rebirth of the earth and the return of the rains.[29] As Jesus dies, Maximón lives. Peter Canby witnessed the festival and writes that

the core paradigm of Maya religion is that everything evolves into its opposite. The *atitecos* [residents of the town] divide the year into two halves: a female half that has to do with gestation, dryness, and death, and a male half that has to do with rebirth. The transition between the two is now, at the equinox, just before the rains start, when the world is half male and half female. That's Maximón's power. He's the attraction of opposites: day to night, wet to dry, male to female.[30]

This oppositional role is both part of Maya notions of cosmological balance and process and an assertion of Maya traditions against the assaults of Catholic activism and Protestant evangelism. A website associated with Tata Apolinario states

the Mam has been accused of being part of witchcraft, according to the structure of the Church. On account of that, the Mam is a deity in revolt against what is conventional; it is a resistance against the Catholic or evangelical imposition. The Ajq'ij [Daykeepers] consider it [Maximón] to be one of the great ones that come from the creation of the maize man.[31]

Maximón's procreative power is both a resource for transformation and a dangerous attraction. Living at the interstices of the worlds, Maximón's creative energy can bring about transition, change, and rebirth. But he can, just as well, change life into death. There are many stories of Maximón as a shape-shifter, appearing to lonely men and lonely women as a tempting lover and leading them to their deaths. In conversations with botánica owners, I've heard some say that Maximón is a deity only for women, while others warned me he is particularly dangerous to women. This seeming contradiction may mean that Maximón is at the space between life and death and therefore both dangerous and efficacious to new life. As Nana Eufemia, priestess and wife of Tata Apolinario told Jim Pieper, "I am very careful, because he is a very delicate spirit for me."[32]

"You don't play with Maximón," José of Botánica El Salvador del Mundo told me, "he is very stern." Georgetown student Sarah Vazquez said that when she went to a Maximón shrine in Guatemala, she was told to "bring her vices to the Mam, such as liquor and cigarettes, and he will take them and heal you." The creative and dangerous in-between of Maximón seems particularly effective in the world of commerce. Pieper says Maximón is sometimes seen to "represent or become Judas Iscariot" who betrayed Jesus to the Jerusalem authorities for the infamous thirty pieces of silver. "Having done this deed for money, he is viewed by many as the patron saint of business men, stimulator of sales and protector of profits."[33]

Otto Chicas, partner in the original Botanical Gardens store in New York, has written a remarkable book about Maximón in his native Guatemala. He records a number of testimonies of Maximón devotees that highlight his appeal. At San Andres Itzapá, one of the highland centers of Maximón veneration, he asks a woman if she believes in Maximón. "Of course," she replies, "after God there is Little Brother [Hermanito] Simón or as you say Maximón. He helps me a lot especially in the business I have in the Zone 4 Terminal. I began with a vegetable basket, reselling merchandise: now I have a warehouse." She offers this prayer:

Oh Lord of the green hills and good causes, don't let my business sink in the sea of the envy of my enemies and thieves. Protect me Brother Simón. Protect me and give me abundance in money and everything that is sold here. I promise you Lord not to harm anyone and on the contrary to share with my peers. Free me Lord from these sudden attacks of thievery, you who are just, will help me with my problems. Remember that business is the basis of my success and the bread of my children.[34]

In Guatemala City, we are introduced to a prosperous merchant who has a statue of Maximón in his warehouse with offerings of incense, flowers and liquor. The merchant tells us

Maximón gave me a hand and lifted me up from utter nothingness. . . . I am indigenous, something of which I am very proud. I didn't learn Spanish until I was sixteen. . . . I finished my elementary education in three years and now I am advancing in computer science courses. All this I owe to Maximón who has helped me enormously.[35]

A final testimony reveals Maximón's appeal to others at the margins of society. The owner of a brothel on the outskirts of Guatemala City tells her story:

I used to practice prostitution from the age of sixteen. Guys with no scruples exploited me. I was beat up and humiliated. A colleague from El Salvador took me to meet Maximón. At the beginning I did not understand the matter and thus I didn't believe in him. But as time went by I understood the rituals and that I, as an outcast, had to be on his side because he too is an outsider.

The woman prayed to Maximón for help, and after two years of performing "the lottery numbers ritual," she won a huge prize. She continues:

Honestly I couldn't really escape the business so I established my own bar in the Parroquía neighborhood where it all went well and it started to grow little by little. Today I have several businesses. I also have several adopted children to whom I have provided education and motherly love. Two of them come from women that have worked in my bars and that the mothers have abandoned.

See, I know that I'm a sinner, but I've tried to do good, first and foremost to my adopted children who love me and I love them. That gives me absolute peace. . . . I am seventy five years old and I think I have not much time to enjoy what God and the Little Brother Simón have given me, maybe even without me deserving it all.[36]

Maximón embodies these traits of indigenous identity and resistance; outsider empowerment; and dangerous, creative potency. He is venerated in his present incarnation as indigenous communities are under siege from evangelizing Catholicism and Protestantism, from the displacements of multinational economic forces, and from a brutal thirty-six-year civil war. Over one million Guatemalans and at least five hundred thousand Salvadorans came to the United States from their war-ravaged countries in the last decades of the twentieth century, forming significant communities in California, the Southwest, and many American cities there and elsewhere. Maximón has been the most popular santo to accompany these immigrants, and it is not surprising that it is the immigration process itself that inspires much of his veneration.

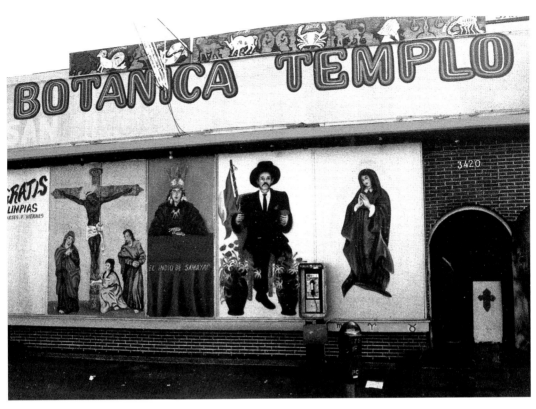

In 2000, UCLA researchers Patrick Polk and Michael Owen Jones visited Botánica Templo San Simón de los Llanos in Los Angeles and got to know owner Hermano Carlos.[37] Carlos had come to Los Angeles in 1988 after a difficult and dangerous journey from Guatemala, and he thanks God and San Simón for his safe arrival. He is a member of a cofradia dedicated to San Simón, and every year around October 28, the feast of San Simón and San Judas Tadeo, the cofradia forms a procession, moving through the streets of Los Angeles, carrying aloft the statue of the saint. Hermano Carlos has transformed his botánica into a beautiful and spacious temple to San Simón, and he consults for all who come to him. He advises on physical ailments and would like to work with medical doctors to help his clients. He treats alcoholics and victims of domestic abuse and tries to help undocumented workers who have no other recourse. He told of a woman who came to him with a problem with the immigration service:

Botánica Templo San Simón, Los Angeles, photo courtesy Jim Pieper.

They asked her for an I.D. but she didn't have an I.D. . . . or an interpreter with her. In fact, she didn't have an appointment that day and she was able to get in . . . you see, she had been praying to San Simón. The agent told her that because she was an honest woman he was going to help her. The agent was very nice to her. He filled out a passport form for her because she didn't have one, signed her paperwork, and she was done. Lots of people come here to see San Simón because he performs a lot of miracles.[38]

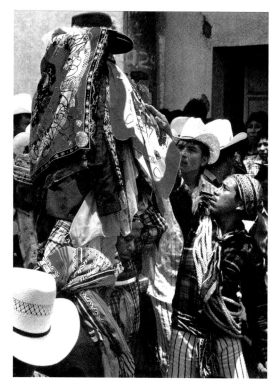

Maximón being taken for hanging, Holy Week, Santiago Atitlán, Guatemala, 1992, photo courtesy of Jim Pieper.

San Simón/Maximón, Botánica Tres Potencias, Falls Church, Virginia.

The images of Maximón at the botánica are developed out of the original bundles that continue to be venerated in Guatemala. The inner parts of some of these Maximón images seem consistent with the oldest documentation of Maya material religion. In 1688 Lopez de Cogolludo Diego wrote,

They had a timber that was made into a dummy that was put on a bench, on top of a mat. They offered this doll food, and other offerings, in homage. When they ended the ritual, they undressed the doll, and they put the stick into a gully in order to care for it so they could use it again, and they called this doll Mam while making offerings and paying homage.[39]

The famous effigies of Maximón at Santiago Atitlán and San Andres Itzapá seem to be such bundles of material arranged and clothed to appear roughly anthropomorphic. Their faces are made with wooden masks, and their heads are topped by one or sometimes two broad-brimmed hats. They are also draped with native cloths coded to the calendar. Other Maximón images are more directly anthropomorphic, showing a seated male figure often clothed in a fine suit and tie and wearing a large cowboy hat. He carries a staff in his right hand. They can sometimes have glasses and other adornments that he has accepted from the shrine holder and other suppli-

Maximón shrine, House of Candles/Otto Chicas, New York, New York.

cants. The most common image of Maximón at the botánica depicts a seated, light-skinned, mustachioed man in a dark suit and bright tie. He holds the staff and a bag, often brimming with money. When I asked José at Botánica Salvador del Mundo why Maximón seemed white rather than Maya, he said that this figure was a "reincarnation" of Maximón, a dead person who had inherited his spirit. The Maya Maximón, he said, is darker and wears a sterner expression. On another occasion, he said that San Simón was a reincarnation of Judas Tadeo (Jude Thaddeus), a biblical apostle. Hermano Carlos in Los Angeles told Polk and Jones that this Maximón was formerly a saintly Italian doctor who treated poor Indians in Guatemala. When he came to San Andres Itzapá a mysterious old man gave him coffee, and he was transformed into Maximón.

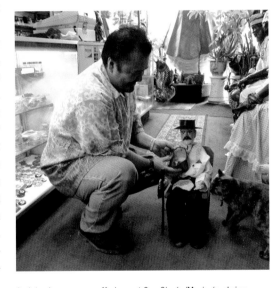

Andrés shows money offerings at San Simón/Maximón shrine, Botánica Yemayá y Changó, Washington, D.C.

The image of Maximón at Otto Chicas's botánica in New York expresses the older, sterner Maya type. Little of the armature of the effigy can be seen, except for carved fingers suggesting a wooden doll that likely has been built around bundled cloth and other objects. This has been covered with a dark suit, collared shirt, and bright red tie. A grave and impassive carved facial mask is crowned by a black cowboy hat. His carved fingers hold a heavy wooden staff, and a rich Native cloth covers his lap and knees. The shrine is lovingly tended with fresh flowers, clear water, and white rum. Cigars have been placed in his pockets and sleeves. His is every inch a prosperous gentleman.

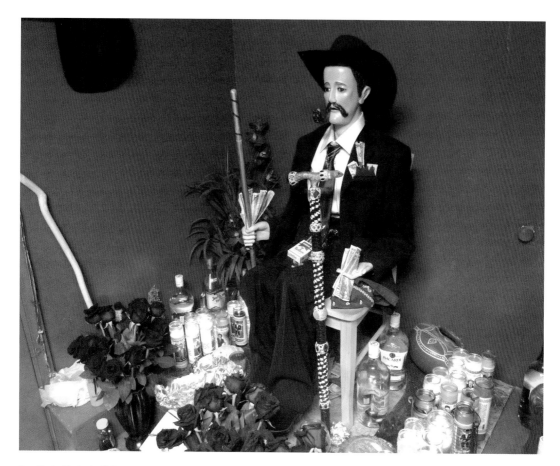

San Simón/Maximón Shrine, Botánica El Salvador del Mundo, Gaithersburg, Maryland.

Andrés at Botánica Yemayá y Changó in Washington tells how his shrine to Maximón came to be:

Five years ago a customer came asking for a statue of San Simón. She told me her story of what happened to her in her country Guatemala. She had a booth to sell drinks at festivals at different cities, beer and liquor. She always had San Simón in her house. One day a guy got angry because they didn't have any more beer to sell, very upset. He started shooting people. She prayed to San Simón, "Save me from this situation!" The guy tried to shoot at her but no bullets came out. She decided to emigrate to the U.S. because life was very rough there in Guatemala. She came to the store and gave us this very nice statue. It's handmade and expensive. She comes now every week to bring him tortillas, aguardiente [liquor] every week. Other people came to see him then.

My own encounter with Maximón at the botánica came seemingly by chance. After several years of visiting Washington area stores I happened to come across Botánica El Salvador del Mundo in the outer Maryland suburbs. I met owners José and Carmen from El Salvador, who were as gracious as they could be but too busy with customers to talk. At one

point, I asked Carmen if I could photograph a life-sized carved figure of Maximón that stood at the end of one of the aisles. She said something to José and seemed to put me off by saying "later." I waited a good while and decided to ask again. Just then José finished with his customers and said that they didn't want me to photograph the one displayed in the store because in the shrine room in back there was a beautiful one! Would I like to photograph it?

José opened the door to a small, narrow room painted a bright, rich green. Against one wall was a small table with two chairs for consultations and against the other a life-sized resin statue of seated Maximón in suit, tie, and hat, surrounded by myriad flowers and flickering candles, cigarettes, and rum. A giant horseshoe lies on the floor ringing his chair. It was to me an astounding sight, here in the heart of American suburbia, a magnificent shrine to a Maya divinity. Of course, after so many years of botánica visits it should not be so surprising, yet the opulence of the shrine and the evident care in its display were revealed so dramatically and unexpectedly. José and Carmen are justifiably proud of the shrine and tell me that this is the biggest Maximón shrine in the region. There's a big one in New York, they say, but they think that this one is bigger. People come from all over the East Coast on Maximón's feast day to make their offerings.

"I have come to San Simón step by step," José says. He started with a small statue, and Maximón gave him enough money for a larger one, which allowed him to have the big one here. "I have stayed true to him, not veering to the left or to the right." I ask him if Maximón could be dangerous. José and Carmen exchange glances and she says, "Yes, but only for people who don't walk the straight and narrow, like if you make a *promesa* and

San Simón/Maximón smoking, Botánica El Salvador del Mundo, Gaithersburg, Maryland.

don't keep it." José says that you shouldn't promise the moon. "Give a little something, but you must give something." Carmen gives this example: if a woman wants a man and she asks San Simón for one, if she gets the man, she owes San Simón. If she doesn't give him something, the saint will become jealous and punish her or her man. Sometimes people ask for bad things, to kill people, but they will come to evil as a result.

Perhaps the most common offering for Maximón is cigarettes, and carton upon carton sit before his shrine. José tells me that if Maximón smokes an offered cigarette all the way, that is a sign that he will grant the giver's wish. He takes a cigarette from an open pack, lights it, and places it on the small table. "If you light a cigarette like this, it just goes out. But if you put it in San Simón's mouth he will smoke it." José relights the cigarette and places it in the circular hole between Maximón's lips. Sure enough, Maximón smokes José's offering enthusiastically. José tells me that there is a woman who comes here to Maximón, but the saint will not smoke her cigarettes because she has bad intentions. Maximón enjoys the coarse tobacco puros that are set before him as well as the more refined cigarettes. José and Carmen say that they change the offerings of coffee, liquor, and tortillas every day. "If people make *promesas* and don't keep up the shrine, San Simón will pay them back double!"

José and Carmen invite me to join them at the annual ceremony for Maximón held on the joint feast days of San Simón and San Judas Tadeo on October 28. I arrive with student researcher José Madrid, who has met San Simón before in his native Denver. He translates some of the rapid colloquial Spanish ringing around the room. We are a little late, and the botánica is crammed with people, all, as nearly as I can tell, of Central American background. They usher us forward through the crowd, people kindly twisting and turning so that we can get to the little shrine room where Maximón holds court. The large effigy is there, bedecked in flowers, dollar bills stuck in his hands and clothing. An aluminum foil tray has been placed below his chin to catch his cigarette ash, which would have spoiled his elegant suit and tie. He is accompanied by an equally imposing statue of San Judas Tadeo, the biblical disciple of Jesus and, in José's explanation, one San Simón's reincarnations. Michele of Botánica Santa Barbara had once said that San Simón was a very old spirit, "one of the impossibles, like San Judas." I think that she was referring to San Judas's well-known patronage of lost causes and linking San Simón together in this capacity, but she could also be implying their identity in transmigration.

Some time earlier, San Simón *había bajado* "had come down on" José in ceremonial trance, and he sits now at the little table across from the holy effigies. His eyes are cast down; he is drinking rum, smoking *puro* cigars, and gently smiling. Carmen stands behind him, tending to him and directing the flow of supplicants. As we squeeze in before the incarnated santo, he extends his hand in greeting and, as we shake, Carmen introduces us as the Georgetown professor and student. We offer our own cartons of cigarettes

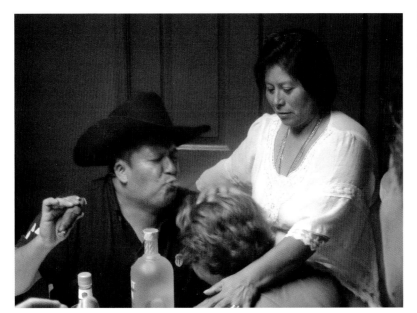

San Simón/Maximón blessing devotee, Botánica El Salvador del Mundo, Gaithersburg, Maryland.

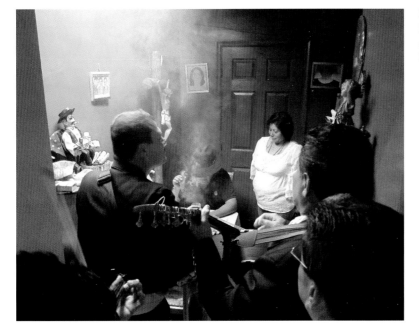

Mariachis play for San Simón/Maximon Botánica El Salvador del Mundo, Gaithersburg, Maryland.

and they thank us. José addresses the santo as *hermano*, and we ask him for his blessing, to which he replies, "Mis bendiciones las doy con ron," "My blessings I give with rum." We realize what he means shortly as we are directed to kneel before him. He takes big puffs of his *puro* cigar and blows the smoke five times on our heads. Then he takes mouthfuls of rum and sprays them on our heads three times. Somewhat startled, we thank the santo for the honor, and he says with the royal pronoun, "We are here to help."

As more visitors come, we move to the edge of the door of the shrine

room and shortly afterward the mariachis arrive. They are pushed through the throng to San Simón's presence and begin their offerings with "Las Mañanitas," a famous birthday song, José tells me, and so appropriate to the santo on his feast day.

Estas son las mañanitas, que cantaba el Rey David,
This is the morning song that King David sang

Hoy por ser día de tu santo, te las cantamos a ti,
Because today is your saint's day we're singing it for you

Despierta, mi bien, despierta, mira que ya amaneció,
Wake up, my dear, wake up, look it is already dawn

Ya los pajarillos cantan, la luna ya se metió.
The birds are already singing and the moon has set

Que linda está la mañana en que vengo a saludarte,
How lovely is the morning in which I come to greet you

Venimos todos con gusto y placer a felicitarte,
We all came with joy and pleasure to congratulate you

Ya viene amaneciendo, ya la luz del día nos dio,
The morning is coming now, the sun is giving us its light

Levántate de mañana, mira que ya amaneció.
Get up in the morning, look it is already dawn.[40]

The mariachis continue to play songs for San Simón, "old ones that my grandparents liked," says José. There is an old-time festive air in the cramped room, and everyone is smiling and at times singing along. At one point San Simón says to the musicians, "¿Se saben 'La Del Moño Colorado?'" (Do you know "The Girl with the Red Ribbon?") The band duly sings the sentimental favorite:

La del moño Colorado,
The girl with the red ribbon

Me trae todo el día mareado,
Has me all dizzy all day

Me trae todo el día mareado,
Has me dizzy all day

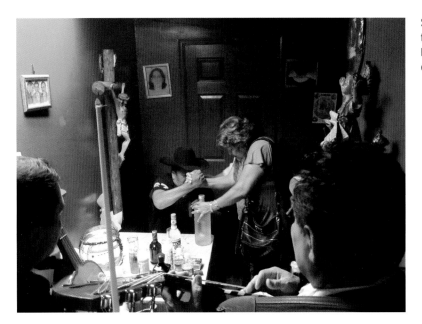

San Simón/Maximón and devotee receiving Santa Marta, Botánica El Salvador del Mundo, Gaithersburg, Maryland.

La del moño colorado,
The girl with the red ribbon[41]

When the mariachis take a break, more devotees come forward to greet San Simón and receive his blessing. One man wearing a brimless red cap with a leopard-skin band comes forward to say that he brings greetings from his community in New Jersey. The saint receives him and gives him the rum blessing that he gave us. Another, older man comes before the santo and is reprimanded for his inadequate devotion. Where were the foods and coffee for the shrine? "¡No me traigas esa mierda!" (Don't bring me that shit!) the santo scolds. He tells the crowd that the man is a cheapskate: "¡Este pendejo, quería mandar $20 a Guatemala!" (This jerk-off wanted to send $20 to Guatemala!) After this lashing he dismisses the man, telling him not to abuse his good will or the kindness and help that José and Carmen have given him.

Drama of another sort soon follows when one of the devotees begins to go into trance herself. The mariachis return and are playing in the small shrine room. A woman brings San Simón a large bottle of rum and then, as the santo grips her hand firmly, she trembles and throws her head back and forth. Carmen steadies her and says that she has received Santa Marta. José told me earlier that Santa Marta was from India and a very popular santa at their botánica. She frequently came to him in dreams and predicted the future. The woman now manifesting Santa Marta proceeds to go about the room offering blessings of her own to those near her. This is clearly not to San Simón's liking and he asserts his power. He reprimands the *santa*: "*Aqui no hay govierno, solo yo govierno*" (There is no governance

here, only I govern). I recall the phrase from Maggie of Botánica Gran Poder that Santa Marta is called La Dominadora because she dominates men.

Perhaps at San Simón's behest, she quickly comes out of trance and returns to ordinary consciousness. Back to being the center of attention, San Simón is offered fresh-cooked food before he, too, departs. He compliments the women who made the chicken: "Este pollo esta muy bueno." As he eats and continues to drink rum, he calls good-naturedly to a woman who has just arrived, "Here, eat this, it's very good."

José has told me that these trance sessions are very hard on him and that he loses three pints of blood each time he works as a medium for the santo. When I asked if he can request San Simón not to come down, he just smiles and says it's not his choice.

"People here want to talk a lot," he says, "especially women. In Salvador people ask their questions and leave quickly but here people like to talk. There was one woman who was here for two hours. ¡Basta!" Throughout these sessions, he drinks and smokes large amounts of alcohol and tobacco, but when the saint leaves him, he says that there's no alcohol on his breath and he's not the slightest bit drunk. Sometimes San Simón will come down three times in a week, and then he is very tired. "They say that my face looks like San Simón, my skin becomes white like a corpse."

Santos in Manifestation

We have seen on a number of occasions how different spiritual persons can "be" others: El Niño de Atocha is Eleggua, Santa Barbara is Changó, San Simón is Maximón. We have also tried to understand these simultaneous identities and distinctions in a variety of ways. We can say that in the thought of botánica devotees there is a primal power that we call Eleggua that manifests itself in people, things, and events. I have sometimes heard santeros use the indefinite article to say that a certain person is "an" Ellegua, a member of a class of things that expresses Eleggua's fundamental energy, his aché. Maya Deren speaks of spiritual principles that manifest as distinct *lwa (loa)* spirits in Haitian Vodou: "The separate figures have been integrated around a principle, as its modifications, variations, or multiple aspects, just as individual ancestral loa, who share a similar character, become grouped together as personal variations on a principal theme."[42]

Other writers on Haitian Vodou speak of families of spirits, suggesting that Erzulie Freda and Erzulie Danto share a family name and characteristics but manifest distinct personal characteristics.[43]

In Yorubaland at the height of the Oyo Empire in the eighteenth century, the Alafin ruler sent out the priests of Changó throughout his dominions to incarnate his presence in ceremonial trance.[44] These "wives" of the king, through the metaphor of domestic and sexual union, were understood to be the very presence of the Alafin throughout his realm. Thus, human beings could also "be" others under the ritual conditions of trance.

We have noted that Maximón can also be a variety of other things. According to Tata Apolinario he is the bundled essence of the lineage of the Maya kings: Axmon, Axuan, Ajpop. Maximón can shift shapes to be a seductive man or woman, a dangerous or helpful animal, an old man on the road. He can be Judas Iscariot, betrayer of Jesus, or Judas Tadeo, loyal disciple. And he is Simon Peter, who has been both a true believer of Jesus and one who denied him on the eve of his death. José at Botanica El Salvador del Mundo is the first person I have met who uses the notion of reincarnation to talk about the identities and differences between San Simón and the others. He sees the mustachioed, fair-skinned San Simón as the reincarnation of the Maya Maximón, along with the biblical Judas Tadeo and the Salvadoran folk santo Hermano Macario Canizáles. It seems worthwhile to consider ceremonial trance or spirit possession as another form of reincarnation where the santo principle incarnates itself in the human form within the time and space of the ritual occasion. And as José is San Simón while in trance, so San Simón, Judas Tadeo, Macario, and a host of strangers on the road are Maximón in manifestation, channeling the authentic presence of the santo.

The capacity of santos to "be" other santos has some interesting cross-cultural implications at the botánica. When I asked Andrés, who is from El Salvador, about San Simón, he said "for me he's an Echú, an Ellegua." Maximon's staff in Otto Chicas's shrine looks remarkably like Eleggua's garabato. Juana at Botánica Santa Barbara has enshrined el Niño de Atocha and Maximón together at the entrance to her store, noting that they

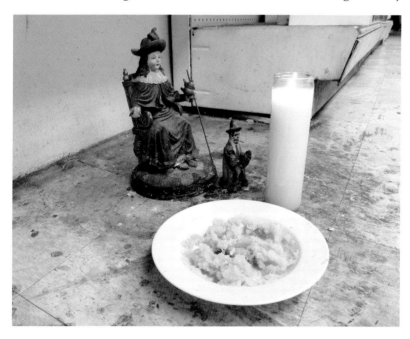

Niño de Atocha/Eleggua and Maximón, Botánica Santa Barbara, Washington, D.C.

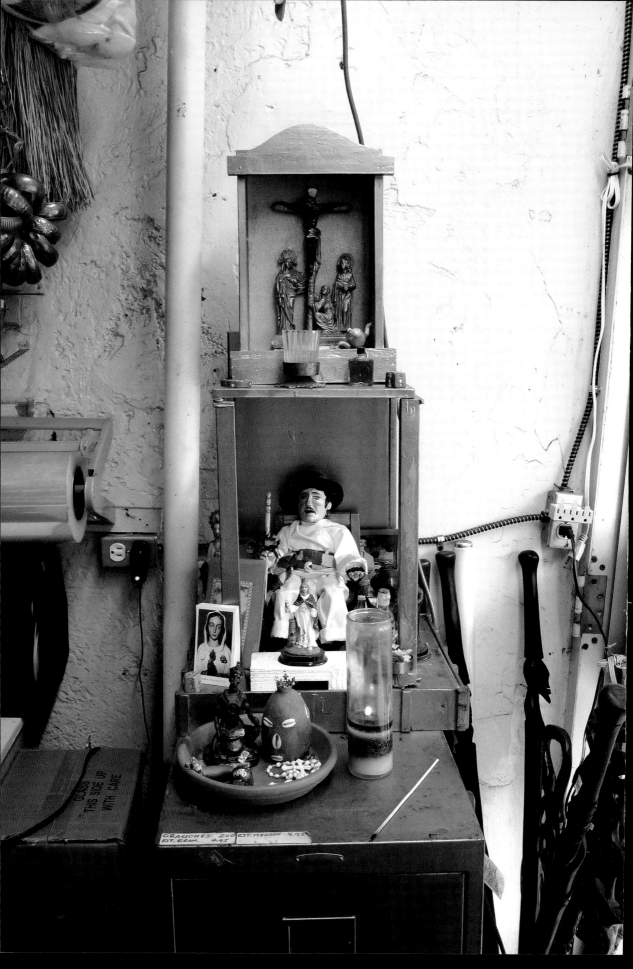

eat together. So, too, at Paco's Botánica in New York, Conchita has placed the two together by the entryway.. Vincent Stanzione calls Maximón a "trickster deity" and offers a description that could be of Eleggua:

Mam, or Maximón, is a boundary crosser and a liminal character that lives at the threshold of this world of humans and the other world of the gods. He is the go-between and messenger that relays communication between humanity and their deities. In this middle ground between humans and gods he takes his payment in the form of offerings, including only flowers, incense, candles, liquor, tobacco, sweet-smelling waters, song, and prayers. He takes part of all that once was given only to the gods, and in this way he makes a good living by existing between and betwixt two worlds.[45]

A final example of botánica multiculturalism comes in the form of Sanfancón, a Cuban santo whose veneration was brought to the island by Chinese laborers in the nineteenth century. His name is likely a creolization of Guan Gong (Lord Guan), prefixed with the Christian title "San"

Sanfancón or San Kwan, Botánica Yemayá y Changó, Washington, D.C.

and deemed the patron of Chinese emigrants.[46] The historical Guan Yu was a warrior in Han China in the third century of the common era and often imaged as red-faced, long-bearded, and wielding a sword. He was deified in the Daoist/Confucian pantheon and became one of the most popular divinities throughout China, especially in the south, where most Chinese immigrants to Cuba came from. He lives on in the devotions of the botánica as an avatar of Changó, as Andrés says, "when he was in China." Maggie explains the multicultural motives of the santos: "The spirit manifests itself in a way that it will be accepted. If Changó appeared in China—a huge Black man with an ax—they'd run, so he appears as Chinese. Same with Santa Barbara, the stories are so close. If you look at the stories of Shiva, he's connected to fire and he's a dancing god. Is he Changó?"

The ability of the santos to speak the multicultural languages of their devotees gives them the power to transform and heal. The botánica houses this power when it acts as a site of cultural intersection, a health care dispensary, and a ritual space of encounter with the sacred world. We look now to the botánica and its cultural, therapeutic, and spiritual powers.

< Maximón and Eleggua, Paco's Botánica, New York.

6

Power

"If I could sum up in one word what our botánica stands for, it would be "Victory!"

Michele, Botánica Santa Barbara

In this final chapter, we consider the religion of the botánica and why it is effective for its practitioners. Botánicas provide their patrons with access to power: power from the natural world, the social world, and the world of the spirit. Devotees are seeking power to meet the challenges of ordinary life: problems of health, wealth, and love. People come to the botánica with wayward spouses, children at risk, nervous conditions, and underemployment. And the botánica offers, as in Michele's marvelous phrase, victory. With combinations of herbs and candles, objects and actions, devotion and faith, people can triumph over illness, poverty, and unhappy social relationships. The devotions of the botánica can effect changes in the lives of patrons as they receive healing, be it physical, social, psychological, or spiritual. They so often get better—or better enough—that we can see that the botánica plays a vital therapeutic role in its community and offers a fulfilling spirituality to its patrons.

In this chapter we will examine the quest for power at the botánica in the light of the community that sustains it: largely Latino, mostly women, often immigrant. The world of the botánica makes sense in this community, and its efficacy lies in the specific cultural idioms through which it communicates. From this community base, we can consider the power of the "pharmacy for poor people": how the prescriptions of herbs and candles, powders and baths, may work as a culturally appropriate alternative health care system. Finally, after these views of botánicas in the light of immigration, ethnicity, and health care, we will see botánicas as sites of religious devotion. For in addition to being consulting rooms and dispensaries, botánicas are shrines where owners and patrons alike interact with the spiritual world and receive blessings and power from it. We will look at the particular spirituality of the botánica, its relation to magic and to puissant spiritual beings: the santos of the invisible realm. The botánica acts as a sacred space for the community, a refuge and opportunity along the streets of urban America.

Something from Home

Carolyn Long has shown that the roots of the botánica pre-date the rise of immigration from Latin America in the mid- and later twentieth cen-

tury, stretching back to hoodoo drugstores in the American South of the previous century. The original Botanical Gardens store in Harlem, while founded by Alberto Rendon from Guatemala, sold fresh herbs primarily to African American and West Indian patrons. The large migrations of Puerto Ricans from the island to New York in the middle decades of the twentieth century transformed the Harlem neighborhood into El Barrio, and Cuban resident Rómulo Lachatañeré was moved to say that by the 1940s it seemed like a Puerto Rican city. Yet he saw in the Botanical Gardens store a mixture of Antillean and African American approaches to spiritual healing based on herbal preparations together with the icons of Roman Catholic devotion.

Latin Caribbean migrants and immigrants brought their own particular "little traditions" of popular healing and religion to the cities of the Northeast. These were blends of their common "great tradition" of Spanish Catholicism with the variety of indigenous and African spiritualities that had sustained them in their homelands. The botánicas of today are still rooted in herbalism and permeated by folk Catholicism, with its baroque aesthetic and saint-centered piety expressed in the sacred vow of the promesa. At the botánica, this Catholic heritage enhanced the power of herbs with a communion of santos, both canonical and noncanonical. Along with their saintly patrons, Puerto Ricans, Cubans, and Dominicans brought their own forms of espiritismo, with its courts of deceased spirits of ancestral Indians, Africans, Gypsies, Arabs, and Asians who appear in trance at spiritual misas. Cubans also brought the African-derived religions of Palo and Ocha, which venerated African divinities who worked through ritual systems of divination, sacrifice, initiation, and ceremonial trance. Central Americans brought complex hybrids of indigenous and Spanish traditions such as those to Maximón, while Mexicans brought indigenous curanderismo and uniquely Mexican santos like Guadalupe, Jesús Malverde, and La Santa Muerte.

In addition to seeing the botánica of the 1940s as a mixture of African American and Latin Caribbean cultures, Lachatañeré was perceptive in recognizing contestation as well. He wrote of the botánica as an important resource in the development of Latino identity in Harlem and saw Latino patronage of the store as a form of cultural assertion in a "clash and tension" with the African American community with whom Latinos were competing for space in Harlem and in the economy of urban America. Between 1970, when census records began to record such data, to the latest census of 2010, the Hispanic/Latino population in the United States rose from 9.6 million, or 4.7 percent of the total population, to 50.5 million, or 16 percent of the total. Some 40 percent of Latinos today are immigrants.[1] They have transformed the urban landscape and been transformed by it. The botánica has played an important role as a mediating institution in this transformation, helping people adjust to new environments and challenges and providing armor and an array of weapons in the fight to find a safe and sustaining place in the new world.

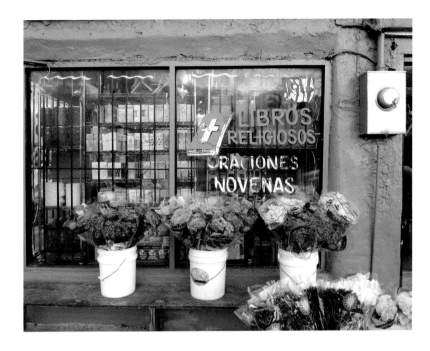

Not the least of powers that the spiritual world of the botánica accesses is the power to cross the border itself. We have seen people appeal to Maximón, Jesús Malverde, and La Santa Muerte in order to find ways through and around the immigration system. These santos, as transgressors of the official power structure and the morality that sustains it, are particularly appropriate for the challenges of migration and urban survival. A promesa to these santos is a moral commitment in a violent world where the protections of middle-class law and order are often absent and irrelevant. The materials and shrines of the botánica allow for a continuation of this commitment and a means to connect with and inspire fellow immigrants. The patronage of the santo offers a web of real and supportive relationships that sustains ties between families and communities across the border.

Once in the United States, Latino immigrants can find a place at the botánica that has some of the sights and smells and sounds of home. Rosa Chicas, owner of the store descended from the original Botanical Gardens, speaks of customers finding at her botánica a precious connection with home:

I always say to everyone who comes to the United States you should study . . . well the first thing you do is thank God I'm here and thank God they opened the doors for me. To pay that opportunity you should learn the language, read more about the history of the United States, but don't lose your identity. If you're Guatemalan you will be Guatemalan until you die. Don't throw it away. This is your time, your opportunity. Our business is . . . a service to them, to making them feel like they are in their own country.

Rosa notes that at her store, people find herbs and devotions from home and so an opportunity to maintain and pass on treasured cultural ways at risk of being lost in the United States.

I see the faces of people who come here, like one woman, 70–75 years old with her grandchild, and I heard her saying, "I remember that my parents used to give me this herb." I heard the kid say, "Grandma what's the name of that thing—how do you call that—what is it?" We call it *yagrumo* and she told her granddaughter it was trumpet leaf. And the little girl says "you mean like the instrument?" I don't know if she'll be able to teach the girl about the tree, where it comes from, that it's very high up, but the girl will have some information about her culture that her grandmother is passing on.

There is power in this heritage and in the positive identity that transcends the individual and offers meaning and dignity in an environment

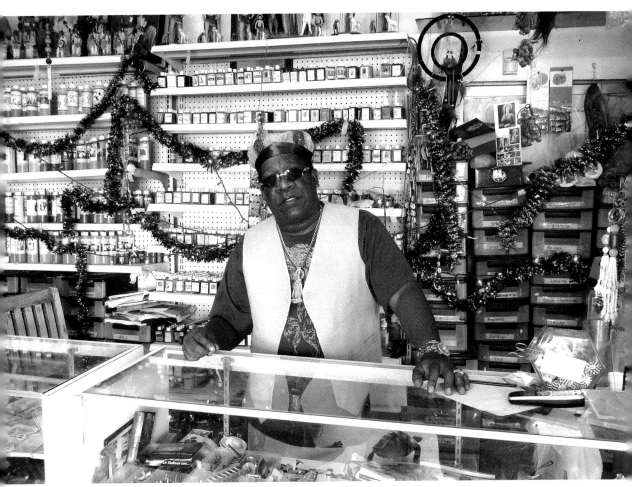

Dima, Riviera Botánica, Miami.

where these are often denied. At the botánica, people can find strength in this affirmation of identity, both in the preservation of creative, sustaining traditions from home countries as well as in building a new space in a new world. Back in the 1940s, Lachatañeré recognized the emergence of a "Latino" identity in New York, putting the word in quotes perhaps to indicate his skepticism about the neologism or its foreignness to his ears.[2] He saw becoming "Latino" as a process of cooperation and conflict with African Americans in Harlem. While the ethnonym "Latino" today is far from universally acceptable to Americans whose families have come from Latin America, its use, along with "Hispanic" in the U.S. census after 1980, is an indicator of a growing sense of panethnic identity and solidarity among a great diversity of peoples.[3] American systems of ethnic classification force people into these great and unwieldy categories that belie important differences in self-identification, yet also offer power in the clash and tension of American identity politics. By becoming "Latino" or "Hispanic," people become American.

We have seen that botánicas have supported and enacted some of the most cherished and deeply felt traditions from their patrons' home countries, but they have also fostered devotional commonalities and crossovers. As so many botánica owners told us, their clients are "from all over," and they and their clients have pooled and shared ritual knowledge so that Salvadorans are petitioning the patroness of Cuba and Dominicans are using herbs from Puerto Rico.

Many botánicas are ritual spaces for communal devotions as well as shrines. As a result of their patronage at the botánica, clients may be brought into spiritual families where new initiatory relationships are developed as godchildren and godparents and the powers of the santos are incarnated and passed along. These fictive relationships represent very real interpersonal commitments and offer the security and responsibilities of communal life. The core community in Ocha/Santería, for example, is called an *ilé*, or house, in the sense of extended family.

People usually become involved in the communal life of the ilé because they have encountered serious problems in their lives, and sustained devotion to the orishas was seen to be necessary to resolve them. Learning the language, gestures, prayers, and songs of the orishas is a lifetime commitment and can only be accomplished by participation in the ritual life of the ilé. Progress in this spiritual journey is marked by carefully delineated stages of initiation that require serious obligations of service to elders and to juniors in the initiatory hierarchy. Botánicas often bring people to these ritual families and can be actual meeting sites where this family life is lived out. For immigrants and others, botánicas can offer an alternative extended family with a strong sense of social place and identity in a strict and ideally loving environment. When I entered the life of an ilé many years ago in the Bronx, my Cuban godmother said to me, "You know the love you have for your family and the love your mother has for you? You are now part of

my family, my *ilé*, my spiritual family, and we love each other in the same way. Welcome to my family."[4]

The presence of a white family member in an Ocha family in the Bronx of the 1970s was unusual but indicative of new social relationships proceeding from the communal life of many botánicas. Here, patrons encounter people from all over Latin America as well as African Americans, white Americans, and Asian Americans.[5] In the ritual life of the botánica, these others become family, and so a new self-understanding and social identity is realized. People enter into new relationships of obligation, affection, and authority.

The botánica offers patrons power from Latin American cultural roots and power from new associations in American cities. These powers create opportunities to address very real problems of health, safety, domestic life and employment. People find help at the botánica in a community that both speaks their language and supports them in new social networks. It offers power in a community where there might seem to be little. This power is seen to stem from the natural world in the botanical garden within the city and the spiritual world in the heavenly host of spirits on call.

A Pharmacy for Poor People

Rosa Chicas's description of her business as a "pharmacy" is echoed throughout the literature on botánicas. Beginning with Lachatañeré in the 1940s, whose own education as a pharmacist may have influenced his view, botánicas have often been described as dispensaries of herbal remedies to a largely Latino clientele in American cities. The first in-depth look at the relationship between botánicas and healing came in the 1970s from anthropologists Mary Ann Borrello and Elizabeth Mathias, who explored the connection between the wares of the botánica and the practices of Puerto Rican espiritismo. They write that "the *botanica* functions as a folk pharmacy, through which the medium ministers to the physical and spiritual health of the community. . . . Spiritism's devout followers go to *botanicas* not only to fill the medium's prescriptions, but also to buy herbs (which purportedly can cure most ailments)."[6]

The power of herbs to treat illness is still central to the influence of the botánica in the lives of its patrons. Many immigrants grew up with highly developed herbal healing traditions, and the botánica is now a place where they can find familiar plants and share traditions with people from other nations and ethnicities. While many smaller botánicas do not stock fresh herbs and only the most popular dried ones, the larger stores can carry an amazing array of fresh plants. Otto Chicas in Harlem regularly has on hand over 70 different fresh herbs, while Original Products in the Bronx offers at least 35 fresh plants and over 130 dried roots and herbs for sale.

There is a large literature on the ethnopharmacology of Latin America and of Latin American immigrants in the United States. One study of

John Cazares, Botánica Green
and White, Austin.

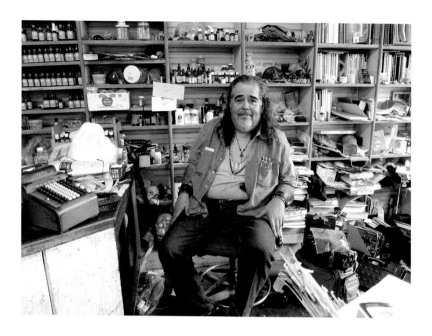

Elena with Anaisa Pie, Botáni-
ca San Miguel, New Britain,
Connecticut.

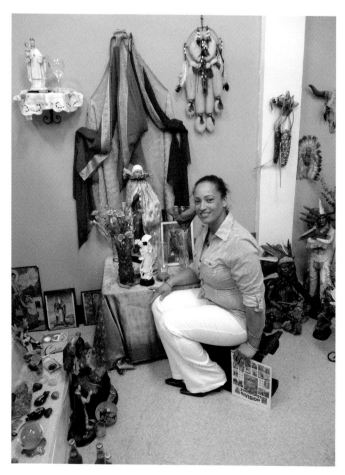

Dominican Americans in New York charted the use of eighty-seven herbs and their applications in the Dominican Republic and the United States.[7] Herbs are used to treat everything from minor conditions such as headaches and stomach upsets to serious illnesses such as HIV/AIDS.[8] A glance at the pharmacopeia of the botánica shows that many of the plants are used in the treatment and promotion of women's health. *Anamú* (Petiveria alliacea) is used to relieve pain during childbirth, *cundeamor* (Momordica charantia) is used to regulate menstruation, and *tilo* (Tilia mandshurica) is effective for hot flashes.[9] One study of herbal healing among Dominicans in New York found sixty-five species of plants sold at botánicas used in the treatment of uterine fibroids alone.[10] One of the most popular plants at the botánica is *ruda* (Ruta graveolens), which is used to regulate menstruation and can be a contraceptive and abortifacient. It is understandable that during my years of visits to botánicas no one spoke of these powers of ruda with me, but I think that it is likely that this is an important part of health care available through the botánica.

The efficacy of traditional herbalism is often recognized but underacknowledged by professional biomedicine. Modern pharmacology is based on the scientific observation, application, and syntheses of plants in use by indigenous and traditional healers. Rubén Bernal, in his study of Mexican American herbalism in Dallas, writes that

74% of the drugs that are used in modern allopathic medicine, are, or have been, obtained from plants, providing verification in the scientific community for the traditional use of medicine. . . . Modern medicines are still heavily dependent on drugs derived from plants. . . . The indigenous knowledge that was harvested to develop the drugs that reap enormous profit for pharmaceutical companies is poorly compensated for by those same companies.[11]

The chemical efficacy of herbs that is of interest to professional pharmacology is only part of the healing power of the botánica and its vital role in its community. We might see the success of botánicas as health care providers as stemming from two sources: one compensatory, the other creative. Botánicas can be viewed as compensatory in that they provide health services to people who often have grave difficulties of access to professional medical treatment. Botánica patrons are often poor, have no health insurance, and must cross barriers of language and culture to meet with health care professionals. Public clinics are crowded, understaffed, and are often at a distance from patrons' homes and jobs. A visit to a clinic is a large investment in time and is frequently a trying experience because of long waits for an examination and the difficulty of communicating effectively across language and cultural barriers. Prescriptions can be costly and might require identification that immigrants may lack. All of these expenses, frustrations, and indignities in seeking professional medical care make the botánica an attractive and effective alternative. For botánicas are

located in patrons' neighborhoods. Costs are usually within reach. Patrons and providers usually know each other as peers and sometimes as fellow members of ritual families. Patrons and providers speak the same language and recognize the same array of illnesses and treatments. And, finally, and perhaps most importantly, botánica patrons and providers usually share the same spiritual worldview: that illness and misfortune often have spiritual causes, brought on by the agency of invisible, sentient powers.

When we view botánicas as pharmacies of the poor, we recognize that they provide health care that is frequently unavailable to poor people otherwise. They can function as invisible hospitals for people who have difficulty accessing visible ones.[12] The health services of the botánica are thus compensating for a lack of access to professional medical care. This view partially explains why botánicas are popular, but it might assume that, given adequate access to professional medical care, patrons would no longer have need for the botánica. And this is where the creativity of the botánica provides a fuller explanation for its success. For the healing traditions at the botánica are creative expressions of deeply rooted, time-honored spiritual beliefs and practices forged in the diverse cultural experience of Latin America and the still more diverse experience of the United States. These spiritualities are at once traditional and flexible. They reflect and incorporate the long and diverse cultural history of their practitioners, and they have shown remarkable creativity in layering and integrating new experiences, new rituals, and new santos. They have offered cultural tools of resistance to the coercive powers of privileged elites. These approaches to healing, rather than simple compensations for the absence of professional medicine, are active, holistic styles of treatment largely unavailable in biomedical care. They rely on engaged, personal relationships with lay healers who diagnose underlying causes of illness and misfortune that are connected to the personal and social life of the client. We have seen with botánica healers such as Marta and Maria that they were called to healing as part of their own spiritual path. As Michael Taussig says, "It is an enchanting and empowering notion that, in striking contrast to what we might call the scientific model of healing and sickness, on which the university training of doctors is now based, folk healers and shamans embark on their careers as a way of healing themselves."[13]

The herbal and herb-derived treatments of the botánica are oriented as much to personal and social problems as they are to physical health. This treatment of the whole person usually involves intimate time with patients often in the presence of family members, friends, and concerned others. Joan Koss Chioino, who has spent a lifetime working with spiritual healers, writes,

In spirit healing the healer-sufferer relationship is expressed as an affective interchange aimed at removing barriers to the awareness of separateness between healer and client. Barriers between the conscious self and the world of

spirits are breached through the medium-healer's acting as intermediary and vehicle.

In contrast, I suggest that the therapist-client dyad, especially when there is unequal power and authority, is not as effective as the triad of healing relationships in spirit healing in which sufferers are brought into direct contact with the extraordinary and/or sacred forces in their life-worlds.[14]

These differences in approach to healing have not gone unnoticed by many physicians and social workers who interact with botánica patrons. They have written on the special issues of health care for American Latinos and the role that the botánica often plays in diagnosis and treatment. In 1968 physician Stanley Fisch recognized that the botánicas of an unnamed metropolis were connected to ritual communities of faith in spiritual healing. He attended spiritual misas in the Puerto Rican community of his city and recommended that medical doctors become aware of and cooperate with the spiritual healers of their clients. He writes that "if physicians were given some insight into how mediums work, and if mediums were given some training in psychotherapy to supplement their own skills, then perhaps cooperation could begin in this area, resulting in more and better mental health services for the neighborhood."[15]

Since this first study, a number of other medical doctors and social workers have become sensitive to the cultural contexts underlying their Latino clients' notions of illness and their expectations of treatment. Lee M. Pachter, a physician who works with many Latino patients in Hartford, Connecticut, writes to urge urban doctors to recognize the cultural differences between the biomedical worldview in which they were trained and the Latino traditions of their patients. He writes

Mama Juana, trabajo for impotence, Botánica Gran Poder, Hyattsville, Maryland.

a culturally sensitive health care system is one that is not only accessible, but also respects the beliefs, attitudes, and cultural lifestyles of its patients. It is a system that is flexible—one that acknowledges that health and illness are in large part molded by variables such as ethnic values, cultural orientation, religious beliefs, and linguistic considerations. It is a system that acknowledges that in addition to the physiological aspects of disease, the culturally constructed meaning of illness is a valid concern of clinical care. And finally, it is a system that is sensitive to intragroup variations in beliefs and behaviors, and avoids labeling and stereotyping.[16]

Pachter writes of one case of empacho, a "folk illness" well-known among his Latino patients that is characterized by stomach distress and depression. It can be brought on by physical causes such as spoiled food or by spiritual causes instigated by restless spirits or malign human beings. A Puerto Rican family brought to Pachter a twenty-month-old boy who was losing weight and failing to thrive. After an extensive period of examination in the hospital, the staff could not find any organic problems with the child. In interviews with his parents, Pachter learned that they were convinced he was suffering from empacho. Pachter contacted a local botánica and was put in touch with a *santiguadora*, a spirit-healer, who agreed to come to the hospital. She performed a "ritual healing massage" on the child, and two days later he was discharged from the hospital with a modest weight gain. Pachter concludes the story of the case:

As an afternote, a few days after contacting the *botanica* owner for a recommendation of a *santiguadora*, I received a call from the owner. He had a child with a rash in the store—the mother brought the child to the *botanica* to seek a remedy—and the owner was unsure of the cause of this rash. He called me to request that I see the child and help treat the rash. This seems to be an example of effective bidirectional consultation between folk and biomedicine.[17]

Psychiatrists and psychiatric social workers have also collaborated with botánicas and espiritistas in seeking culturally appropriate mental health care for suffering clients.[18] Social worker Sam Tsemberis, working with the Homeless Emergency Liaison Project (HELP) in New York, writes of a case of a homeless Puerto Rican man who was repeatedly hospitalized with auditory hallucinations.[19] Doctors could not diagnose his disorder but ruled out schizophrenia or organic brain problems. Neither drug nor alcohol abuse was at the core of the patient's delusions, and he was released after each hospitalization. The HELP team found him again on the streets, delusional and a danger to himself. As they were about to take him to the hospital once again, a man nearby on the street said that hospitalization would be useless as the hallucinating man "believes he's possessed." This fortuitous statement from a bystander inspired Tsemberis and the team to seek the help of an espiritista with the alias of Julia. Much to Tsemberis's surprise, Julia was well-known to some of the hospital staff and had been treating Latino patients at the hospital for years. Julia saw some three inpatients and five outpatients a week and refused any fee for her services. She conducted a lengthy interview and healing session with the disturbed patient that Tsemberis had brought to her. Julia told him that she could remove the spirit that was possessing him and asked his permission to perform an exorcism. As hospital staff looked on, she anointed him with water and read from the Bible and declared that he was no longer possessed. Subsequently, the patient became an active participant in his treatment, taking his medications, and he did not return to the streets.

More formal collaborative projects have been documented by physicians and social workers such as Projecto Cooperación in Lawrence, Massachusetts, that sought to build trust between the health care communities in the treatment of HIV/AIDS.[20] Botánica owners were trained on the nature of HIV/AIDS, common symptoms, and testing procedures. As they encountered clients who might be at risk for the virus, the owners would give them literature and referrals for testing. There have also been several in-depth studies describing and assessing the effectiveness of botánicas as components in Latino health care. The Immigration and Health Initiative of Hunter College at the City University of New York, under the leadership of social work professor Anahí Viladrich, conducted a broad survey of botánicas in New York City as health care providers.[21] The ethnographic team contacted 145 botánicas in four New York boroughs and conducted in-depth interviews with 42 healers connected to them. The team concluded that botánicas were key components in the health care of the city and formed the "entry door" to Latino folk healing practices. Viladrich writes that botánicas

offer cost-efficient and fast face-to-face services by local experts, sometimes the owner or a Latino employee. The effectiveness of practices that are cheap and highly available is another reason that keeps attracting Latinos to botanicas' doors. Botanicas' clients are largely recruited among the uninsured immigrant poor who are more likely to experience the physical and psychological impact of grueling economic conditions, including unemployment, the loss of safety net services, access barriers to health care, discrimination, police brutality, and so on. To a certain extent, Latino healers are botanicas' ethnic gatekeepers connecting immigrants, like themselves, to alternative networks of care within a culturally meaningful explanatory model of disease and healing.[22]

Alfredo Gomez-Beloz and Noel Chavez reached similar conclusions in their study of clients at a botánica in a Mexican-American community in Chicago.[23] They conducted extensive interviews with twenty-six clients of botánicas who used the health services of the botánica alongside those of professional medicine. Gomez-Beloz and Chavez refer to the health care of the botánica as "Latino complementary and alternative medicine." They, like other researchers, speak of the barriers that Latinos face in getting adequate health care in the United States and find the botánica as a "desirable health option." They write

the *botánica* emerges as an important culturally appropriate health care resource for Latinos. The *botánica* meets the needs of the population it serves. . . . [It] gives Latinos a point of reference that allows them to negotiate the U.S. conventional health care system in a culturally appropriate manner that is more familiar to them.[24]

Of course, not all treatments proceeding from botánicas are effective, and it is difficult to know which of the intertwined factors of culture, expectation, and chemistry is playing a role in cures. It is not our interest here to determine the medical reasons why people get better, but mention should be made of the study of placebos and the role of expectation in healing. Stanley Fisch, in his groundbreaking essay on botánica healing, writes that "faith is the participant's emotional investment in the process, the attitude of openness upon which a successful outcome greatly depends."[25] Placebo studies can be very controversial, but there is a growing body of evidence that demonstrates the power of placebos to reduce pain and ameliorate illness, if not necessarily cure it. In his survey of placebo literature, Robert A. Scott writes, "Placebos may not help people get well, but they can certainly help them feel better."[26] As Lee Pachter points out, physicians themselves form a cultural group with its own set of beliefs about illness.[27] Patients undergoing care by physicians have "faith" in medical treatments, and these expectations affect the effectiveness of the outcomes. Virtually no one gets better unless they "believe" that they are going to get better. We quoted Jaime of Botánica Gran Poder in the introduction of this book as saying that the botánica offers objects so that people can see their faith. The details of the treatments—the words, ingredients, gestures—in a culturally relevant and personally significant framework create a rhythm, a spell if you will, that can integrate the whole person and open him or her to success and positive results.

Again, not all treatments are effective, and there is valid concern that some may be unsafe. A problematic treatment at botánicas that has caught the attention of the public health community is the use of mercury (*azogue*) in amulets, baths, and scattered about a room to cleanse it of evil influence. In espiritismo it is thought that mercury "flows smoothly" and so will dissipate the evil intentions and envy of others. It also can be an ingredient in the initiation preparations in Ocha/Santería and Palo. In 1995 Luis Zayas and Philip Ozuah surveyed forty-one botánicas in New York and found that 93 percent of them sold three to four capsules of mercury a day.[28] Public heath officials have made considerable efforts to alert botánica owners and patrons to the highly toxic nature of treatments with mercury. According to the social work group headed by Alison Newby, this seems to have driven the sale of the element underground. The botánica owners and patrons that she worked with in New Jersey denied that they sold it but expressed opposition to its use not for health reasons but for legal ones. One botánica owner told Newby and her colleagues that "we could get in trouble so we only sell to people that we know very well. There are always other people out there who are looking to make trouble, so we try to be careful. In fact, we usually only sell to people who are already our customers."[29]

Zayas and Ozuah as well as Newby caution concerned health officials to keep this use of mercury in perspective. In the first place, the practice of

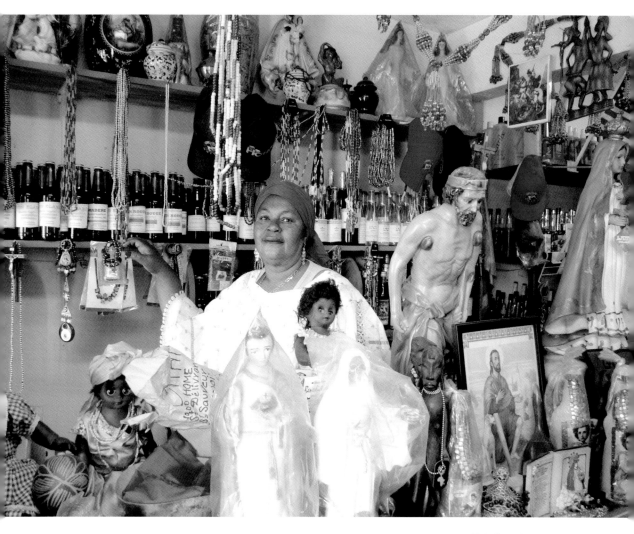

Marie Carmelle Jerome,
Botánica 3x3, Miami

scattering a capsule of mercury to cleanse a house will produce a concentration of vapor at a "minimal risk level," below the threshold established by OSHA for workplace safety.[30] While higher concentrations are possible and repeated use can increase risks, it is a potential rather than an actual health hazard. And second, in the context of the vital and effective healing available through botánicas, Zayas and Ozuah state that

as providers of community health and mental health services in underserved areas, we recognize the public health threat of dispensing mercury. However, we recommend also that the dangers of mercury be sensitively separated from the social-psychological benefits of spiritualism. In inner-city Hispanic communities, espiritismo is an indigenous source of community socialization and support. Spiritualists frequently represent the first line of extrafamilial mental health intervention. Since botanicas also sell medicinal plants and herbal remedies, they offer some basic health care familiar to the cultures of Latin

America. Therefore, public health interventions must be aimed at helping spiritualists find safe alternatives to mercury.[31]

All the researchers and most of the owners and clients interviewed in these studies saw the botánica and spiritist healing as complementary to biomedicine rather than an exclusive alternative. My main botánica informants—Maria, Marta, and Michele—all said that they send clients to doctors. Andrés at Botánica Yemayá y Changó in Washington has an ongoing consultancy with Howard University Hospital. The pervasive feeling was that medical doctors are skilled technicians but are blind to the spiritual world, the underlying agent in illness and misfortune. "Doctors treat symptoms," says Maggie, "but I get at the causes."

We've seen that this ability to do what American doctors cannot is a source of some pride at the botánica. And this leads us back to the theme of power. Nearly every conversation that I had with owners and patrons eventually led to a story where spiritual treatments through the botánica succeeded where biomedicine failed. So often they would say, "The doctors said there was nothing wrong with her, but . . . ," or "the doctors told him he had six months to live, but . . ." Robert Orsi has shown in his study of the National Shrine of St. Jude in Chicago that the veneration of "the patron saint of hopeless causes" offered devotees power in a variety of ways.[32] Most devotees in his study were daughters of immigrants struggling to be true to the old ways of their parents and the new ones of America in the middle decades of the twentieth century. Old ethnic enclaves were dispersing into the suburbs, extended families were yielding to nuclear households, and women's domestic and professional domains were changing rapidly. Devotion to St. Jude became a way that women asserted control over their lives and resisted the "hopelessness" of impotence in the face of disease and domestic strife. Not the least of the empowerments of religious devotion was the resistance to the professionalization of medicine and its co-option of women's authority in nursing, gynecology, and midwifery. By seeking spiritual healing, devotees of St. Jude—and patrons of the botánica—could find an empowering alternative, complementary or not, that, in Orsi's words, "brought them into an active and efficacious engagement with their circumstances."[33]

Baer, Singer, and Susser have argued that many forms of herbal and spiritual healing empower practitioners as active forms of resistance to the dominance of professional biomedicine:

Lower social classes, racial and ethnic minorities, and women have often utilized alternative medicine as a forum for challenging not only biomedical dominance but also, to a degree, the hegemony of the corporate class in the U.S. as well as other advanced capitalist societies. . . . Alternative medical systems often exhibit counterhegemonic elements that resist, often in subtle forms,

the elitist, hierarchical, and bureaucratic patterns of biomedicine. In contrast to biomedicine, which is dominated ultimately by the corporate class or state elites, folk healing systems are more generally the domain of common folk.[34]

In this light, the health care of the botánica might be seen as an empowering force creating an effective identity over and against the established power structures of North America: an assertion of old ways against the unfeeling and exploitative values of the new. At some botánicas, this stance as alternative medicine has resulted in a convergence of traditional healing with New Age ideas of natural living. One can find many products labeled as natural at these stores, and owners will explain that their Latin American ancestors lived the natural lifestyles sought by many middle-class white Americans. This seemingly shared purpose has opened the wares and healing opportunities of the botánica to yet another clientele, and one can find what might be called New Age botánicas in Miami and New Orleans. For most botánica owners and patrons, however, the focus is on the maintenance and cross-fertilization of Latino traditions, and the alternative power of the healing rests in the authority of the natural world, Latin American ancestors, and very often, women of the spirit.

We've seen that the help sought at the botánica is often concerned with issues of women's health. But the botánica is not only—or perhaps even primarily—concerned with physical healing but also social healing. Women patrons come to the botánica for help in dealing with problems in the home, at-risk children, spiteful in-laws, and wayward and abusive spouses. In his research among the devotees of St. Jude, Orsi found similar concerns and speaks of the social power of the materials of the devotion:

The decision to pray to the Patron Saint of Hopeless Causes was a public declaration that a limit had been reached, as men knew when they saw images of the saint appear before them in their homes. The candle lit before the statue in the bedroom or the prayer card taped to the refrigerator signaled new expectations and a new willingness not to hide from the truth anymore.[35]

We can see that the material religion of the botánica acts in this way not just to reassure the devotee but—indirectly yet pointedly—to engage the primary relationships in the devotee's life. Thus the herbs and candles, statues and tools offer real power to frame the underlying social causes of distress and open up ways to change them. So many preparations are about locking and unlocking, containing misfortune and releasing healing: I Can and You Can't, Rompe Saraguey (Break Spell), Tapa Boca (Shut Up), Abre Camino (Open Way), Run Devil Run. The objects and actions produce resolve and flow; the devotee is empowered to stop what is wounding her and to open up the possibilities for change. And malefactors are put on notice by the display and arrangement of the objects from the botánica in

patrons' homes as well as public offerings at botánica shrines themselves. These visible displays of dissatisfaction and resolve can have effects among those interested parties who observe them.

These social interpretations of the efficacy of botánica healing—symbols of identity, culturally appropriate care, tools of resistance—are all recognized by owners and patrons. Nearly all my interlocutors spoke of these resources in various ways. Frank at Paco's Botánica in New York said, "There's positive energy at our botánica, the help people get here calms them down." And Carlos at Botánica Changó in Hartford said, "The botánica makes people, especially immigrants, feel comfortable. It works because they're relaxed and they trust us." Yet in one way or another, most owners said that they see a "deeper" agency at work in the botánica's power to heal. For them the botánica is not only a pharmacy, parallel to those of professional medicine, but more so a site of encounter with the spiritual world, a point of access to the invisible powers that underlie the visible. The powers and preparations are effective at the level of the natural world and the social world, but perhaps most importantly, at the level of the spiritual world. The spirits empower the herbs to work, and it is the knowledge of and contact with the spirits that allows healers to cure disease, fix broken relationships, find clients work, or get them justice in an unjust world.

Religion and Magic

Throughout this book, I've been interested in what I've called the religion of the botánica. It's what first drew me to the stores, imagining and learning the ritual purposes of the objects and experiencing the shrines amid the commerce. So after the discussion of the more conventional views of botánicas as mediating institutions and dispensers of alternative health care for immigrant and minority Latinos, I want to see the botánica as an expression of a particular kind—or combination of kinds—of religion.

This, of course, begs the question of what religion is and what kind or kinds of it can be found at the botánica. We have seen that botánicas offer healing in a variety of senses: physical, social, and spiritual. People come to botánicas with pressing problems and so there is an instrumentality to its religion. It is vital to owners and patrons that the performances at and from the botánica be seen, in some way, to actually work. This may be a function of folk religions everywhere and perhaps related to the economic and social pressures that we've discussed above. Most botánica patrons are poor, without easy access to professionalized services and vulnerable to a host of threats from which the middle classes are insulated. As anthropologists Susanna Rostas and André Droogers point out, there is "a practical problem-solving intention in popular religion. In the case of lower-class people, seeking for meaning often involves searching for a solution to problems of survival. Religions offer resources for this quest, and popular religions particularly so."[36]

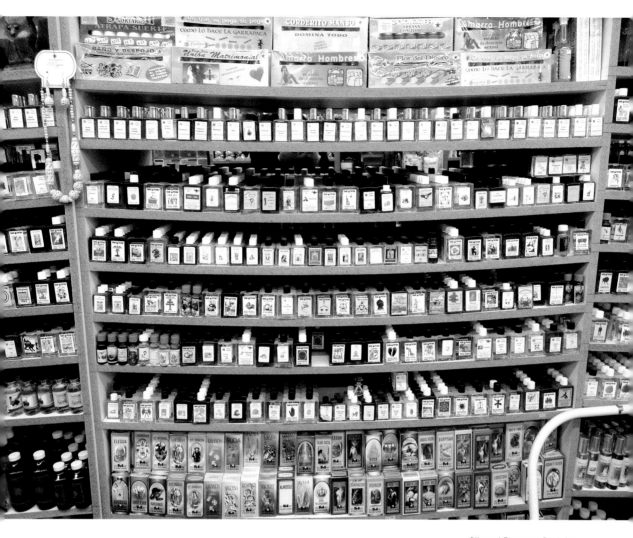

Oils and Essences, Botánica
Boricua, Arlington, Virginia.

As "solutions for survival" the spiritual forces of the botánica are not as divorced from issues of health, prosperity, and justice as they might be among the more comfortable classes. The issue of efficacy may beg the question whether the devotees are practicing religion or magic. The distinction between the two has a long and robust history in religious studies, and a brief look at the issue may be helpful in understanding the religion of the botánica. The most influential thinker on the subject is the great "armchair anthropologist," James G. Frazer (1854–1941), who distinguished magic and religion as evolutionary stages in the mental life of human beings.[37] Frazer saw magic as a kind of primitive technology that attempts to manipulate natural laws for practical results such as the fertility of crops or the success of the hunt. Marshaling examples of ritual practices from a huge sample of "primitive" peoples under colonial rule, Frazer concluded that magic operates according to two principles: homeopathy and contagion. Homoeopathic or imitative magic attempts to achieve results in the

real world by the magical manipulation of like things in the hands of the magician. Contagious magic seeks results by operations on objects that have once been in contact with the thing that the magician wishes to influence.

We can find innumerable examples of these principles at work at the botánica. Owners or others will do homeopathic trabajos for clients, such as construct effigies of lovers that can be "bound" with strings or "sweetened" with perfumes. And many trabajos use "contagious" objects such as a lover's (or enemy's) clothing, hair, or body fluids. Frazer thought that these symbolic principles were evidence of a simplistic level of thought, that practitioners mistake

applications of one or other of two great fundamental laws of thought, namely, the association of ideas by similarity and the association of ideas by contiguity in space or time. A mistaken association of similar ideas produces homoeopathic or imitative magic; a mistaken association of contiguous ideas produces contagious magic.[38]

The gradual realization of this logical mistake, as Frazer saw it, led to the next evolutionary step in human thought, religion. Rather than the manipulation of natural forces by acts of homoeopathy or contagion, religion seeks results by appeal to divinities who can grant what humans desire through their supernatural powers. The priest who can divine the will of the divinities and the offerings and behaviors that are appropriate to them would therefore replace the magician whose manipulations produced such uncertain results. Frazer grants that this evolutionary leap of reasoning did not happen at once and that there are instances where magic and religion might be seen to coexist. The trabajos of the botánica offer many examples of the simultaneous practice of sympathetic magic and the petition of spiritual beings. Here is a trabajo for the return of a lover that we referenced earlier from a spell book for sale at a botánica: "Put the name of the person that you desire on a piece of paper wrapped with a bit of your panties, put some perfume that you use on it, light a yellow candle in offering to [Ochún] the goddess of love, and ask her to bring the person to you."[39]

In this short spell, we find the magic of homoeopathy in the enfolding of the name of the lover in the panties (he's now in her pants), the magic of contagion with the intimate apparel which touches erogenous zones and with the personal perfume that touches the skin. And we can see religion in the appeal to the goddess of love to bring the lover to the petitioner. In this single trabajo, magic and religion are combined and the distinction does not seem relevant to the actual practitioner. Yet the displacement of magic by religion is important to Frazer because it sets the stage for a more momentous transition in the development of human thought.

For reliable results from supplication to divinities are also hard to come

by. The apparent failure of religion as well as magic to secure the practical benefits that humans seek leads to Frazer's final intellectual stage of human evolution, science. Science achieves dependable technological results through experimentation, falsifiability, and the critical observation of trial and error. Frazer explained the persistence of magic and religion in the age of science by citing the weight of tradition and the emotional impact of a few fortuitous successful outcomes over the myriad failures to which the magical and religious techniques give rise. Our botánica patrons, for Frazer and for many people since, would thus be thinking at an early stage of human ratiocination, deluded in their seeking health, or jobs, or true love through the manipulation of similar objects or in the appeal to santos.

Frazer's ideas of rationality and the progress of human thought have had a lasting impact on popular views of magic and religion. It is an axiom of many contemporary critics of religion that scientific rationality has demonstrated the falsity of magical and religious thinking and that one can only "believe" in religious truths by abjuring rational thought altogether. For example Richard Dawkins, a zoologist, writes, "Scientific beliefs are supported by evidence, and they get results. Myths and faiths are not and do not."[40] This view accepts Frazer's notion that the essence of magic and religion is the postulation of empirical truths about the world that their practitioners are failing to subject to scientific testing. Victor J. Stenger, a physicist, reveals the impact of Frazer's work in the title of his 2007 book, *God: The Failed Hypothesis—How Science Shows That God Does Not Exist*.[41] In talking about botánicas with colleagues, students, and friends, I encounter this attitude frequently. The magic and religion of the botánica seem to them quaint and outmoded, if not actively benighted. These educated folk seem unable, like the best-selling critics of religion, to imagine religion, or magic for that matter, as anything but irrational, pre-scientific assertions about empirical facts. Botánica owners and patrons often hear this criticism as well. Michele speaks for many when she says that when people try to convince her of her religion's falsity or primitivity she just tells them that she "just sells things" and waits until they go away.

While Frazer's views of religion continue to grip a large segment of the popular mind and sell large numbers of books, the notion of religion as a form of primitive mentality has not fared so well among social scientists and professional students of religion. Frazer's evolutionary scheme and reduction of magic and religion to theoretical modes of thought have had a host of critics, not the least being Bronislaw Malinowski (1884–1942). After long experience among a so-called primitive people of Melanesia—where he learned their language and participated in their daily activities—Malinowski showed convincingly that the Trobriand Islanders thought scientifically in a host of pursuits—planting, fishing, boatbuilding, navigating—and yet still practiced magic. Malinowski explained the coexistence of magical and scientific thinking by arguing that in endeavors that were likely of success, and therefore of low psychological stress, people rarely

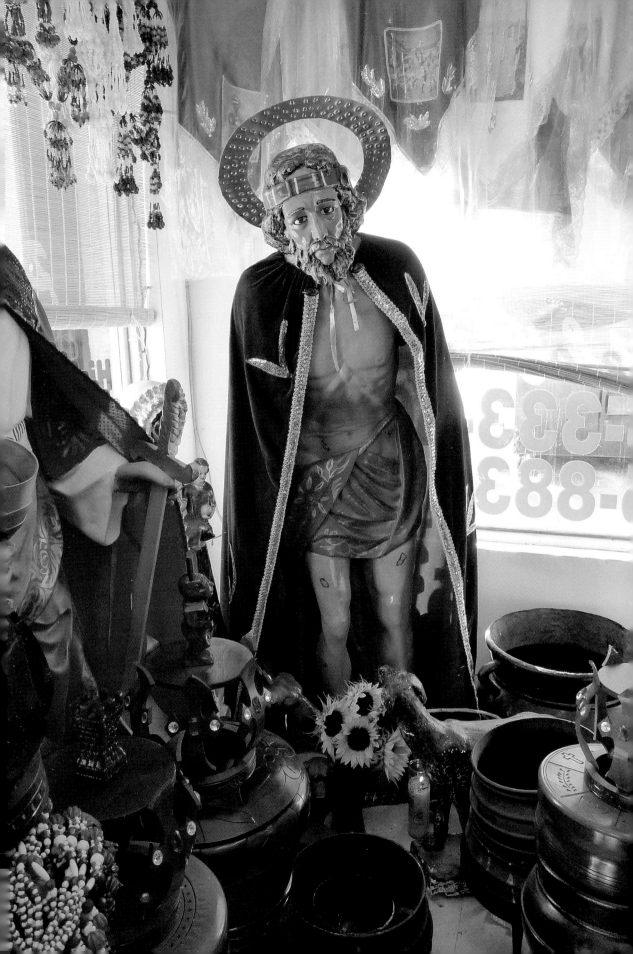

resorted to magic. But in endeavors where success was uncertain and attachment to results was highly emotional, magic would be used. It is not that people neglect scientific or rational thinking—they continue to fertilize and irrigate crops or observe star patterns to navigate ocean voyages—but they add to these actions magical ones to allay uncertainty and relieve stress.[42]

It could be said that botánica patrons are doing much the same thing. They are perfectly rational in seeking to make a living in the cities of the United States. Many work long hours at difficult jobs where they build straight walls, sew perfect garments, and clean houses and offices top to bottom. Yet in matters of uncertainty and stress—which as we have seen are aggravated by systemic inequities of poverty and discrimination—they find in the religion of the botánica a meaningful and effective way to address their problems. Malinowski's years of leading the life of the people he wished to understand showed him the cultural context in which magic, religion, and science operate. And it is this recognition of the pervasive power of culture over what is "rational" or "self-evident" and what constitutes "knowledge" that leads us to a second classic thinker on religion and magic, Emile Durkheim (1858–1917).

If Frazer's notions of magic and religion continue to be influential in popular critical discourse on religion, Durkheim's impact on contemporary social science has been far more profound. For Durkheim located the issues of the rationality and efficacy of magic and religion not in individual thought processes but rather in the power of socially constructed categories. For Durkheim, magic and religion are operating at different levels of social rather than individual thought. Religion, for Durkheim, is a system of practices to interact with a powerful, transcendent reality, the realm of the sacred. The sacred world is created by and reflects the collective social experience of a "single moral community" or "Church," in his terminology. Magic, on the other hand, is a social arrangement between magicians and their clients. He writes that

there is no Church of magic. Between the magician and the individuals who consult him, as between these individuals themselves, there are no lasting bonds which make them members of the same moral community, comparable to that formed by the believers in the same god or the observers of the same cult. The magician has a clientele and not a Church.[43]

This clientele/Church distinction is a useful one in understanding the spiritual work at and from the botánica. It neatly divides the trabajos that involve only the client and counselor from those collective acts that bring together spiritual families such as those of Espiritismo, Palo, or Ocha. From this perspective, botánica patrons are interacting with the sacred world at different levels of social participation and so could be seen to be practicing either magic or religion, depending on the level of integration

< San Lázaro, Botánica Olocum, Miami.

with a group. Maya Deren, in her insightful study of Haitian Vodou, follows Durkheim in distinguishing religion and magic among the Haitian folk: "Religion, being a collective enterprise, is concerned with directing the cosmic forces toward a collective public good. . . . Magic is an individual action . . . dedicated to the means by which some portion of those forces may be 'tapped,' channeled and focused to some personal end."[44]

In her study of Afro-Brazilian religions, Kelly Hayes speaks of the limitations of the clientele/Church distinction and the consequences of such classificatory schema. She shows in her review of Brazilian literature that the classifications of magic and religion have been used as categories of the legitimate and illegitimate: religion being seen as "collective acts of submission" and magic "individual acts of manipulation."[45] She writes that

theory-making not only explains human behavior, but creates knowledge and apportions power in ways that carry real-world consequences . . . the opposition between religion and magic is discursive not practical: the result of a continuous process of identity formation in which "magic" is progressively displaced on to another. What separates the two is the degree to which those groups who claim to practice religion have achieved a measure of social legitimacy by distancing their own practices from accusations of magic . . . the illegitimate underside of that set of practices labeled "religion."[46]

Durkheim's lasting influence on the social sciences in general and the study of religion in particular is to locate religious thought and practice, not in individual ratiocination but in "collective representations." Magic and religion—indeed, any social institution—can be seen as products of social thought and therefore operate at a different level that that of individual experience. Human thought itself is product of social experience, and what is "rational" is socially conditioned. Durkheim speaks of "the irreducibility of reason to individual experience."[47] He continues:

In as far as he belongs to society, the individual transcends himself, both when he thinks and when he acts. . . . The ideas of time, space, class, cause or personality are constructed out of social elements . . . [therefore] . . . religion is something eminently social. Religious representations are collective representations which express collective realities; the rites are a manner of acting which take rise in the midst of the assembled groups and which are destined to excite, maintain or recreate certain mental states in these groups.[48]

[Religion is] a system of ideas with which the individuals represent to themselves the society of which they are members, and the obscure but intimate relations which they have with it.[49]

With this perspective, we can see that the efficacy of the ritual life of the botánica—the reason why it works for owners and patrons—lies in that its symbolism reflects the social reality of its practitioners. This is the realm of

the sacred, the power of collectivity over the individual. The sacred power that botánica patrons seek is real and objective for Durkheim, though not proceeding from the same source as they might suppose. He writes that "in fact, we can say that the believer is not deceived when he believes in the existence of a moral power upon which he depends and from which he receives all that is best in himself: this power exists, it is society."[50]

The power accessed at the botánica is thus real and greater than that of the individual. It is not surprising that healings occur when the great power of society, hedged and hemmed by prohibitions and formulae, is encountered by the individual patron at the store or the home shrine. Durkheim explains that "this is all because social thought, owing to the imperative authority that is in it, has an efficacy that individual thought could never have; by the power which it has over our minds, it can make us see things in whatever light it pleases; it adds to reality or deducts from it according to the circumstances."[51]

The truth of this observation is reflected perfectly by a practitioner who told researcher Raquel Romberg, "I don't believe in magic, but it works."[52] As a social construct, the world of power accessed at the botánica is a reflection of the world of its seekers, with their notions of health, justice, competition, hierarchy, gender, patronage, and intercession. Seekers are bound to spiritual beings by vows, promesas, which must be symbolized and solemnized by actions. Evil, negativity, discord, violence are the forces against which the seeker must battle, and the herbs, sprays, baths, candles, and statues of the botánica are the tools to purify the home and the body of these intractable powers. These forces are very real in the world of the botánica, and the knowledge and compassion of botánica workers give patrons a fighting chance to expel them from their homes and bodies. Thus, the objects—and the activating mixtures that energize them—purify the home and body, invest them with the tranquility and static beauty of the shrine, and seal them off from the negative forces that encroach upon them.

When energized by placement, words, actions, and intentions, the objects of the botánica create an encounter with sacred power. A final quote from Durkheim illuminates the material religion of the botánica and its efficacy in the lives of its community:

Even the fact that collective sentiments are thus attached to things completely foreign to them is not purely conventional: it illustrates under a conventional form a real characteristic of social facts, that is, their transcendence over individual minds. In fact, it is known that social phenomena are born not in individuals, but in the group. Whatever part we may take in their origin, each of us receives them from without. So when we represent them to ourselves as emanating from a material object, we do not completely misunderstand their nature. Of course, they do not come from the specific thing to which we connect them, but nevertheless it is true that their origin is outside of us. If the

moral force sustaining the believer does not come from the idol he adores or the emblem he venerates, still it is from outside of him, as he is well aware. The objectivity of its symbol only translates its externalness.[53]

We have been using the ideas of classic theorists like Frazer and Durkheim to illuminate the religion of the botánica because I think that nearly everything written since about magic and religion is derived from them.[54] There have been many valuable refinements and critiques of these scholars of a century ago, and we will conclude the discussion with a glimpse of a master ethnographer on Latin American spiritual healing who makes use of both. Raquel Romberg became the student of the late Haydée Trinidad, a Puerto Rican bruja (sorcerer, witch) who maintained a large clientele in San Juan in the 1990s. Romberg was able to attend and document many consultations, trabajos, and collective rites in Haydée's community. She saw Frazer's principles of homoeopathy and contagion and Durkheim's power of the collective at work in the trabajos and rites that Haydée performed for her clients. Here Romberg describes the construction of a spell for uniting lovers:

Haydée carefully opens, one by one, small sachets containing several magical powders and puts them inside a four-inch-diameter goblet placed over the pieces of folded papers with the names written on them. She states, "I'm uniting the five senses of José to the five senses of Wendy. This is for uniting a couple. He wants to stay with her, but she is a pain in the neck." The various colored powders—violet, blue, yellow, green, red, each serving a purpose on the amorous plane—are topped one over the other, creating an irregular, fluffy rainbow at the bottom of the goblet. "Look, Wendy, how this works. I'm going to put in the azogue [mercury] now; [in rhyming phrase] *para que José corra y corra nadie lo socorra* [so that José may *run* and *run* and nobody helps him] until he arrives to Wendy's feet. Look, look how the azogue *runs* through the powders." Then the climactic moment of this trabajo arrives: tiny shavings of gold and silver, the symbols of happiness and wealth, are showered over the mercury moving aimlessly (running) between the rainbow powders of love.[55]

Romberg shows us that the power of the trabajo lies both in the mimetic association or homoeopathy between the elements, their names, and the lovers, and in the collective power of the socially constructed reality of contemporary Puerto Rico. She sees brujería, espiritismo, and other healing rites as products of Haydée's community's response to welfare capitalism. Brujería, she writes, "becomes necessary when the increasingly neoliberal social order fails to provide for those who lack fiscal or cultural capital with the legitimate means to fulfill their desires for capitalistic accumulation."[56] Rather than a survival of a pre-scientific worldview as Frazer would have it, Romberg and other contemporary anthropologists see in magic a response to and of expression of modernity. Peter Geschiere sees magic as

"interpret[ing] the mysteries of the market" for people most affected by the chaotic fluctuations of the world economy, "trying to make sense of the modern changes—and notably the shocking new forms of wealth and inequality."[57] The power of the magic to reflect the social and economic situation of the client is at least part of the key to its efficacy. Romberg writes "this mirroring drama is powerful enough to motivate even the most bewitched client (that is, one who has lost even the willpower to heal) to stop being passive and, instead, to engage in some recommended proactive, mending action, such as the performance of a cleansing ritual or retaliatory magic work."[58]

Magic and religion are techniques of power at the botánica allowing patrons access to the sacred world in order to address their problems. The practices of magic and religion are not mutually exclusive, but varying techniques of ritual experience. The devotion to divinities is not a fundamentally different mode of thought as Frazer would have it, but a distinctive form of symbolism. What Frazer called "a propitiation or conciliation of powers superior to man"[59] remains a useful marker in understanding the religion of the botánica and, while the meanings of the term *religion* may comprehend more than dealing with spiritual beings, it is still this congress with them that interests students of religion. According to Jonathan Z. Smith in his essay on the uses of the term religion, the definition of religion formulated by anthropologist Melford Spiro has achieved broad assent among scholars of religion.[60] Spiro writes that religion is "an institution consisting of culturally patterned interaction with culturally postulated superhuman beings."[61]

I am content at this point to speak of "the religion of the botánica" as encompassing all ritual approaches to a sacred world, be they identified as magic or religion. Further, I'm content to use the singular "religion" while well aware that there are many historic traditions brought together and juxtaposed at botánicas. The "religion of the botánica," then, comprises many religions and many magics, too. Botánicas are sacred sites for contact with the healing and transformative power of a sacred world through mimetic trabajos and interaction with "superhuman beings," that is, santos. It remains to look at the botánica as a sacred space of possibility and power.

Sacred Spaces

Throughout this book, I've tried to show that botánicas are special places in their communities, providing vital occasions for solidarity and support, for health and social services, and for religious experience. In this final section, I would like to further explore the role of the botánica as a sacred space of spiritual encounter and transformation. Once again, Durkheim is a classic guide to the role of the sacred in regard to the botánica. "Sacred things," he writes, "are those which the interdictions protect and isolate;

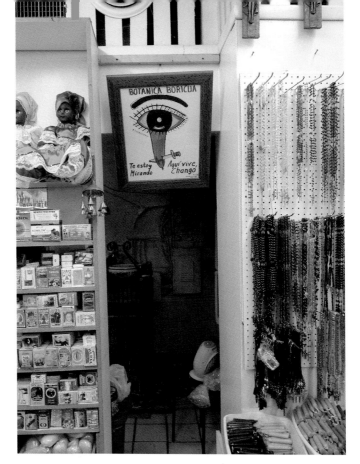

"I am watching you: Changó lives here." Eye and pierced-tongue warning, Botánica Boricua, Arlington, Virginia.

Limens protections over door, Botánica San Elias, Alexandria, Virginia.

profane things those to which these interdictions are applied and which must remain at a distance from the first."[62] Mircea Eliade extends this division of sacred and profane, seeing sacred space as a site of intersection between the two realms. He speaks of "hierophanies" or "irruptions" of the sacred, timeless, and infinite world into the ordinary profane world of time and space. He writes that a hierophany "effects a break in plane, that is, it opens communication between the cosmic planes (between earth and heaven) and makes possible ontological passage from one mode of being to another."[63]

For Eliade, the presence of the sacred in the profane is experienced by religious people as a paradoxical and puissant reality that has the power to transform and renew life. Any space and any object can function as a hierophany for religious people, and so the wares, consultations, trabajos, and shrines of the botánica can all work to bring the sacred world of the santos into the ordinary world of the patron.

Cross in water at limens, Botánica San Elias, Alexandria, Virginia.

This intersection of worlds is explored by Victor Turner in his explication of social and ontological "betweenness," which he calls "liminality" after the "limens" or threshold in the passage between architectural zones. He writes that "if our basic model of society is a 'structure of positions,' we must regard the period of margin or 'liminality' as an interstructural situation."[64] This space of betweenness—the intersection between the sacred and the profane if we follow Durkheim and Eliade—is one of peculiar power and creativity. Turner's classic discussion of liminality was formulated in the context of rites of passage in which initiates are transformed from one social state into another by means of a stateless period of transition. The in-betweenness of the space between these states can be a model for all sacred spaces, including those of the botánica. Here Turner writes of initiatory neophytes, but the observation is applicable to the devotee at the botánica shrine, at the cleansing rite, or at the making of a trabajo:

During the liminal period, neophytes are alternately forced and encouraged to think about their society, their cosmos, and the powers that generate and sustain them. Liminality may be partly described as a stage of reflection. In it those ideas, sentiments, and facts that had been hitherto for the neophytes bound up in configurations and accepted unthinkingly are, as it were, resolved into their constituents.[65]

Thus, by meeting the sacred world at its irruption at the botánica, patrons are brought into a realm where the structures of ordinary reality—the pressures and problems of urban life—are "resolved into constituents" so that new orders and new solutions can be structured. The encounter

Bembé for San Lázaro,
Botánica Riviera, Miami.

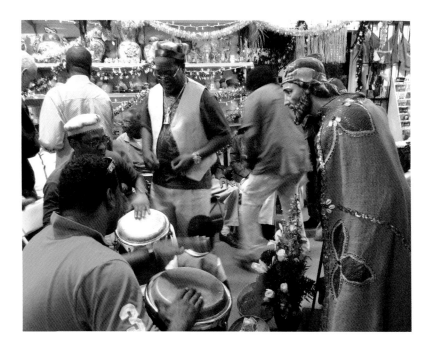

with sacred is an encounter with power, the unstructured world of the santos both reveals and undermines the structures of ordinary life, showing the arbitrariness of the conventions of social life and the individual ego. In liminality is possibility, a sacred state of indeterminacy in which healing can happen.

We have seen that the sacred and liminal nature of the botánica in its setting on city streets is signaled by a variety of threshold symbols. *Mariwo* raffia hangs across the entryway of many stores, alerting those who understand its meaning that sacred mysteries are within and that one must conduct oneself as in the presence of the santos. This warning is sometimes reinforced pictorially in a "see but don't speak" image which tells visitors that they may observe a mystery but cannot speak of it. The orisha Eleggua guards the gate at most stores, turning back on malefactors the evil that they would do. Eleggua is accompanied by a host of creatively allied guardian figures reinforcing the sacred precincts of the store. Lintels are hung and doorways protected with charms to neutralize negativity and impurity that may happen to cross over.

We've seen, too, that the stores may function in off-hours as communal spaces for rituals of trance mediumship. In these rites, human beings themselves become the hierophanies, incarnating the santo into their bodies in trance to prophesy and heal the assembled congregations. The words and touch of the santo carry transformative power which irrupts into the botánica and reconfigures existing realities. The santos speak the truth, which sometimes hurts yet might set one free. And the royal touch of Changó or Ochún can be felt by the devotee as gentle, like a warm stone or cool water, and as overwhelming, like a bolt of lightning or roaring torrent.

In vivid, sensory contact with these powers, devotees may recognize the arbitrary and profane structures that bind them and, so, open themselves to change.

This is the power of religion: its capacity to remake the person by revealing that identities are ephemeral constructions. In sacred spaces and times, the self is shown to be a social construction, according to Durkheim and his intellectual descendants, and ontologically less than real in Eliade's thought. This revelation of antistructure is creative for it allows the self to be reintegrated into society at another level and to be reborn on the cosmological level. Eliade speaks of the cosmogonic power of sacred space: "The experience of sacred space makes possible the 'founding of the world': where the sacred manifests itself in space, the real unveils itself, the world comes into existence."[66]

These creative capacities are evident in the ritual construction of trabajos and despojos that create sacred spaces and times, opening patrons to new possibilities. The mimetic work of the magic takes the patron outside the box to novel outcomes. The very details of the work require a concentration and reorientation of thought, imagining and embodying an alternative to the world as it has seemed to be. The careful and difficult acts of magic create a state of mind—a rhythm of concentration—that operates on rational and nonrational levels, integrating the whole person toward his or her end. The gathering of the materials—many esoteric, expensive, and hard to find—requires an investment of time, energy, and hope. This is what practitioners call "faith," which in this context is the commitment of the patron to possibility and change. The magic works because people have faith that it will work, a faith developed in the experience of the careful preparation of ingredients and the deliberate, active performance of their engagement in ritual space and time. This kinetic, sensory experience in the "other world" of sacred space, the limens between our world and eternity, make possible the efficacy of the work. It is effective not simply because patrons believe in the magic but rather that they are mentally and physically placing themselves in a new zone, another space, where their intentions are actualized in the experience of the five senses.

Raquel Romberg sees this potency in the trabajos that her mentor, Haydée, created for her clients. She suggests that "ritual correspondences, like metaphors and poetic devices, cause us to be aware of and be moved by intangibles while also mobilizing us to take some form of action."[67] The performance in the sacred space and time of the ritual has the power to change the client and so his or her situation. One can sense the experiential power of the magic in this passage:

During rituals and the performance of trabajos, one's gaze also has the power "to do." Haydée was adamant that every time she performed a trabajo the client should be present and witness the entire procedure, which would assure its having the desired effect. Step-by-step, as each configuration of distinct

elements is gradually and precisely assembled and all its elements—candles, carpenter nails, powders, potions, plants, colored ribbons—sequentially introduced, the final trabajo emerges in front of the client's eyes. "Look how beautiful this trabajo is!" expresses both the satisfaction achieved at seeing the completed trabajo and at having summoned its expected effects. In other words, by means of their concerted gaze, clients together with brujos actively take part in promoting (as if igniting) the success of the trabajo made on the clients' behalf. Involving both clients and brujos, this performative aspect of the making of trabajos highlights the present-oriented dramatic nature of this process at the expense (I would venture) of the expected future effects of the trabajos made.[68]

In this captivating description, Romberg shifts our understanding of magic from the expectation of results to the experience of them. Rather than "believing" in magic, botánica clients are experiencing it in the mimetic work of the trabajo. They have been, perhaps, seeking this experience all along and speaking of it through the language of results. The same dynamic is at work in the devotion to the santos of the botánica. Santos, like all sacred figures, occupy a liminal space in the lives of their devotees. They are neither humans nor gods, yet they are functionally both; they are neither living nor dead, yet both. By virtue of their humanity, they can be drawn into reciprocal relationships of service and patronage, and by virtue of their divinity they can access the sacred world of infinite creativity. The santos of the botánica reflect the social and cultural experience of their devotees. They are, as Frank Graziano has pointed out, lo nuestro, "one of us."[69] Cubans call the Virgin of Charity by the nickname Cachita, a diminutive of Caridad. I have even heard them call her *mi negrita*, a Cuba idiom of familiarity meaning "my little black one," implying a shared identity as "just folks." Mexicans call the Virgin of Guadalupe sweetly by the name Lupita and jokingly refer to La Santa Muerte as La Flaquita, "the little skinny one," a macabre reference to her bony frame. Many of the botánica santos are folk saints unrecognized by official Catholicism who are felt by their devotees to represent the common people alongside and even against the official establishment. These santos may be seen to draw their power from the inequalities and injustices of society, and the disapproval or suppression of them by elites confirms their efficacy for common men and women. The Indios and Congos of Espiritismo, the *mpungus* of Palo and the orishas of Ocha, the outlaw santos like Maximón or Jesús Malverde, all work for ordinary believers. They occupy a special liminal space where the familiar and sacred come together to heal and renew their ordinary devotees.

Even the officially canonized saints of the botanica are made lo nuestro by their devotees, who transform them from the submissive moral exemplars as promulgated by the elite into effective advocates for people with problems. They have been reinterpreted on folk terms and appropriated, drafted into relationships with other cosmologies and other santos. Santa

Barbara, the virgin martyr, represents Changó, the thunder king of Oyo; San Simón the loyal and treacherous disciple of Jesus signals Maximón the Maya trickster. We've discussed these creative popular religious initiatives using the analytical terms *syncretism*, *symbiosis*, *hybridization*, and *creolization*. Each term presents a different nuance of the fact of religious mixture at the botánica. For now we need only say that there is power in mixture, a social power born of reinterpreting the symbols of diverse social experience, and a spiritual power in multiple and multivalent symbols of the divine.

We've been seeing that the religion of the botánica makes the santos "ours" and so not "theirs." The mixtures are calculated appropriations of religious symbols from multiple cultural and social sources to empower those who have been disempowered by structures built, maintained, and policed by elites. Raquel Romberg

Image of N.S. de Guadalupe and *sopera* for Ochún, Botánica Boricua, Arlington, Virginia.

writes of the "cunning of the subaltern" wherein "the symbols of civilizing powers that had meant to subdue them were rechanneled into actual magical power. How can one not be amazed by such magic?"[70]

Andrew Apter speaks similarly of the cultural creativity of enslaved Yoruba who mixed their orishas with the Catholic santos. Catholicism, he says,

was not an ecumenical screen, hiding the worship of African deities from official persecution. It was the religion of the masters, revised, transformed and appropriated by slaves to harness its power within their universes of discourse. In this way, the slaves took possession of Catholicism and thereby repossessed themselves as active spiritual subjects.[71]

This seizure of symbols from Catholic, African, indigenous, and now Asian sources creates new opportunities for religious experience. The religion of the botánica places these symbols side by side in altar displays creating dialogues of meaning in the lives of devotees. The santos of the botánica, placed in these stimulating and sometimes startling juxtapositions, accumulate meanings and power by their correspondence in sacred space. The santos are seen as mutually enhancing each other: we learn more about Santa Barbara as we venerate her beside Changó, and we gain a deeper appreciation of Changó as we make an offering to him beside Santa Barbara. The two are the same and different at different levels of experience. At the botánica, the santos are not elided but juxtaposed; their differences are as important as their identities in their efficacy to address devotees' need.

The effect of the juxtapositions is powerful, beautiful and appropriate. I see a cultural genius at work, a keen understanding of the power of religious symbols to take the devotee to a new understanding of his or her life, a new space of transformation and renewal.

The juxtaposition of santos at the botánica, and so the arrangement of similar and different cultural traditions and meanings that gave birth to them, makes for a unique and powerful religious experience. Mircea Eliade speaks of the "ambivalence of symbols," the simultaneous coincidence of opposites in symbolic forms that reflects the intersection of sacred and profane worlds.[72] The paradox of the bush that burns but is not consumed, the mother who is a virgin, the male god who is a goddess, the gateless gate are all markers of an experience of the hierophany. The spatial oppositions of the botánica grow out of the social juxtapositions of the communities of the Caribbean and Latinos in the United States. These symbolic juxtapositions can give rise to the experience of religious mystery. The religion of the botánica works because the religious paradoxes it celebrates allow for transformative experiences to happen. The religion of the botánica fosters an openness to and experience of many-sidededness, an encounter with ambiguity and paradox that makes the impossible possible.

It is through ritual that the sacred world is fully engaged at the botánica, be it the mimesis of the trabajos or the acts of devotion to the santos at their shrines. The shrines are the faces of the santos, sacred spaces of intersection of the worlds. Devotion to the santos of the botánica sets up a special dynamic in the lives of devotees, creating opportunities for victory in the battle of life and occasions for self-knowledge and wisdom.

Devotion to a santo involves a committed relationship with a sacred other. The saintly other is a reflection of the cultural experience of the communities that have developed its cult as well as the personal world of the devotee. The means of expression of the relationship between devotee and santo are the product of centuries of cultural interaction and juxtaposition. The foundation of the relationship is the promesa, the solemn vow of exchange between parties. For the patronage and aid of the santo, the devotee promises service: the more specific the help requested, the more specific the service to be rendered. This pattern of interaction is binding on both parties, a reciprocal relationship of exchange. As human beings want help with the problems of health, money, and love, the santos want sustenance and glorification. The shrines of the botánica and the home shrines of its patrons are the primary sites for fulfilling promesas, spaces of prayers of supplication and thanksgiving and material gifts of finery and foods. In keeping their vows, devotees make shrine displays ever more elaborate with sumptuous cloth, magnificent flowers, glowing candles, and the special foods that each santo prefers. The shrine becomes a baroque accumulation of luxury and memory as each adornment is a memento of past exchanges and so a token of a deepening relationship. Referring to his

Basement Vodou temple below Botánica Yabofer Yabodi Yabola, Brooklyn, New York.

Afro-Cuban creations, shrinemaker Ysamur Flores says that the shrine is "a vision of Lucumi heaven."[73]

The specificity of offerings—coded by color, number, texture, sound, name, and narrative—intensify the experience of faith, and so the efficacy of the intention. The santo may respond to any sincere offering, but he or she can be expected to respond—and the devotee expected to be helped— with the specific offerings appropriate to each santo. I remember the chagrin of priestess Oba Oggun Bemi when I told her that I had once given a beer to Eleggua. When I asked the santo through obi divination if he was satisfied, I received an emphatic "no" in answer. "Of course," said Oggun Bemi, "it's wrong for the system." Felix of Botánica F & F in New Orleans said that inappropriate offerings are like putting cheap gas in your car. "It'll work with cheap gas," he said, "but not well and not for long."

On special occasions the shrine becomes the focus of full ceremonies of thanksgiving or petition, carried out in devotees' homes or on site at the botánica. We've described two ceremonies of spirit mediumship before altars at botánicas, and it is worth mentioning one more site in my experience. Looking to visit a Haitian botánica in New York to complement the ones that I had seen in Miami, I wandered into Botánica Yabofer Yabodi Yabola in Brooklyn. I struck up a conversation in English with Marcia, who after a while asked something in Kreyol of a man sitting behind by the door. I learned later that he was M. Roger Marc, the owner and an *ounga* or

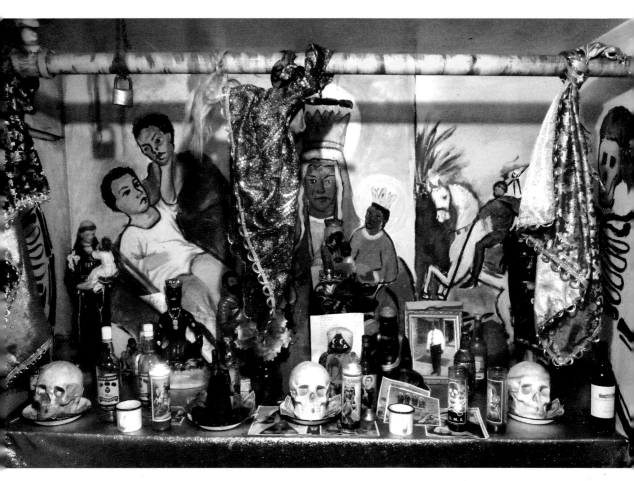

Altar to Petro *lwa*, Botánica Yabofer Yabodi Yabola, Brooklyn, New York.

priest of Vodou. Marcia then asked me if I'd like to go downstairs, and as we came to the bottom of a steep and rickety staircase I was amazed to see five shrine rooms dedicated to the lwa, the spirits of Vodou. Marcia showed me altars for what she said are the "black" Petro spirits and then the "white" Rada lwa. She told me that they have ceremonies here according to the calendar of the Catholic counterparts to the lwa and also "when people need them." The frontmost room is large enough to hold dances for the lwa, and Marcia said that fifty or more people will come to celebrate. The spacious rooms, colorful murals, and ornate altars show Botánica Yabofer Yabodi Yabola to be a labor of love for New York's Haitian community.

Ceremonies of spirit manifestation in the United States are usually carried out in people's homes. Yet as communities of devotion and religious tolerance grow, more rites are being conducted in botánicas and public halls. Professionals may be engaged to build the shrines, musicians hired to play the santo's favorite songs and rhythms, and caterers engaged to feed guests. The presence of spirit mediumship in small- or large-scale gatherings is a key in understanding the power brought to devotees through their devotion to the santos. For in sacred trance the human self and the

Altar to Rada *Iwa*, Botánica Yabofer Yabodi Yabola, Brooklyn, New York.

spiritual other are brought into intersection, a sacred space of the human body, a hierophany of the human and the divine. Maya Deren, perhaps the most acute of all interpreters of the spirituality of Vodou, sees the relationship of human and lwa spirit as one between the self and a natural force or principle which underlies it. The ritualized relationship between spirit and *serviteur* is, for the devotee, a means for understanding him or herself. For while the self is temporal and mortal, it is an expression of the underlying principle. The self is the principle's serviteur and vehicle. The santo works through the devotee to do its healing work, its "charity," in Spiritist parlance. Another American initiate and interpreter of Vodou, the legendary dancer Katherine Dunham, describes her relationship with her patron lwa (loa), Danbala, in this way: "It was as though an electrodynamic pattern were at work, loa choosing abode because of qualities of himself already latent in the abode, or abode gravitating to loa and discovering itself on some polar current."[74]

The electrical metaphor is most apt because it shows that the devotee and spirit are at once opposites and yet the same in dynamic counterpoint. The santo is the other side of the devotee, screened from him or her by the conscious self. At another point in the narrative of her initiation Dunham likens Vodou to psychoanalysis in seeking to discover a "dominant personality hidden under the social layers" of the devotee's psyche. And so the ultimate insight of devotion, like that of psychotherapy, may be that the "it" of the personality is "me" as much as the "me" is "it." The santo is not the ego but the self on another level. Here sociology, psychology, and mysticism seem to agree: the rational ego is not the only actor in the construction of the person. There is an other to the conscious self that has its own mind. Rituals of devotion to this other can thus be a process of self-knowledge, as the externalized exchange of services becomes the polar current of identity and otherness.

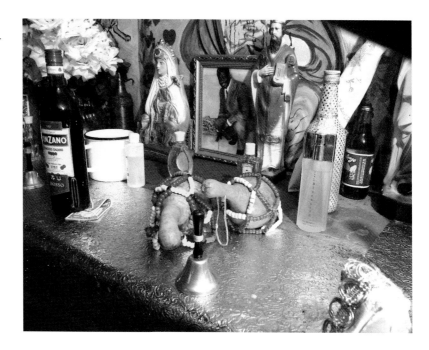

Altar to Rada *Iwa*, Botánica Yabofer Yabodi Yabola, Brooklyn, New York.

Not all devotional relationships achieve these goals, of course, and devotionalism has its critics. Church officials are concerned with "abuses, excesses, or defects" in the devotion to saints, such as seeking material benefits or "multiplying external acts."[75] And the resort to saints for justice against enemies or success in crime may be assumed to be unacceptable to official morality. A parish priest whom I interviewed about devotions to saints at his church spoke sympathetically of the piety of his parishioners, but he saw among some what he called a pharaseeism, an attention to ritual detail at the expense of love and charity.[76] The greatest concern of church officials is that devotion to the saints not obscure the worship of the Supreme Being. Still, the official documents of the Catholic Church conclude positively on the question of saint veneration, stating that, "in the fuller light of faith," devotion to saints "more thoroughly enriches the latreutic worship we give to God the Father, through Christ, in the Spirit."[77]

Devotionalism as a wisdom path plays a major role in Hinduism and Buddhism. The Bhagavad Gita argues that devotion to Krishna is one of the highest and most accessible ways to enlightenment. The devotionalism of the Gita may be seen to parallel that of botánica devotee and santo in that its effect is to relativize the ego and reveal a mystical identity with the divine. Krishna tells his human devotee Arjuna,

Be absorbed in me,
Lodge your mind in me:
Thus you shall dwell in me,
Do not doubt it,
Here and hereafter.[78]

While the Gita accepts that devotion to all deities is ultimately devotion to Krishna, it shares the Catholic clergy's concern with the ultimate object of devotion, though it sees the error as a failure to recognize the divine unity behind diversity. Krishna says, "Even those who worship other deities, and sacrifice to them with faith in their hearts, are really worshipping me, though with a mistaken approach. For I am the only enjoyer and the only God of all sacrifices. Nevertheless, such men must return to life on earth, because they do not recognize me in my true nature."[79]

The parallels between botánica devotional practices and those of Indian traditions are not entirely fortuitous. One of the primary figures in the Spiritist movement of the nineteenth century, Allan Kardec, was deeply influenced by Europe's rapidly expanding awareness of Eastern traditions as

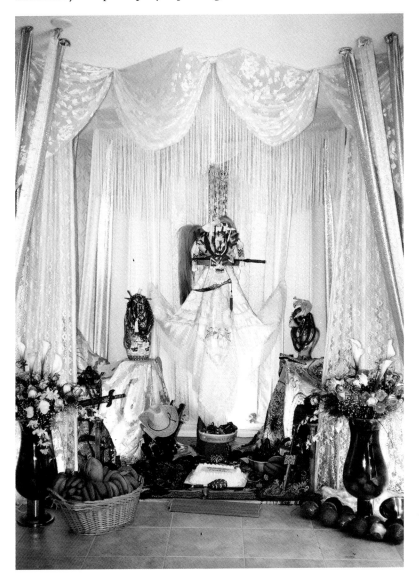

Professional anniversary altar for Obatalá, Miami, 2002.

Hindu and Buddhist texts came to be translated into European languages. Kardec's *Book of the Spirits*, published in 1871, is a systemization of experiences of mediumship with an Eastern-derived philosophy of the transmigration of the soul.[80] The book was a best seller in Latin America and Brazil and deeply influential in the ways that spirit mediumship and morality are expressed at botánicas today. The goal of contact with the spirits for Kardec was a final perfection of the soul, joining in union the individual spirit with the perfected spirits of the past.

The perfected spirits tell Kardec "God has created all spirits in a state of simplicity and ignorance; that is to say, without knowledge. He has given to each of them a mission, with a view to enlighten them and to make them gradually arrive at perfection through the knowledge of the truth, and thus to bring them nearer and nearer to Himself."[81]

A final Eastern parallel that might show botanica devotions to be a wisdom path comes from the tantric traditions of Tibet. In the meditation text "Essential Points of Creation and Completion," seekers are instructed in "deity visualization practices" in which a deity is created, mediated upon, ritually served, and ultimately joined in mystic union.[82] "The deities," writes translator Sarah Harding, "represent an alternate reality that more precisely reflects the innate purity of our minds." The deity is as real as the individual ego that is worshipping it; it is not invented any more than the ego is. The devotee first interacts with the deity, then dissolves it into the self, then dissolves the self. Harding concludes that

"all the different ways of relating with deities are ways we already have of relating to our experience. In this sense, the practice of deity meditation is a skillful way of undermining our ordinary mistaken sense of solid reality and moving closer to a truer mode of perception."[83]

In the Tibetan tradition, the benefits of these practices—the realization of one's own and the world's buddha-nature—is only possible under the direction of a guru, a teacher who can guide the seeker through the subtle pitfalls of ego and desire. The religion of the botánica has its own teachers, whose relationships with devotees are often characterized as those of godparent and godchild. Though the nondualist aspirations of the Tibetan adept are not articulated as such at the botánica, they may be inferred from the language of union with the santo that we've seen used above. Relationships with santos must be developed, as José of Botanica El Salvador del Mundo says, "step by step," in initiatory stages presided over by community elders. If the goal is not precisely the realization of buddhahood, it is something not unlike it in its quest of selflessness and perfect charity.

Not all devotees are mystic seekers, of course; perhaps not many. The criticism of devotionalism as materialistic or infantile may apply to many botánica devotees. As Robert Orsi found in his study of the devotees of Saint Jude,

Devotional practice is never innocent; it may be effective, but it is not always decent, respectful, selfless. . . . The point here is not that women were always right and good in what they did with Jude, but that with Jude's help they were always working on their family lives, for better or worse. . . . For a moment in their prayers, the devout could enter the world as they wanted it to be, in the company of the figure whose gaze legitimated and encouraged their hopes. . . . As women prayed to Jude they sensed a subtle shifting of the axes of their experience; the closed space of hopelessness was opened.[84]

Botánicas empower their patrons for victory in the battle of life. They empower immigrants with familiar cultural resources to survive in the new and too-often hostile land of the United States. They provide networks of support for the stresses of life for people away from extended families, friends, elders and their ways of discipline, comfort, and loving care. Botánicas empower poor people by offering alternative, effective health care that recognizes the cultural context of their illnesses and expectations of treatment. Botánicas offer techniques for the experience of health, wealth, love, and redress. The magic and religion of the botánica create sacred spaces of renewal, where constricting patterns of life can be dissolved and rearranged into new ones of hope. Botánicas are portals into the world of sacred, intersections with the power of the santos. And devotion to the santos offers an ever-deepening relationship with the sacred other that may lead to confidence, self-knowledge, and wisdom.

Epilogue

"The botanica is a curative promise. With a pluralist and eclectic world view, botánicas are a community enterprise, a heritage, and a symbol of Caribbean cultural healing."

Margarite Fernández Olmos[1]

Everything changes, and botánicas are no exception. For one thing, the current national economic situation has been very hard on small businesses. Since I began active study of the stores in the D.C. area in 2005, thirteen of the twenty-seven botánicas that I visited have gone out of business. This compares with two stores that have started up during that time. Many factors can contribute to the closures, of course; most botánicas are shoestring operations that rely on consulting more than sale of retail merchandise for their income. People get tired of the work, their life situations change. I heard that two owners retired to their home countries in Latin America. Yet it is clear from talking with owners that the sale of merchandise is down and patrons have less money to spend.

In the last decade we've seen the rise of Internet botánicas at which much of the herbs, candles, statues, and spiritual tools can be bought. Some of these are strictly online businesses, but many are extensions of actual stores that have transferred active mail-order services to the Internet. Original Products in the Bronx does a large business online in addition to maintaining a retail store, a "Home Depot of spirituality" according to the *New York Times*.[2] Perhaps the development of a such a "Home Depot" in town has been hard on small stores, and the attrition we see in the mom-and-pop botánicas is the result of competition as well as a recessionary national economy.

Consulting room, Ile Awore, Miami.

The online botánicas provide competition, particularly in the area of handcrafted spiritual tools such as the metal crowns and beaded wands that ornament Ocha altars and initiation ceremonies. Artists are now selling outstanding *herramientas para santo* (tools for the orishas) directly to devotees via the Internet. Scholar-santero David Brown, for example, offers a wide array of quality handmade spiritual tools at his online botánica at folkcuba.com. In the past, botánicas have been the primary retail outlets for handmade pieces like these, and I've noticed a decline in their presence at the stores

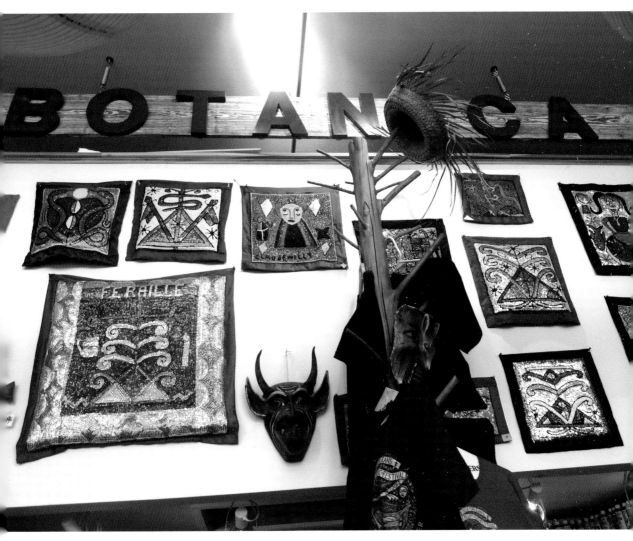

Island of Salvation Botánica,
New Orleans.

that I've visited in the last decade. An outstanding exception is the shop Artesania Yoruba in Hialeah. This specialty store produces high-quality custom beadwork for well-off clients, including music stars Gloria Estefan and India Arie.[3]

While online merchants may be having an effect on sales, we've seen that much of the power of the botánica rests on face-to-face interactions with experienced spiritual readers and healers and with devotions to sacred beings themselves at shrines and ceremonies. An innovative approach is being taken by Liurys Burey at Ile Awore in Miami, where original orisha-inspired arts are combined with high-tech consultation. She showed us aura-reading computer software that she uses to scan clients in order to offer a spiritual reading in tune with contemporary New Age therapies. Island of Salvation Botánica in New Orleans harmonizes traditional Vodou spirituality with contemporary ceremonial magick and yoga. Owner

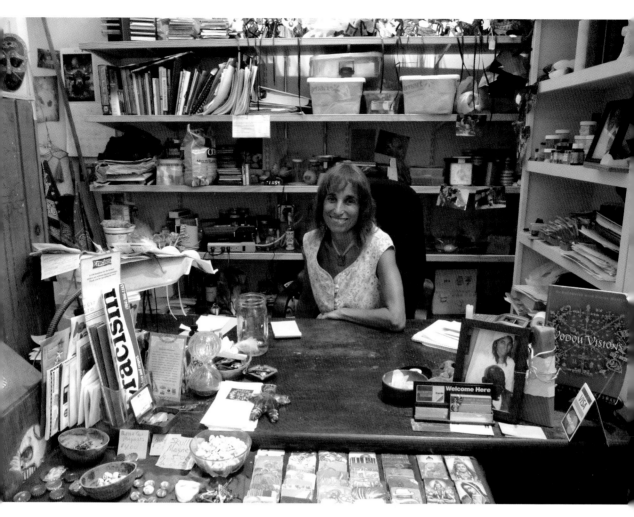

Sallie Ann Glassman, Island of Salvation Botánica, New Orleans.

and Vodou priestess Sallie Ann Glassman sees her botánica as part of an greater project of healing for the entire city of New Orleans.

The convergence of cultures giving birth to these new botánicas has been part of the history of botánicas from their inception. The active symbols of the botánica were constructed in Latin American by peoples forced into multiple cultural contacts by conquest and enslavement. Out of these dreadful encounters they created living traditions of protection and healing. The ability of these traditions to integrate seemingly disparate religious discourses gave their practitioners the power to negotiate multicultural environments and live with dignity and authority. Margarite Fernández Olmos and Lizabeth Parvisini-Gebert call these traditions "creole religions" characterized by "malleability and mutability of various beliefs and practices as they adapt to new understandings of class, race, gender, power, and sexuality."[4] We've seen numerous juxtaposed religious traditions at the botánica that reflect the juxtaposed cultural and social identities of the devotees. These mixtures have power because they speak

Botánica Ganesha, San Antonio, Texas.

Ocha initiates being presented to Nuestra Señora de la Regla/Yemayá, Regla, Cuba, 2001.

"Botánica Ochún," painting by Tony Mendoza, courtesy of Tony Mendoza.

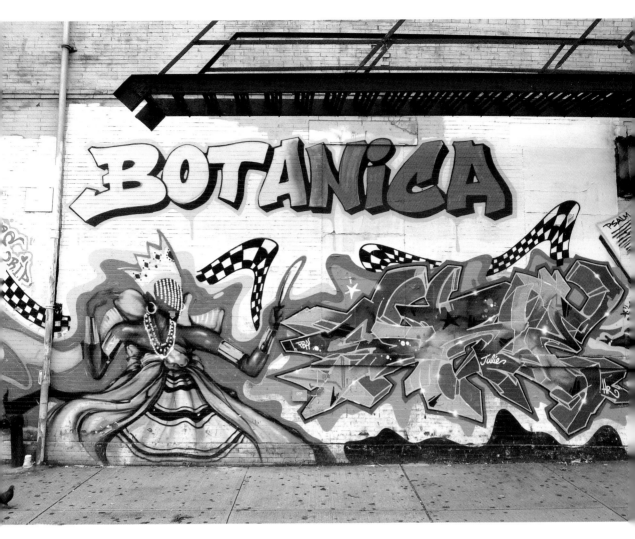

Mural, Original Products
Botánica, Bronx, New York.

a creole language that communicates and empowers those who put it into practice. Rather than rejecting the impurities of syncretic identities and practices, owners and patrons of the botánicas tend to embrace them in order to live and effect change in their world.

Juxtaposed magical ingredients and juxtaposed santos reflect the real world of devotees and, increasingly, the real world of all Americans. We are hurtling into a new era of multiculturalism where there is no majority and diverse identities are the norm that are being explored and organized in the lives of communities and individuals. As I write, the family of the president of the United States includes Americans of African, European, and Asian heritage. The creole religions of the botánica, forged in the fires of violent cultural encounters, may be models for new spiritualities that simultaneously affirm similarity and difference among their religious roots. The botánica acknowledges and celebrates America's creole heritage and offers new spiritual opportunities to all who enter it.

Glossary

Unless otherwise noted, all terms are either Spanish words or proper names.

(L) Lucumi or Cuban Yoruba
(C) Congo
(E) Espiritismo

A

aché (*ashé*) (L): power, grace, divine force.

akpon (L): songmaster at *bembé* drum ceremonies.

Alafin (L): "the Owner of the Palace," a title of the Yoruba/Lucumi *orisha* Changó.

Anaisa Pie: spirit of love and wealth in Dominican Twenty One Division.

B

Babalawo (L): "father of the mystery," Yoruba/Lucumi diviner.

Babalu Ayé (L): *orisha* of disease and healing, associated with San Lázaro.

banté (L): decorated wrappings for ceremonial *batá* drums.

batá (L): sacred drums that call the *orisha*, consisting of the Iyá, Itótele, and Okónkolo.

bembé (L): drum and dance ceremony of invocation of the *orishas*.

Black Hawk: Native American warrior and statesman, invoked by New Orleans Spiritists.

botánica: religious goods stores, shrines, and sites of consultation and healing.

botica: Cuban herbal pharmacies.

boveda (E): "vault," water vessels that reveal the presence of the dead.

bruja/o: "sorcerer," "witch," "healer."

brujería: "sorcery," "witchcraft."

C

cabildos africanos: "African assemblies," mutual aid religious organizations in colonial Cuba.

cacique: Native American chief.

cartas españolas: "Spanish cards," archaic playing cards used in divination.

Changó (L): *orisha* of fire, thunder, lightning, royalty, and swift justice. See Alafin.

cofradia: brotherhood, organization throughout Latin America often used to evangelize non-European peoples.

collar de mazo: large necklace signifying initiation into *orisha* traditions.

comisión (E): "commission," a grouping of like spirits such as *indios* (Indians) or *gitanas* (Gypsies) See *linea* (line), *corte* (court).

Congo: originally an ethnonym referring to peoples of West Central Africa, expanded to refer to a pattern of rites.

corte (E): "court," a grouping of like spirits such as *indios* (Indians) or *gitanas* (Gypsies). See *linea* (line), *comisión* (commission).

costumbre: the "old inherited ways of knowing and doing," pre-Columbian traditions, especially among the Maya.

creole: born in the New World as opposed to Europe or Africa, suggestive of racial and cultural mixture.

curandera/o: "curer," "healer," in long-established traditions of healing and worship throughout Latin American, especially Mexico.

curanderismo: alternative healing and worship traditions of Latin America, especially Mexico.

D

derecho: literally "right," a fee paid for spiritual service.

despojo: literally "stripping," a spiritual cleansing rite.

diloggun (L): literally "sixteen," referring to 16 cowrie shells used in divination.

E

ebo (*ebbó*) (L): literally "work," an offering or sacrifice to the *orishas*.

Ékékó: indigenous Andean spirit of wealth.

Eleggua (Echú, Esu) (L): liminal trickster *orisha*.

elekes (L): protective, beaded necklaces dedicated to the *orishas*.

empacho: a "folk illness" characterized by stomach distress and depression.

enquisi (*nkisi*) (C): spiritual objects that can channel the powers of the dead.

envidia: "envy," thought capable of physical effects on its object.

Espiritismo: "Spiritism," European-derived tradition of contact with spirits, creolized in Latin America to include indigenous and African traditions.

espiritista: practitioner of Espiritismo, one who works with spirits.

ewe (L): "leaves," sacred herbs in Santería/Ocha.

ex voto (Latin): "from the vow," offering in fulfillment of a religious vow.

eyá aranla (L): "the rite of the room," singing and dancing phase of *bembé* drum ceremony.

F

Francisca (E): archetypal slave spirit of Espiritismo who dispenses wisdom and healing.

Francisco (E): male complement to Francisca.

fundamento: "fundamental," objects that contain, channel, or reveal the essential presence of the *orishas*.

G

Gagá: Dominican spiritual tradition.

garabato (L): hooked staff dedicated to Eleggua.

Guaicaipuro: Native Venezuelan resistance fighter and healer, head of the Indian court of spirits in the Venezuelan tradition Maria Lionza.

guerreros: "warriors," triad of hunter/warrior *orishas*: Eleggua, Ogun, and Ochosi.

H

hechicería: "sorcery," "witchcraft."

Hermano Macario Canizáles: Salvadoran folk hero and santo.

herramientas para santo: "tools for *santo*" work with the *orishas*.

High John the Conqueror: powerful protective and healing root in African American herbalism.

hoodoo: African American herbal, healing, and protective traditions.

I

Ifá (L): Yoruba divination system developed in Cuba and Brazil.

igbodu (L): shrine room containing the fundamental presence of the *orishas*.

ilé (L): "house," "community," congregation dedicated to the orishas.

iyawo (L): "bride," new initiate in Santería/Ocha.

J

Jesús Malverde: outlaw folk *santo* of Sinaloa, Mexico.

José Gregorio Hernández: saintly physician of Caracas, Venezuela.

L

letra: "sign" or pattern of meaning in Afro-Cuban divination.

limpieza: "cleansing," rites to remove negative influences.

linea (E): "line," a grouping of like spirits such as *indios* (Indians) or *gitanas* (Gypsies). See *comisión* (commission), *corte* ("court").

Lucumi (Lukumi): the language, culture, and religious traditions of the West African Yoruba peoples in Cuba.

lwa (loa): spirit of Haitian Vodou.

M

madrina: "godmother," priestess of Santería/Ocha who initiates her godchildren into the tradition.

Makengue (Tiembla Tierra) (C): Congo *mpungu* spirit, associated with wisdom.

mal de ojo: "evil eye," frequently diagnosed cause of misfortune stemming from an envious or malicious gaze of another.

Mam: "Grandfather," Mayan title of respect for Maximón/San Simón.

Maria Lionza: indigenous spirit of Venezuela, generalized as the name of a popular tradition of spirit invocation and healing.

Marie Laveau: New Orleans Voodoo "queen," herbalist, healer, and priestess.

mariwó (L): fringed palm fibers, hung as marker of sacred precincts.

mavi (*mabi mauby*): tree bark beverage associated with Indians in Espiritismo.

Maximón: ancestral Maya trickster spirit of wealth and transitions, identified with San Simón.

milagros: "miracles," tokens of vows, left at shrines.

misa espiritual (E): "spiritual mass," rite of invocation of deceased spirits.

mpungu (C): Congo powers, spiritual personalities.

muertos: "the dead," active in the lives of the living and invoked in rite.

N

Negro Felipe: African resistance fighter and magician, head of the "court" of African spirits in the Venezuelan tradition called Maria Lionza.

negros de nación: "Blacks of nation," term for Afro-Cubans born in Africa who identified as members of a particular African "nation" or ethnicity.

nfume (C): deceased spirit invoked in Cuban Palo.

nganga (C): spiritual power in objects and persons in Cuban Palo.

Niño de Atocha: Spanish devotion to the Christ child popular throughout Latin America.

Nsasi (Siete Rayos) (C): Congo *mpungu* spirit associated with lightning.

O

Obatalá (L): *orisha* of seniority, wisdom and rebirth.

obi (L): Afro-Cuban divination system using coconut pieces.

obra: "work," spiritual activity or offering.

Ocha/Santería: "Orisha," "Way of the Santos," generic name for Yoruba-derived religious practices in Cuba and its diaspora.

oché (*oshé*) (L): Changó's ritual ax.

Ochosi (L): warrior *orisha* of the hunt.

Ochún (L): regal *orisha* of cool water, beauty, and riches.

Ogun (Oggun) (L): warrior *orisha* of the forest and the forge.

omiero (L): "soft water," herbal-infused water used in Ocha ceremonies and healings.

orisha (*oricha*) (L): divinity/power venerated by Yoruba peoples in Africa and diaspora.

oro del igbodu (L): "cycle of the shrine": phase of the *bembé* drum ceremony where rhythms are played with *batá* drums without singing or dancing.

Orula (L): *orisha* of divination and wisdom.

Osain (L): *orisha* of sacred plants.

ounga (*houngan*): Haitian Vodou priest.

Oyá (L): *orisha* of storms, sovereign of the dead.

Oyo: imperial city of the Yoruba, center of empire from the fourteenth to the eighteenth century.

P

palera/o: one who works with the dead in the Congo-derived Cuban tradition of Palo.

palo (*palo mayombe*, *palo monte*): Afro-Cuban Congo-derived tradition of working with the dead.

Papa Candelo: Dominican spirit venerated in the tradition of 21 Division.

pataki (L): sacred narratives in Afro-Cuban divination.

Petro: category of creole *lwa* in Haitian Vodou.

potencia: "power," "potency," descriptive term for *orishas* or other spirits in Espiritismo.

prenda: literally "jewel," the vessel, usually a cauldron, containing the symbols that comprise the power of the dead in Palo.

promesa: "vow," "promise," basis of exchange in spirit veneration.

puro: literally "pure," the rough "homegrown" cigars preferred by San Simón.

R

Rada: category of African-derived *lwa* in Haitian Vodou.

Regla: harbor town of Havana under the patronage of Nuestra Señora de la Regla, "Our Lady of the Rule," a Franciscan devotion.

retablo: plaques left at shrines to commemorate miraculous healings, often in fulfillment of a *promesa*.

rompimiento: "breaking," cleansing ceremonies to "break" the power of a negative influence on a client.

S

San Antonio de Padua: popular thirteenth-century Catholic saint associated with lost articles and children.

San Benito el Moro: sixteenth-century Afro-Sicilian Catholic saint.

San Judas Taddeo: Catholic saint, companion of Jesus, patron of lost causes.

San Lázaro: Biblical figure venerated by the folk as the saint of the poor and healing, associated with the *orisha* Babalu Ayé.

San Simón: Guatemalan *santo* associated with transitions and wealth, identified with Maya divinity Maximón.

Santa Barbara: Catholic saint and virgin martyr of antiquity, associated with storms, firepower, and the military, corresponded to *orisha* Changó.

Santa Marta Dominadora (E): *santa* of water, serpents, and domination.

Santa Muerte: Mexican skeleton *santa*, personification of "holy death."

santera/o: one who works with *santos*, specifically one who "has" an orisha in the body and in the fundamental objects of the shrine, priest or priestess of Ocha/Santería.

Santería/Ocha: "Way of the Santos"/"Orisha," generic name for Yoruba-derived religious practices in Cuba and its diaspora.

santiguadora: spirit worker and healer in Puerto Rican *spiritist* traditions.

santo/a: "saint," "holy," spiritual power.

Sarabanda (Rompe Monte) (C): Congo *mpungu* spirit associated with iron.

serviteur: "servant," one who serves the spirits, specifically used in Haitian Vodou.

sopera: "tureen," pot that contains the fundamental symbols of an *orisha*.

T

Taino: Native Caribbean people.

Tonantzin: "Our Mother," generic title for Mexica goddesses.

trabajo: "work," "job," "spell," spiritual work performed to achieve a specific material purpose.

Tres Juanes: "The Three Juans," seventeenth-century witnesses to the miraculous appearance of the image of La Virgén de la Caridad del Cobre, Cuba.

Tres Potencias: devotion in the Venezuelan tradition of Maria Lionza consisting of the triad La Reina Maria Lionza, Guaicaipuro, and El Negro Filipe.

21 Division: Dominican spiritual tradition integrating *espiritismo* and Haitian Vodou.

V

Virgén de Guadalupe: Patroness of Mexico and the Americas recognized as the Virgin Mary by Catholics.

Virgén de la Caridad del Cobre: Patroness of Cuba recognized as the Virgin Mary by Catholics and as an avatar of the *orisha* Ochún by devotees of Santería/Ocha.

Voodoo (Vodou): In the double "o" spelling, a generic term for any African-influenced sorcery, more accurately a term used alternately with "Hoodoo" referencing African American herbalism; spelled "Vodou," the folk religion of Haiti.

Y

Yemayá: *orisha* of the seas, water, and maternity.

Yoruba: African people of present-day Nigeria, enslaved in large numbers in the eighteenth and nineteenth centuries, influential in the development of Latin American popular spiritualities.

Notes

Introduction

1. "La gente tiene fe, pero también necesitan poder ver su fe. Así que lo que ayuda no es el objeto, pero el objeto es necesario para 'ver' esa fe. Lo que hacemos aquí es proveer ese objeto." Interview conducted and translated by Tanya Olmos, research assistant extraordinaire.

Chapter 1

1. Rómulo Lachatañeré, "Los Jardines Botánicos en el Harlem," [1942], in *El Sistema Religioso de los Afrocubanos*, Havana: Editorial de Ciencias Sociales, 1992, p. 393. My translation.

2. Lachatañeré, "Los Jardines," p. 394. My translation with much help from Georgetown student researcher Anahi Cortada. For a thorough comparison of botánicas in the United States with equivalents in Cuba see José Antonio Lammoglia, "Botanicas: Presence in Miami, Absence in Cuba," M.A. thesis, Latin American and Caribbean Center, Florida International University, 2001.

3. Francis X. Clines, "About New York: Taking Stock of Some City Spirits," *New York Times*, September 11, 1979, p. B20.

4. Migene Gonzalez-Wippler, *Santería: The Religion*, St. Paul, MN: Llewellyn Publications, 1994, p. 283.

5. Gonzalez-Wippler, *Santería: The Religion*, p. 284. Cf. Carolyn Morrow Long, *Spiritual Merchants: Religion, Magic, and Commerce*, Knoxville: University of Tennessee Press, 2001, p. 169. There were herb stores in New York and Boston dating back to the nineteenth century called "botanical depots," which sold herbs with suggestive powers. One store in New York described itself as "the oldest and best known herb store," claiming to be founded in 1847. The proprietor, Dr. James A. Bass, a graduate of the Eclectic College of Surgery and Medicine, offered "an unusually large and exceptionally complete stock of vegetable remedies . . . having the aid of the most proficient Indian root and herb doctors in the world." See *History and Commerce of New York, 1891* (n.p.: Ulan Press, 2012 [1891]), 206.

6. Long, *Spiritual Merchants*, p. 140.

7. David J. Winslow, "Bishop E.E. Everett and Some Aspects of Occultism and Folk Religion in Negro Philadelphia," *Keystone Folklore Quarterly*, volume 14, number 2, 1969, pp. 59–80.

8. Winslow, "Bishop E.E. Everett," p. 62. Note the double entendre of "doorstep," for it is a prime site for an enemy to set hoodoo medicines for the unwary resident to step in and become "crossed." See two examples in Chapter 3.

9. Winslow, "Bishop E.E. Everett," p. 77.

10. Don Yoder, "Toward a Definition of Folk Religion," *Western Folklore*, Symposium on Folk Religion, volume 33, number 1, January 1974, pp. 2–15.

11. Robert Redfield, *The Little Community and Peasant Society and Culture*, Chicago: Phoenix Books, 1968 [1956].

12. E. R. Leach, editor, *Dialectic in Practical Religion*, Cambridge: Cambridge University Press, 1968.

13. See Lara Medina, "Altars and Shrines," in *Hispanic American Religious Cultures*, volume 1, edited by Miguel A. De La Torre, Santa Barbara, CA: ABC-CLIO, 2009, pp. 28–36.

14. Quoted in Rubén G. Rumbauit, "The Americans: Latin American and Caribbean Peoples in the United States," in *Americas: New Interpretive Essays*, edited by Alfred Stepan, New York: Oxford University Press, 1992, p. 279.

15. Rumbaut, "The Americans," pp. 276–277, 282.

16. http://palante.org/History.htm.

17. The two million figure is from http://www.topuertorico.org/people.shtml. On its website, the Pew Research Center says 4.4 million, http://pewhispanic.org/data/origins/, accessed 2009.

18. Angela Jorge speaks of two forms of espiritismo in Puerto Rico and Puerto Rican New York: espiritismo científico, which relies on European models and eschews contact with "less developed" creole spirits, and espiritismo practico, which embraces them. See Angela Jorge, "*La madama francesita*: A New World Black Spirit," in *Global Dimensions of the African Diaspora*, 2nd edition, edited by Joseph E. Harris, Washington, DC: Howard University Press, 1993, p. 211.

19. Silvia Pedraza, *Political Disaffection in Cuba's Revolution and Exodus*, New York: Cambridge University Press, 2007.

20. Maria de los Angeles Torres, *In the Land of Mirrors: Cuban Exile Politics in the United States*, Ann Arbor: University of Michigan Press, pp. 73ff.

21. Marta Moreno Vega, "The Yoruba Orisha Tradition Comes to New York City," *African American Review*, volume 29, number 2, Summer 1995, pp. 201–206; Steven Gregory, *Santería in New York City: A Study in Cultural Resistance*, New York: Garland, 1999.

22. Martha Ellen Davis, "Vodu of the Dominican Republic: Devotion to 'La Veintiuna Division,'" *Afro-Hispanic Review*, volume 26, number 1, Spring 2007, pp. 75–90. See also Margarite Fernández Olmos and Lizabeth Paravisini-Gebert, editors, *Sacred Possessions: Vodou, Santería, Obeah, and the Caribbean*, New Brunswick, NJ: Rutgers University Press, 1997; and Margarite Fernández Olmos and Lizabeth Paravisini-Gebert, eds., *Creole Religions of the Caribbean: An Introduction from Vodou and Santería to Obeah and Espiritismo*, New York: New York University Press, 2011.

23. Clayton cited in Long, *Spiritual Merchants*, p. 147.

24. http://www.feyvodou.com/index1.htm.

25. Felix Eme Unaeze and Richard E. Perrin, "Haitian Americans," *Countries and Their Cultures*, http://www.everyculture.com/multi/Du-Ha/Haitian-Americans.html. Total population figures from http://www.census.gov/prod/2010pubs/acsbr09-18.pdf

26. See Ray Stepick, Terry Stepick, and Alex Stepick, *Crossing the Water and Keeping the Faith: Haitian Religion in Miami*, New York: New York University Press, 2013, esp. pp. 118–130.

27. See R. Andrew Chestnut, *Devoted to Death: Santa Muerte, the Skeleton Saint*, New York: Oxford University Press, 2012.

28. Claudio Lomnitz Adler, *Death and the Idea of Mexico*, Brooklyn, NY: Zone Books, 1995, p. 43.

29. Figures for Guatemalan refugees from http://www.everyculture.com/multi/ Du-Ha/Guatemalan-Americans.html. Figures for Guatemalan Americans from Pew Research Center, http://pewhispanic.org/

30. Figures from http://www.everyculture.com/multi/Pa-Sp/Salvadoran-Ameri cans.html.

31. Vincent Stanzione, "Maximón," in *Encyclopedia of Religion*, edited by Lindsay Jones, Detroit: Macmillan Reference USA, 2005, pp. 5790–5792.

Chapter 2

1. See Lydia Cabrera, *El Monte*, Miami: Ediciones Universal, 1970; Morton Marks, "Exploring *El Monte*: Ethnobotany and the Afro-Cuban Science of the Concrete," in *En Torno a Lydia Cabrera*, edited by Isabel Castellanos and Josefina Inclán, Miami: Ediciones Universal, 1987; George Brandon, "The Uses of Plants in Healing in an Afro-Cuban Religion, Santería," *Journal of Black Studies*, volume 22, number 1, 1991, 55–76; Maria Oggun Gbemi, *Ritual Use of Plants in Lucumi Tradition*, Raleigh, NC: Lulu Press, n.d.

2. Alberto Gomez-Beloz and Noel Chavez, "The *Botánica* as a Culturally Appropriate Health Care Option for Latinos," *Journal of Alternative and Complementary Medicine*, volume 7, number 5, October 2001, p. 543a.

3. Brandon, "The Uses of Plants," pp. 70–73.

4. In a personal communication, a scholar of Yoruba religion, Mei Sanford, writes that "ero is anything (usually a substance, like water, or herbs, but also a force) that softens, ameliorates difficulty and opposition, and is the antidote to poison. It works silently without attracting attention to itself. Water is the epitome of ero. So omiero is the intensification of these qualities in water." September 8, 2012.

5. Maria Oggun Gbemi, *Ritual Uses of Plants in Lucumi Tradition*, Raleigh, NC: Lulu Press, n.d. [ca. 2008], p. 39.

6. Carolyn Morrow Long, *Spiritual Merchants: Religion, Magic, and Commerce*, Knoxville: University of Tennessee Press, 2001, p. 159ff.

7. The following is imprinted on the label of Orishas brand aerosol sprays: "This spray will create a pleasant peaceful atmosphere in your surroundings which should help you concentrate on your desires. No supernatural powers are claimed for this air freshener."

8. Arturo Gil, *Las Velas y Sus Poderes en La Obra Espiritual*, n.p.: 1987, pp. 28–29.

9. Gil, *Las Velas*, p. 20, my translation.

10. Gil, *Las Velas*, p. 62, my translation. The text actually invokes the orisha Yemayá, but I am almost certain that this is an error.

11. See Jim Pieper, *Guatemala's Folk Saints*, Los Angeles: Pieper and Associates, 2002.

12. Angelina Pollak-Eltz, "Imagination in the Creation of New Spiritual Cults in Latin America: The Cult of Maria Lionza," in *Imagination in Religion and Social Life*,

edited by George F. McLean and John K. White, Washington, DC: Council for Research in Values and Philosophy, 2003, pp. 79–88.

13. For beautiful examples, see Dana Salvo, *Home Altars of Mexico*, Albuquerque: University of New Mexico Press, 1997; or David H. Brown, *Santería Enthroned: Art, Ritual, and Innovation in an Afro-Cuban Religion*, Chicago: University of Chicago Press, 2003.

14. The Spanish text is somewhat different: "Santissima Virgen, aclamo a ti esta hora de necesidad come llamaron a tu intercesion. Los Tres Juanes cuando se vieron azotados por una tempestad en su frajil barca, protegeme como los protegiste a ellos y con tu infinita caridad y misericordia intecede por mi a nuestro Señor Jesu Cristo para que me conceda esta peticíon."

15. *Euphemism* is the mot juste for this perspective, used by Henry John Drewal in his "Art or Accident: Yoruba Body Artists and Their Deity, Ogun," in *Africa's Ogun: Old World and New*, 2nd edition, edited by Sandra T. Barnes, Bloomington: Indiana University Press, 1997, p. 231n.25

16. Church of Lukumi Babalu Aiye v. City of Hialeah 508 U.S. 20 (1993). See David M. O'Brien, *Animal Sacrifice and Religious Freedom: Church of Lukumi Babalu Aye v. City of Hialeah*, Landmark Law Cases and American Society, Lawrence: University Press of Kansas, 2004.

17. Website of Botanica La Madrina, http://botanicalamadrina.vpweb.com/HOME.html, accessed 12 November 2010.

Chapter 3

1. Most of the botánica owners I've interviewed have been reticent when talking about income. With a few exceptions, it's been my experience that retail sales are slow at most stores while consultations are in demand. Given that consultations can cost anywhere from twenty-five to seventy-five dollars and works to remedy problems much more, it seems likely that the majority of botánica income is from consultations and related spiritual work on behalf of the client. Melinda Hernandez, who owned Botánica San Francisco de Asis in Washington, D.C., told the *Washington Post* that 90 percent of her revenue came from readings and spiritual work, *Washington Post*, 19 July 2004.

2. A 2004 Henry J. Kaiser Family Foundation study documented that 43 percent of Latino adults in D.C. have no health insurance compared to 13 percent of the total population. While 78 percent of the white population receives regular care at a doctor's office or HMO and 54 percent of African Americans receive such care, only 25 percent of Latinos do. Aragón Blanton, Regina Blanton, and Marsha Lillie Blanton, *Uninsured and Underserved: The Health Care Experiences of Latinos in the Nation's Capital*, Menlo Park, CA: Henry J. Kaiser Family Foundation, 2004.

3. Newbell Niles Puckett, *The Folk Beliefs of the Southern Negro*, New York: Dover, 1969 [1926], pp. 277–278.

4. Interview translated by Georgetown student researcher Anahi Cortada.

5. Raquel Romberg, *Witchcraft and Welfare: Spiritual Capital and the Business of Magic in Modern Puerto Rico*, Austin: University of Texas Press, 2003, p. 139.

6. Migene Gonzalez-Wippler, *Rituals and Spells of Santería*, New York: Original Publications, 1984, p. 106.

7. Gonzalez-Wippler, *Rituals and Spells*, p. 91.

8. Church of Lukumi Babalu Aiye v. City of Hialeah 508 U.S. 20 (1993). See David M. O'Brien, *Animal Sacrifice and Religious Freedom: Church of Lukumi Babalu Aye v. City of Hialeah*, Lawrence: University Press of Kansas, 2004.

9. José Antonio Lammoglia, "Botanicas: Presence in Miami, Absence in Cuba," M.A. thesis, Latin American and Caribbean Center, Florida International University, 2001, p. 49.

10. I'm indebted to student researcher Erica Hanichek for sharing with me her investigation of controversies over animal ceremonies in South Florida. The ASPCA quote is from their website, http://www.aspca.org/about-us/policy-positions/animal-sacrifice.aspx.

11. Interview translated by Georgetown student researcher Anahi Cortada.

Chapter 4

1. Benjamin Keen, "Introduction: Approaches to Las Casas, 1535–1970," in *Bartolomé de las Casas in History: Toward an Understanding of the Man and his Work*, edited by Juan Friede and Benjamin Keen, DeKalb, IL: Northern Illinois University Press, 1971, pp. 3–63.

2. Bartolomé de las Casas, *The Devastation of the Indies: A Brief Account*, translated by Herma Briffault, Baltimore: Johns Hopkins University Press, 1992 [1552], p. 55.

3. Maximilian C. Forte, editor, *Indigenous Resurgence in the Contemporary Caribbean: Amerindian Survival and Revival*, New York: Peter Lang Publishing, 2006.

4. Antonio Benítez-Rojo, *The Repeating Island: The Caribbean and the Postmodern Perspective*, translated by James Maraniss, Durham, NC: Duke University Press, 1992; Terry Rey, *Our Lady of Class Struggle: The Cult of the Virgin Mary in Haiti*, Trenton, NJ: Africa World Press, 1999; Michele Annette Goldwasser, "The Rainbow Madonna of Trinidad: A Study in the Dynamics of Belief in Trinidanian Religious Life," Ph.D. dissertation, University of California at Los Angeles, 1996.

5. Levi Marrero, *Los esclavos y la Virgen del Cobre: Dos siglos de lucha por la libertad de Cuba*, Miami: Ediciones Universal, 1980.

6. Judith Bettelheim, "Caribbean Espiritismo (Spiritist) Altars: The Indian and the Congo," *The Art Bulletin*, volume 87, number 2, June 2005, pp. 312–330.

7. Brujo Luis, "Sanse! Santerismo! Puerto Rican Bujeria & Espiritismo!," http://sansespiritismo.blogspot.com, accessed 25 February 2012.

8. http://www.puntotarot.com/v2/?p=718, accessed 26 February 2012. My translation.

9. Jason Berry, *The Spirit of Black Hawk: A Mystery of Africans and Indians*, Jackson: University Press of Mississippi, 1995, p. 25.

10. Berry, *Spirit of Black Hawk*, p. 32.

11. Berry, *Spirit of Black Hawk*, p. 69.

12. Berry, *Spirit of Black Hawk*, p. 69.

13. Claude F. Jacobs and Andrew J. Kaslow, *The Spiritual Churches of New Orleans: Origins, Beliefs, and Rituals of an African-American Religion*, Knoxville: University of Tennessee Press, 1991, pp. 136–147.

14. Berry, *Spirit of Black Hawk*, p. 20.

15. Lawrence Clayton, "Bartolomé de las Casas and the African Slave Trade," *History Compass*, volume 7, issue 6, November 2009, pp. 1526–1541.

16. Philip D. Curtin, *The Atlantic Slave Trade: A Census*, Madison: University of Wisconsin Press, 1969.

17. On the famous Haitian "oath of Bois Caiman" that crystallized slave resistance, see Jean Price-Mars, *Thus Spoke the Uncle*, translated by Magdaline W. Shannon, Washington, DC: Three Continents Press, 1983 [1928], pp. 47–48. For Cuban freedom movements, see Miguel W. Ramos, "The Empire Beats On: Oyo Batá Drums and Hegemony in Nineteenth-Century Cuba," M.A. thesis, Florida International University, 2000; Philip A. Howard, *Changing History: Afro-Cuban Cabildos and Societies of Color in the Nineteenth Century*, Baton Rouge: Louisiana State University Press, 1998; Stephan Palmié, *Wizards and Scientists: Explorations in Afro-Cuban Modernity and Tradition*, Durham, NC: Duke University Press, 2002.

18. Manuel Moreno Fraginals, "Africa in Cuba: A Quantitative Analysis of the African Population in the Island of Cuba," in *Comparative Perspectives on Slavery in New World Plantation Societies*, edited by Vera Rubin and Arthur Tudin, New York: New York Academy of Sciences, 1977, p. 189.

19. Isabel Castellanos and Jorge Castellanos, "The Geographic, Ethnological and Linguistic Roots of Cuban Blacks," *Cuban Studies*, volume 17, 1987, pp. 95–110.

20. Lydia Cabrera, *Reglas de Congo*, Miami: Peninsular Printing, 1979, p. 60.

21. Esteban Montejo, *The Autobiography of a Runaway Slave*, edited by Miguel Barnet, translated from the Spanish by Jocasta Innes, New York: Pantheon Books, 1968, pp. 33–35; Miguel Barnet, *Biografía de un Cimarrón*, Barcelona: Ediciones Ariel, 1968, pp. 30–32. My translation relies on Innes's but reinstates some of the Congo and Lucumi terms that appeared in the original that the Innes version decided to translate.

22. Barnet, *Biografía*, pp. 24–25; Montejo, *Autobiography*, p. 26.

23. Robert Farris Thompson, *Faces of the Gods: Art and Altars of Africa and the African Americas*, New York: Museum for African Art, 1993, p. 62.

24. Lydia Cabrera, *El Monte*, Miami: Ediciones Universal, p. 131.

25. Bettelheim, "Caribbean Espiritismo," p. 327. Patrick Polk sees these images of enslaved congos as "constructions of blackness" deeply influenced historically by North American Spiritism and white attraction to and repulsion from Black others. See this provocative argument in Patrick Polk, "Black Folks at Home in the Spirit World," in *Activating the Past: History and Memory in the Black Atlantic World*, edited by Andrew Apter and Lauren Derby, Newcastle upon Tyne, UK: Cambridge Scholars Publishing, 2010, p. 399.

26. Angela Jorge, "*La madama francesita*: A New World Black Spirit," in *Global Dimensions of the African Diaspora*, 2nd edition, edited by Joseph E. Harris, Washington, DC: Howard University Press, 1993, pp. 206–207.

27. Jorge, "*La madama,*" p. 219.

28. Ysamur Flores-Peña, "'Candles, Flowers and Perfume': Puerto Rican Spiritism on the Move," in *Botánica Los Angeles: Latino Popular Religious Art in the City of Angels,* edited by Patrick Arthur Polk, Los Angeles: UCLA Fowler Museum, 2004, p. 93.

29. Brujo Luis, "Sanse! Santerismo!" In her in-depth study of espiritismo in an African American spiritual house in Chicago, Elizabeth Pérez shows the ways in which Caribbean images of Indians, enslaved Africans, and madamas work to embody African American ancestors. See Elizabeth Pérez, "Spiritist Mediumship as Historical Mediation: African-American Pasts, Black Ancestral Presence, and Afro-Cuban Religions," *Journal of Religion in Africa,* volume 41, fasc. 4, 2011, pp. 330–365.

30. Stephan Palmié, "*Wizards and Scientists,*" pp. 25, 27, 178. On the ideas of freedom and slavery in Afro-Atlantic religious traditions, see J. Lorand Matory, "Free to Be a Slave: Slavery as a Metaphor in the Afro-Atlantic Religions," in *Africas of the Americas: Beyond the Search for Origins in the Study of Afro-Atlantic Religions,* edited by Stephan Palmié, Boston: Brill, 2008, pp. 351–380.

31. The most famous of all Afro-Cuban cabildos, with roots likely stretching back at least to the beginning of the nineteenth century, was known alternately as Changó Teddun and Cabildo Santa Barbara. Cabrera, *El Monte,* p. 24; David H. Brown, *Santería Enthroned: Art, Ritual and Innovation in an Afro-Cuban Religion,* Chicago: University of Chicago Press, 2003, p. 70.

32. Lucumi praise poetry reconstructed and translated by John Mason, *Orin Òrì à: Songs for Selected Heads,* New York: Yoruba Theological Archministry, 1992. List adapted from Joseph Murphy, "Yoruba Religions in Diaspora," *Religion Compass,* volume 4, number 7, 2010, p. 403.

33. Mary Ann Clark, "Asho Orisha (Clothing of the Orisha): Material Culture as Religious Expression in Santería," Ph.D. dissertation, Rice University, 1999, p. 155.

34. Leonard Primiano writes of an "object-oriented subjective sacramentalism" in describing the role of images in what we are calling folk Catholicism. He says, "This idea of 'feeling' an image, of responding to it emotionally, is a way of articulating Catholic sensibility, i.e., the affective component of Catholic experience." Leonard Norman Primiano, "Postmodern Sites of Catholic Sacred Materiality," in *Perspectives on American Religion and Culture,* edited by Peter W. Williams, Malden, MA: Blackwell Publishing, 1999, pp. 197, 195. On American Catholic material culture see Colleen McDannell, *Material Christianity: Religion and Popular Culture in America,* New Haven, CT: Yale University Press, 1995, esp. pp. 18–24.

35. Peter Berger, *The Sacred Canopy: Elements of a Sociological Theory of Religion,* New York: Anchor Books, 1967.

36. Miguel W. Ramos, "Ashé in Flux: The Transformation of Lukumí Religion in the United States," paper presented at the 47th Annual Conference of the Center for Latin American Studies at the University of Florida, Gainesville, 1998; Stephan Palmié, "Against Syncretism: 'Africanizing' and 'Cubanizing' Discourses in North American Òrì à Worship," in *Counterworks: Managing the Diversity of Knowledge,* edited by Richard Fardon, New York: Routledge, 1995, pp. 73–104.

37. The Church of Lukumi Babalu Aye has been active in seeking recognition by

secular authorities for religious and counseling services. See http://www.church-of
-the-lukumi.org. I have been involved with the Federal Bureau of Prisons to work
out ways to accommodate practitioners of Santería/Ocha and other Afro-Caribbean
religions.

38. Frank Graziano, *Cultures of Devotion: Folk Saints of Spanish America*, Oxford:
Oxford University Press, 2007, p. 29.

39. Graziano, *Cultures*, p. 33.

40. Michael Taussig, *Shamanism, Colonialism, and the Wild Man: A Study in Terror
and Healing*, Chicago: University of Chicago Press, 1986, p. 281.

41. James H. Creechan and Jorge de la Herrán Garcia, "Without God or Law: Nar-
coculture and Belief in Jesús Malverde," *Religious Studies and Theology*, volume 24,
number 2, 2005, pp. 7–8.

42. State of Oregon v. Ramona E. de la Rosa, Court of Appeals of the State of Or-
egon, May 27, 2009, http://www.publications.ojd.state.or.us/Publications/A133793.
htm.

43. Stephen Benko, *The Virgin Goddess: Studies in the Pagan and Christian Roots of
Mariology*, Leiden, The Netherlands: E.J. Brill, 1993; Lucia Chiavola Birnbaum, *Black
Madonnas: Feminism, Religion, and Politics in Italy*, Boston: Northeastern University
Press, 1993.

44. Luis Lasso de la Vega, "Our Lady of Guadalupe" [1649], translated by Harriet
de Onis, in *Religion in Latin America: A Documentary History*, edited by Lee M. Penyak
and Walter J. Petry, Maryknoll, NY: Orbis Books, 2006, 96–97.

45. Ana Castillo, "Introduction," in *Goddess of the Americas: Writings on the Virgen
of Guadalupe*, edited by Ana Castillo, New York: Riverhead Books, 1996, pp. xv–xvi.

46. Marcela Hede's Hispanic culture website proclaims, "The most beautiful as-
pect of the Virgin de Guadalupe is that she is mestiza," http://www.hispanic-culture
-online.com/virgin-de-guadalupe.html, accessed March 10, 2012.

47. http://www.vatican.va/holy_father/benedict_xvi/letters/2006/documents/
hf_ben-xvi_let_20060902_xx-incontro-assisi_en.html, accessed 10 March 2012.

48. Charles Stewart and Rosalind Shaw, eds., *Syncretism/Antisyncretism: The Poli-
tics of Religious Synthesis*, London: Routledge, 1994.

49. Robert Baird, *Category Formation in the History of Religions*, The Hague, The
Netherlands: Mouton, 1971.

50. Leslie G. Desmangles, *The Faces of the Gods: Vodou and Roman Catholicism in
Haiti*, Chapel Hill: University of North Carolina Press, 1992, p. 8.

51. Homi Bhabha, *The Location of Culture*. London: Routledge, 1994, pp. 4, 112, 114.

52. Sylvain quoted and translated in Philip Baker and Peter Mühlhaüsler, "Creole
Linguistics from Its Beginnings, through Schuchardt to the Present Day," in *Creoliza-
tion: History, Ethnography, Theory*, edited by Charles Stewart, Walnut Creek, CA: Left
Coast Press, 2007, p. 94.

53. Stewart and Shaw, *Syncretism/Antisyncretism*, p. 7.

54. Raquel Romberg, *Witchcraft and Welfare: Spiritual Capital and the Business of
Magic in Modern Puerto Rico*, Austin: University of Texas Press, 2003, pp. 6, 44.

Chapter 5

1. Eleggua is the creole Cuban name for the Yoruba deity known as Eshu Elegbara, whose names are translated by Robert Farris Thompson as Eshu "the childless wanderer, alone, moving only a spirit," and Elegbara "owner-of-the-power." Thompson, *Flash of the Spirit: African and Afro-American Art and Philosophy*, New York: Random House, 1983, p. 19. People at the botánica seem to use Eleggua and Echú interchangeably, though some reserve Echú for the deity in his more vengeful aspect.

2. Oba Ecun, *Echu Elegbara*, Key Largo, FL: ObaEcun Books, 2003, p. 15.

3. Judith Gleason, editor and translator, *Leaf and Bone*, New York: Viking Press, 1980, p. 163.

4. Ulli Beier, *Yoruba Myths*, Cambridge: Cambridge University Press, 1980, pp. 55–56; Mercedes Cros Sandoval, *La Religión Afrocubana*, Madrid: Playor, 1975, p. 170; Donald Cosentino, "Who Is That Fellow in the Many-Colored Cap? Transformations of Eshu in Old and New World Mythologies," *Journal of American Folklore*, volume 100, number 397, July–September 1987. Some sources say the hat is white and black, also a prominent color pair in Eleggua's array.

5. Victor Turner, "Betwixt and Between: The Liminal Period in *Rites de Passage*," in *The Forest of Symbols: Apects of Ndembu Ritual*, by Victor Turner, Ithaca, NY: Cornell University Press, 1967: 97.

6. John Mason, *Who's That Knocking on my Floor?*, Brooklyn, NY: Yoruba Theological Archministry, 2003, pp. vii, 5.

7. Giovanna Fiume, "St. Benedict the Moor: From Sicily to the New World," in *Saints and Their Cults in the Atlantic World*, edited by Margaret Cormack, Columbia, SC: University of South Carolina Press, 2007, pp. 16–51.

8. http://www.therealpresence.org/eucharst/mir/st_anthony.htm; http://www.stanthony.org/aboutanthony/history.asp#QS1.

9. Story from http://www.ninoatocha.com/history.html. It's interesting that two of the Christian correspondents to Eleggua involve statues of adult saints with a detachable, independent Christ child. The moral problems associated with Jesus as a divine child go back to the roots of Christianity. The second-century Infancy Gospel of Thomas tells stories of Jesus as a little boy who possesses supernatural powers but lacks the moral maturity to use them properly. In one remarkable passage, the child Jesus strikes dead a Nazareth boy who had been bullying him. Only after a reprimand from his father, Joseph, does Jesus recognize his error and restore the boy to life. See David R. Cartlidge and David L. Dungan, editors and translators, *Documents for the Study of the Gospels*, Minneapolis: Fortress Press, 1994, pp. 86–90.

10. Thompson, *Flash of the Spirit*, p. 28.

11. Pierre Verger, *Notes sur le culte des Orisa et Vodun*, Dakar, Senegal: L'Institut Français d'Afrique Noire, 1959, p. 136.

12. Oba Ecun, *Echu Elegbara*, pp. 45–47.

13. Maria Oggun Gbemi, *Ritual Use of Plants in Lucumi Tradition*, Raleigh, NC: Lulu Press, n.d. [ca. 2008], pp. 61–62.

14. Yoruba historian Samuel Johnson, writing at the end of the nineteenth century, considers Changó a "mythological" rather than an "historical" king. See his *The*

History of the Yorubas: From the Earliest Times to the Beginning of the British Protectorate, Lagos, Nigeria: C.M.S. Bookshops, 1921 [1897], pp. 143–155.

15. This story is taken from Johnson, *History of the Yorubas*, pp. 150–152. See also E. Bolaji Idowu, *Olodumare: God in Yoruba Belief*, London: Longmans, 1962, pp. 89–95. For a refutation of the hanging story, see Akinwumi Isola, "Religious Politics and the Myth of Sango," in *African Traditional Religions in African Society*, edited by Jacob K. Olupona, New York: Paragon House, 1991, pp. 93–99.

16. Translated by Judith Gleason and published in *Leaf and Bone*, New York: Viking, 1980, p. 165.

17. David Brown personal communication. See his *Santería Enthroned: Art, Ritual and Innovation in an Afro-Cuban Religion*, Chicago: University of Chicago Press, 2003, pp. 192ff.

18. Miguel Ramos, "The Empire Beats On: Oyo Batá Drums and Hegemony in Nineteenth-Century Cuba," M.A. thesis, Florida International University, 2000, pp. 95–97.

19. J. P. Kirsch, "St. Barbara," in *The Catholic Encyclopedia*, vol. 2, New York: Robert Appleton Company, 1907, http://www.newadvent.org/cathen/02284d.htm, accessed 25 April 2014).

20. I describe this ceremony in some detail from the point of view of batá drumming in "'*Changó 'ta 'veni*'/Changó Has Come: Spiritual Embodiment in the Afro-Cuban Ceremony *Bembé*," *Black Music Research Journal*, volume 32, number 1, Spring 2012, pp. 69–94.

21. Thomas Altmann, *Cantos Lucumí a los Orichas*, 3rd edition, Brooklyn, NY: DESCARGA, 1998, p. 15.

22. Lydia Cabrera, *Anago: Vocabulario Lucumi*, Miami: Ediciones Universal, 1970, pp. 146–147.

23. Personal communication from David Font, June 2005.

24. Robert S. Carlsen, "Meso-American Religions: Contemporary Cultures," in *Encyclopedia of Religion*, Lindsay Jones, editor in chief, Detroit: Macmillan Reference USA, 2005, p. 5925.

25. Carlson, "Meso-American Religions," pp. 5925–5926.

26. Jim Pieper, *Guatemala's Folk Saints*, Los Angeles: Pieper and Associates, p. 19.

27. Apolinario Chile Pixtun in Pieper, *Guatemala's Folk Saints*, p. 54.

28. Apolinario Chile Pixtun in Pieper, *Guatemala's Folk Saints*, pp. 55–56.

29. Robert S. Carlsen, with Martín Prechtel, *The War for the Heart and Soul of a Highland Maya Town*, Austin: University of Texas Press, 1997, esp. pp. 152–157. Carlsen offers a rich and moving description of this rite as well as an engaged account of the religious and political life of this Guatemalan town.

30. Peter Canby, *The Heart of the Sky*, New York: HarperCollins, 1992, p. 317.

31. http://mayabaktun.com/lajMam_eng.html, accessed June 2008.

32. Pieper, *Guatemala's Folk Saints*, p. 61.

33. Pieper, *Guatemala's Folk Saints*, p. 29.

34. Otto Chicas Rendon and Hector Gaitan Alfaro, *The Maximón Deity: Indigenous Santería in Guatemala*, New York: Ebano Editions, 2003, pp. 7, 8–9.

35. Chicas, *Guatemala's Folk Saints*, pp. 9, 10, 11.

36. Chicas, *Guatemala's Folk Saints*, pp. 43–44.

37. Patrick Polk and Michael Owen Jones, "Hermano Carlos and San Simón," in *Botánica Los Angeles: Latino Popular Religious Art in the City of the Angels*, Los Angeles: UCLA Fowler Museum of Cultural History, 2004, pp. 108–129.

38. Polk and Jones, "Hermano Carlos," p. 115.

39. Quoted in Pieper, *Guatemala's Folk Saints*, p. 15.

40. Las Mañanitas text and translation from http://gomexico.about.com/od/historyculture/qt/mananitas.htm.

41. Transcribed and translated by José Madrid.

42. Maya Deren, *Divine Horsemen: The Living Gods of Haiti*, New Paltz, NY: McPherson and Company, 1983 [1953], p. 60.

43. Leslie G. Desmangles, *The Faces of the Gods: Vodou and Roman Catholicism in Haiti*, Chapel Hill: University of North Carolina Press, 1992, pp. 131–144; Harold Courlander, *The Drum and the Hoe: Life and Lore of the Haitian People*, Berkeley: University of California Press, 1985 [1960], pp. 26–27.

44. Robert S. Smith, *Kingdoms of the Yoruba*, 3rd edition, Madison: University of Wisconsin Press, 1988 [1969], p. 37; Andrew Apter, *Black Critics and Kings: The Hermeneutics of Power in Yoruba Society*, Chicago: University of Chicago Press, 1992, p. 25; J. Loran Matory, *Sex and the Empire That Is No More: Gender and the Politics of Metaphor in Oyo Yoruba Religion*, Minneapolis: University of Minnesota Press, 1994, p. 9.

45. Vincent Stanzione, "Maximón," in *Encyclopedia of Religion*, Lindsay Jones, editor in chief, Detroit: Macmillan Reference USA, 2005, p. 5792.

46. See Frank F. Sherer, *Sanfancón: Orientalism, Confucianism, and the Construction of Chineseness in Cuba, 1847– 1997*, Toronto: Centre for Research on Latin America and the Caribbean, 1998, p. 9b. I'm indebted to colleague Erin Cline for unpacking the Confucian heritage of Sanfancón.

Chapter 6

1. Sharon R. Ennis, Merarys Ríos-Vargas, and Nora G. Albert, "The Hispanic Population: 2010," *2010 Census Briefs*, May 2011, http://www.census.gov/prod/cen2010/briefs/c2010br-04.pdf. See also http://www.census.gov/population/www/socdemo/hispanic/files/Internet_Hispanic_in_US_2006.pdf.

2. Rómulo Lachatañeré, "Los Jardines Botánicos en el Harlem," in *El Sistema Religioso de los Afrocubanos*, by Rómulo Lachatañeré, Havana: Editorial de Ciencias Sociales, 1992 [1942], p. 393.

3. A 2012 Pew poll shows that 51 percent of people whose families are of Latin American origin identify themselves with that country, while 24 percent prefer a pan-ethnic label. Of these, 33 percent preferred "Hispanic," while 14 percent identify themselves as "Latino," http://www.pewhispanic.org/2012/04/04/when-labels-dont-fit-hispanics-and-their-views-of-identity/.

4. Joseph M. Murphy, *Santería: African Spirits in America*, Boston: Beacon Press, 1992, p. 83.

5. Using the phrase *white American* here brings up for me what I imagine is a simi-

lar and likely more justified irritation that "Latinos" may feel when they are labeled by others. I remember reacting impatiently when a Mexican American friend called me an "Anglo." I snapped back in broken Spanish: "¡No soy un 'Anglo,' soy un celto!" (I'm not an 'Anglo,' I'm a Celt!)

6. Mary Ann Borrello and Elizabeth Mathias, "Botánicas: Puerto Rican Folk Pharmacies," *Natural History*, volume 86, number 7, 1977, pp. 71–72.

7. Andreana L. Ososki et al., "Ethnobotanical Literature Survey of Medicinal Plants in the Dominican Republic Used for Women's Health Conditions," *Journal of Ethnopharmacology*, volume 79, 2002, pp. 285–298.

8. Melvin Delgado and Jorge Santiago, "HIV/AIDS in a Puerto Rican/Dominican Community: A Collaborative Project with a Botanical Shop," *Social Work*, volume 43, number 2, March 1998, pp. 183–186.

9. Jillian De Gezelle, *Traditional Caribbean Healing in Queens*, New York: Queens Botanical Garden with the support of the J. M. Kaplan Fund, ca. 2004, pp. 4–5; Michael J. Balick et al., "Medicinal Plants Used by Latino Healers for Women's Health Conditions in New York City," *Economic Botany*, volume 54, number 3, July–September 2000, p. 351.

10. Balick et al., "Medicinal Plants," pp. 350–351.

11. Rubén Bernal, "Health Practices among Immigrants to the US: The Intersection of Cosmopolitan Medicine and Traditional Ethnopharmacology," Honors thesis, University of North Texas, 2010, p. 9, http://web3.unt.edu/honors/eagle feather/2010/health-practices-among-immigrants-to-the-usthe-intersection-of -cosmopolitan-medicine-and-traditional-ethnopharmacology.

12. Michael Owen Jones and Patrick A. Polk, with Ysamur Flores-Peña and Robert J. Evanchuck, "Invisible Hospitals: Botánicas in Ethnic Health Care," in *Healing Logics: Culture and Medicine in Modern Health Belief Systems*, edited by Erika Brady, Logan: Utah State University Press, pp. 39–87.

13. Michael Taussig, *Shamanism, Colonialism, and the Wild Man: A Study in Terror and Healing*, Chicago: University of Chicago Press, 1986, p. 447.

14. Joan D. Koss-Chioino, "Spirit Healing, Mental Health, and Emotion Regulation," *Zygon*, volume 40, number 2, June 2005, p. 419.

15. Stanley Fisch, "Botanicas and Spiritualism in a Metropolis," *Milbank Memorial Fund Quarterly*, volume 46, number 3, part 1, July 1968, p. 381.

16. Lee M. Pachter, "Culture and Clinical Care: Folk Illness Beliefs and Behaviors and Their Implications for Health Care Delivery," *Journal of the American Medical Association*, volume 271, number 9, March 2, 1994, p. 692.

17. Pachter, "Culture and Clinical Care," p. 692.

18. See Alan Harwood, *Rx: Spiritist as Needed—A Study of a Puerto Rican Community Health Resource*, New York, Wiley, 1977; Vivian Garrison, "Doctor, Espiritista, or Psychiatrist?: Health-Seeking Behavior in a Puerto Rican Neighborhood," *Medical Anthropology*, volume 1, number 2, 1977, pp. 65–191.

19. Sam Tsemberis and Ana Stefancic, "The Role of an Espiritista in the Treatment of a Homeless, Mentally Ill Hispanic Man," *Psychiatric Services*, volume 51, number 12, 2000, pp. 1572–1574.

20. Melvin Delgado and Jorge Santiago, "HIV/AIDS in a Puerto Rican/Dominican Community: A Collaborative Project with a Botanical Shop," *Social Work*, volume 43, number 2, March 1998, pp. 183–186.

21. Anahí Viladrich, "Beyond the Supernatural: Latino Healers Treating Latino Immigrants in NYC," *Journal of Latino-Latin American Studies*, volume 2, number 1, Spring 2006, pp. 134–148; and Anahí Viladrich, "Botánicas in America's Backyard: Uncovering the World of Latino Healers' Herb-Healing Practices in New York City," *Human Organization*, volume 65, number 4, Winter 2006, pp. 407–419.

22. Viladrich, "Beyond the Supernatural," p. 143.

23. Alfredo Gomez-Beloz and Noel Chavez, "The *Botánica* as a Culturally Appropriate Health Care Option for Latinos," *Journal of Alternative and Complementary Medicine*, volume 7, number 5, October 2001, pp. 537–546.

24. Gomez-Beloz and Chavez, "The *Botánica*," p. 544, 543.

25. Fisch, "Botanicas and Spiritualism," p. 380.

26. Robert A. Scott, *Miracle Cures: Saints, Pilgrimage, and the Healing Powers of Belief*, Berkeley: University of California Press, 2010, p. 129.

27. Pachter, "Culture and Clinical Care," p. 690.

28. Luis H. Zayas and Philip O. Ozuah, "Mercury Use in Espiritismo: A Survey of Botanicas," *American Journal of Public Health*, volume 86, number 1, January 1996, p. 111.

29. C. Alison Newby, Donna Riley, and Tomas Leal-Almeraz, "Mercury Use and Exposure among Santeria Practitioners: Religious versus Folk Practice in Northern New Jersey, USA," *Ethnicity and Health*, volume 11, number 3, August 2006, p. 300.

30. Newby, Riley, and Leal-Almeraz, "Mercury Use and Exposure," p. 289.

31. Zayas and Ozuah, "Mercury Use in Espiritismo," pp. 111–112.

32. Robert A. Orsi, *Thank You, St. Jude: Women's Devotion to the Patron Saint of Hopeless Causes*, New Haven, CT: Yale University Press, 1996.

33. Orsi, *Thank You, Saint Jude*, p. 190.

34. Hans A. Baer, Merrill Singer, and Ida Susser, *Medical Anthropology and the World System*, Westport, CT: Bergin and Garvey, 1997, p. 215.

35. Orsi, *Thank You, Saint Jude*, p. 205.

36. Susanna Rostas and André Droogers, "The Popular Use of Popular Religion in Latin America: Introduction," in *The Popular Use of Popular Religion in Latin America*, edited by Susanna Rostas and André Droogers, Amsterdam: CEDLA, 1993, p. 5.

37. James G. Frazer, *The Golden Bough: A Study of Magic and Religion*, abridged edition, New York: Macmillan, 1924.

38. Frazer, *Golden Bough*, p. 49.

39. Arturo Gil, *Las Velas y Sus Poderes en La Obra Espiritual*, n.p.: 1987, p. 62. My translation. As noted earlier, the text actually invokes the orisha Yemayá, but I am almost certain that this is an error.

40. Richard Dawkins, *River Out of Eden*, New York: Basic Books, 1995, p. 33.

41. Victor J. Stenger, *God: The Failed Hypothesis—How Science Shows That God Does Not Exist*, Amherst, NY: Prometheus Books, 2007.

42. Bronislaw Malinowski, *Magic, Science and Religion and Other Essays*. Garden City, NY: Doubleday, 1954 [1925].

43. Emile Durkheim, *The Elementary Forms of the Religious Life*, translated by Joseph Ward Swain, New York: The Free Press, 1965 [1912], p. 60.

44. Maya Deren, *Divine Horsemen: The Living Gods of Haiti*, New Paltz, NY: McPherson and Company, 1983 [1953], p. 76.

45. Kelly E. Hayes, "Macumba Has Invaded All Spheres: Africanity, Black Magic, and the Study of Afro-Brazilian Religions," in *The African Diaspora and the Study of Religion*, edited by Theodore Louis Trost, New York: Palgrave/Macmillan, 2007, p. 177.

46. Hayes, "Macumba," pp. 184, 185.

47. Durkheim, *Elementary Forms*, p. 29,

48. Durkheim, *Elementary Forms*, pp. 31–32, 22.

49. Durkheim, *Elementary Forms*, p. 257.

50. Durkheim, *Elementary Forms*, p. 257.

51. Durkheim, *Elementary Forms*, p. 260.

52. Raquel Romberg, *Healing Dramas: Divination and Magic in Modern Puerto Rico*, Austin: University of Texas Press, 2009, p. 8.

53. Durkheim, *Elementary Forms*, pp. 263–264.

54. For a critical review of the anthropological study of magic, see Stephan Palmié, "Other Powers: Tylor's Principle, Father Williams's Temptations, and the Power of Banality," in *Sorcery in the Black Atlantic*, edited by Luis Nicolau Pares and Roger Sansi, Chicago: University of Chicago Press, 2011, pp. 316–340.

55. Romberg, *Healing Dramas*, p. 243.

56. Romberg, *Healing Dramas*, p. 5.

57. Peter Geschiere, "Witchcraft and Modernity: Perspectives from Africa and Beyond," in *Sorcery in the Black Atlantic*, edited by Luis Nicolau Parés and Roger Sansi, Chicago: University of Chicago Press, 2011, pp. 238, 235.

58. Romberg, *Healing Dramas*, p. 159.

59. Frazer, *Golden Bough*, p. 50.

60. Jonathan Z. Smith, "Religion, Religions, Religious," in *Critical Terms for Religious Studies*, edited by Mark C. Taylor, Chicago: University of Chicago Press, 1998, p. 281.

61. Melford E. Spiro, "Religion: Problems of Definition and Explanation," in *Anthropological Approaches to the Study of Religion*, edited by Michael Banton, London: Tavistock 1966, p. 96, cited in Smith "Religion, Religions, Religious," p. 281.

62. Durkheim, *Elementary Forms*, p. 56.

63. Mircea Eliade, *The Sacred and the Profane: The Nature of Religion*, translated by Willard R. Trask, New York: Harper and Row, 1959, p. 63.

64. Victor Turner, "Betwixt and Between: The Liminal Period in *Rites de Passage*," in *The Forest of Symbols: Aspects of Ndembu Ritual*, by Victor Turner, Ithaca, NY: Cornell University Press, 1967, p. 93.

65. Turner, "Betwixt and Between," p. 106.

66. Eliade, *Sacred and the Profane*, p. 63.

67. Romberg, *Healing Dramas*, p. 11.

68. Romberg, *Healing Dramas*, p. 112.

69. Frank Graziano, *Cultures of Devotion: Folk Saints of Spanish America*, Oxford: Oxford University Press, 2007, p. 33.

70. Romberg, *Healing Dramas*, pp. 32, 34.

71. Andrew Apter, "Herskovits's Heritage: Rethinking Syncretism in the African Diaspora," *Diaspora*, volume 1, number 3, 1991, p. 254.

72. Mircea Eliade, *Patterns in Comparative Religion*, translated by Rosemary Sheed, New York: Sheed and Ward, 1958.

73. See Ysamur Flores-Peña and Roberta J. Evanchuck, *Santería Altars and Garments: Speaking without a Voice*, Jackson: University Press of Mississippi, 1994.

74. Katherine Dunham, *Island Possessed*, New York: Doubleday, 1969, p. 92.

75. Documents of Vatican II *Lumen Gentium*, article 51, 1964, http://www.vatican .va/archive/hist_councils/ii_vatican_council/documents/vat-ii_const_19641121_lu men-gentium_en.html.

76. The gospels portray the party of the Pharasees unfavorably as opponents of Jesus's liberating message. This first-century rhetorical device lives on in the invidious characterization of Judaism as a religion of law and Christianity as one of love.

77. Documents of Vatican II *Lumen Gentium*, article 51. *Latreutic* refers to *latria*, the worship due God alone. It is often distinguished from *dulia*, veneration, which is appropriate to the Virgin and the saints.

78. *The Bhagavad Gita: The Song of God*, translated by Swami Prabhavananda and Christopher Isherwood, New York: Signet Classics, 2002 [1944], p. 98.

79. *Bhagavad Gita*, p. 83.

80. Allan Kardec, *The Spirit's Book*, Sao Paulo, Brazil: Livraria Allan Kardec Editora, n.d. See, too, Rosa Parrilla's reworking of Kardec's prayer book: *A Collection of Prayers for the Modern Spiritist*, Raleigh, NC: Lulu Press, 2008.

81. Kardec, *Spirit's Book*, p. 101.

82. Jamgön Kongtrul, *Creation and Completion: Essential Points of Tantric Meditation*, translated and introduced by Sarah Harding, Boston: Wisdom Publications, 2002. My thanks to colleague and scholar of Tibetan Buddhism, Benjamin Bogin, for showing me this text.

83. Harding, in the introduction to Kongtrul, *Creation and Completion*, p. 9.

84. Orsi, *Thank You, Saint Jude*, pp. 206, 207, 210, 211.

Epilogue

1. Margarite Fernández Olmos, "*La Botánica Cultural*: Ars Medica, Ars Poetica," in *Healing Cultures: Art and Religion as Curative Practices in the Caribbean and Its Diaspora*, edited by Margarite Fernándes Olmos and Lizabeth Pravisini-Gebert, New York: Palgrave/St. Martin's Press, 2001, p. 1.

2. Kirk Semple, "At a Botanica, New Year Means Renewal, and Jinx Removal," *New York Times*, January 4, 2010, quoted at the Original Products website, http://www .originalbotanica.com/store-history-a-123.html.

3. http://artesaniayoruba.com.

4. Margarite Fernández Olmos and Lizabeth Paravisini-Gebert, *Creole Religions of the Caribbean: An Introduction from Vodou and Santería to Obeah and Espiritismo*, New York: New York University Press, 2011, p. 4.

References

Altmann, Thomas. *Cantos Lucumí a los Orichas*. 3rd revised edition. Brooklyn, New York: DESCARGA, 1998.

Apter, Andrew. *Black Critics and Kings: The Hermeneutics of Power in Yoruba Society*. Chicago: University of Chicago Press, 1992.

———. "Herskovits's Heritage: Rethinking Syncretism in the African Diaspora." *Diaspora*, volume 1, number 3, 1991, pp. 235–260.

Baer, Hans A., Merrill Singer, and Ida Susser. *Medical Anthropology and the World System*. Westport, CT: Bergin and Garvey, 1997.

Baird, Robert. *Category Formation in the History of Religions*. The Hague, The Netherlands: Mouton, 1971.

Baker, Philip, and Peter Mühlhaüsler. "Creole Linguistics from Its Beginnings, through Schuchardt to the Present Day." In *Creolization: History, Ethnography, Theory*. Edited by Charles Stewart. Walnut Creek, CA: Left Coast Press, 2007, pp. 84–107.

Balick, Michael J., et al. "Medicinal Plants Used by Latino Healers for Women's Health Conditions in New York City." *Economic Botany*, volume 54, number 3, July–September 2000, pp. 344–357.

Barnet, Miguel. *Biografía de un Cimarrón*. Barcelona: Ediciones Ariel, 1968.

Beier, Ulli. *Yoruba Myths*. Cambridge: Cambridge University Press, 1980.

Benítez-Rojo, Antonio. *The Repeating Island: The Caribbean and the Postmodern Perspective*. Translated by James Maraniss. Durham, NC: Duke University Press, 1992.

Benko, Stephen. *The Virgin Goddess: Studies in the Pagan and Christian Roots of Mariology*. Leiden, The Netherlands: E.J. Brill, 1993.

Berger, Peter. *The Sacred Canopy: Elements of a Sociological Theory of Religion*. New York: Anchor Books, 1967.

Bernal, Rubén. "Health Practices among Immigrants to the US: The Intersection of Cosmopolitan Medicine and Traditional Ethnopharmacology." Honors thesis, University of North Texas, 2010. http://web3.unt.edu/honors/eaglefeather/2010/health-practices-among-immigrants-to-the-usthe-intersection-of-cosmopolitan-medicine-and-traditional-ethnopharmacology.

Bettelheim, Judith. "Caribbean Espiritismo (Spiritist) Altars: The Indian and the Congo." *Art Bulletin*, volume 87, number 2, June 2005, pp. 312–330.

Bhabha, Homi. *The Location of Culture*. London: Routledge, 1994.

The Bhagavad Gita: The Song of God. Translated by Swami Prabhavananda and Christopher Isherwood. New York: Signet Classics, 2002 [1944].

Birnbaum, Lucia Chiavola. *Black Madonnas: Feminism, Religion, and Politics in Italy*. Boston: Northeastern University Press, 1993.

Borrello, Mary Ann, and Elizabeth Mathias. "Botanicas: Puerto Rican Folk Pharmacies." *Natural History*, volume 86, number 7, 1977, pp. 62–72, 116–117.

Brandon, George. "The Uses of Plants in Healing in an Afro-Cuban Religion, Santería." *Journal of Black Studies*, volume 22, number 1, September 1991, pp. 55–76.

Brown, David H. *Santería Enthroned: Art, Ritual and Innovation in an Afro-Cuban Religion*. Chicago: University of Chicago Press, 2003.

Brujo Luis. "Sanse! Santerismo! Puerto Rican Bujeria & Espiritismo!" http://sans espiritismo.blogspot.com. Accessed February 25, 2012.

Cabrera, Lydia. *Anagó: Vocabulario Lucumi*. Miami: Ediciones Universal, 1970.

———. *El Monte*. Miami: Ediciones Universal, 1970.

———. *Reglas de Congo*. Miami: Peninsular Printing, 1979.

Canby, Peter. *The Heart of the Sky*. New York: HarperCollins, 1992.

Carlsen, Robert S., with Martín Prechtel. *The War for the Heart and Soul of a Highland Maya Town*. Austin: University of Texas Press, 1997.

Carlsen, Robert S. "Meso-American Religions: Contemporary Cultures." In *Encyclopedia of Religion*. Lindsay Jones, editor in chief. Detroit: Macmillan Reference USA, 2005 pp. 5923–5933.

Cartlidge, David R., and David L. Dungan, editors and translators. *Documents for the Study of the Gospels*. Minneapolis: Fortress Press, 1994.

Castellanos, Isabel, and Jorge Castellanos. "The Geographic, Ethnological and Linguistic Roots of Cuban Blacks." *Cuban Studies*, volume 17, 1987, pp. 95–110.

Castillo, Ana. "Introduction." In *Goddess of the Americas: Writings on the Virgen of Guadalupe*. Edited by Ana Castillo. New York: Riverhead Books, 1996, pp. xv–xxiii.

Chestnut, R. Andrew. *Devoted to Death: Santa Muerte, the Skeleton Saint*. New York: Oxford University Press, 2012.

Chicas Rendon, Otto, and Hector Gaitan Alfaro. *The Maximón Deity: Indigenous Santería in Guatemala*. New York: Ebano Editions, 2003.

Clark, Mary Ann. "Asho Orisha (Clothing of the Orisha): Material Culture as Religious Expression in Santería." Ph.D. dissertation. Rice University, 1999.

———. *Santería: Correcting the Myths and Uncovering the Realities of a Growing Religion*. New York: Praeger, 2007.

Clayton, Edward T. "The Truth about Voodoo." *Ebony*, April 1951, pp. 54–61.

Clayton, Lawrence. "Bartolomé de las Casas and the African Slave Trade." *History Compass*, volume 7, number 6, November 2009, pp. 1526–1541.

Clines, Francis X. "About New York: Taking Stock of Some City Spirits." *New York Times*, September 11, 1979, p. B20.

Cosentino, Donald. "Who Is That Fellow in the Many-Colored Cap? Transformations of Eshu in Old and New World Mythologies." *Journal of American Folklore*, volume 100, number 397, July–September 1987, pp. 261–275.

Courlander, Harold. *The Drum and the Hoe: Life and Lore of the Haitian People*. Berkeley: University of California Press, 1985 [1960].

Creechan, James H., and Jorge de la Herrán Garcia. "Without God or Law: Narco-culture and Belief in Jesús Malverde." *Religious Studies and Theology*, volume 24, number 2, 2005, pp. 5–57.

Cros Sandoval, Mercedes. *La Religión Afrocubana*. Madrid: Playor, 1975.

Cunningham, Scott. *Cunningham's Encyclopedia of Magical Herbs*. Woodbury, MN: Llewellyn Publications, 2000.

Curtin, Philip D. *The Atlantic Slave Trade: A Census*. Madison: University of Wisconsin Press, 1969.

Davis, Martha Ellen. "Vodu of the Dominican Republic: Devotion to 'La Veintiuna Division.'" *Afro-Hispanic Review*, volume 26, number 1, Spring 2007, pp. 75–90.

Dawkins, Richard. *River Out of Eden*. New York: BasicBooks, 1995.

De Gezelle, Jillian. *Traditional Caribbean Healing in Queens*. New York: Queens Botanical Garden, with the support of the J. M. Kaplan Fund, ca. 2004.

Delgado, Melvin, and Jorge Santiago. "HIV/AIDS in a Puerto Rican/Dominican Community: A Collaborative Project with a Botanical Shop." *Social Work*, volume 43, number 2, March 1998, pp. 183–186.

Deren, Maya. *Divine Horsemen: The Living Gods of Haiti*. New Paltz, NY: McPherson and Company, 1983 [1953].

Desmangles, Leslie G. *The Faces of the Gods: Vodou and Roman Catholicism in Haiti*. Chapel Hill: University of North Carolina Press, 1992.

Drewal, Henry John. "Art or Accident: Yoruba Body Artists and Their Deity, Ogun." In *Africa's Ogun: Old World and New*. 2nd edition. Edited by Sandra T. Barnes. Bloomington: Indiana University Press, 1997.

Dunham, Katherine. *Island Possessed*. New York: Doubleday, 1969.

Durkheim, Emile. *The Elementary Forms of the Religious Life*. Translated by Joseph Ward Swain. New York: Free Press, 1965 [1912].

Ecun, Oba. *Echu Elegbara*. Key Largo, FL: ObaEcun Books, 2003.

Eliade, Mircea. *Patterns in Comparative Religion*. Translated by Rosemary Sheed. New York: Sheed and Ward, 1958.

———. *The Sacred and the Profane: The Nature of Religion*. Translated by Willard R. Trask. New York: Harcourt, Brace, and World, 1959.

Ennis, Sharon R., Merarys Ríos-Vargas, and Nora G. Albert. "The Hispanic Population: 2010," *2010 Census Briefs*, May 2011. http://www.census.gov/prod/cen2010/briefs/c2010br-04.pdf.

Fernández Olmos, Margarite, and Lizabeth Paravisini-Gebert. *Creole Religions of the Caribbean: An Introduction from Vodou and Santería to Obeah and Espiritismo*. New York: New York University Press, 2011.

———, editors. *Sacred Possessions: Vodou, Santería, Obeah, and the Caribbean*. New Brunswick, NJ: Rutgers University Press, 1997.

———, editors. *Healing Cultures: Art and Religion as Curative Practices in the Caribbean and Its Diaspora*. New York: Palgrave/St. Martin's Press, 2001.

Fisch, Stanley. "Botanicas and Spiritualism in a Metropolis." *Milbank Memorial Fund Quarterly*, volume 46, number 3, part 1, July 1968, pp. 377–388.

Fiume, Giovanna. "St. Benedict the Moor: From Sicily to the New World." In *Saints and Their Cults in the Atlantic World*. Edited by Margaret Cormack. Columbia, SC: University of South Carolina Press, 2007, pp. 16–51.

Flores-Peña, Ysamur. "'Candles, Flowers and Perfume': Puerto Rican Spiritism on the Move." In *Botánica Los Angeles: Latino Popular Religious Art in the City of Angels*. Edited by Patrick Arthur Polk. Los Angeles: UCLA Fowler Museum, 2004, pp. 88–97.

Flores-Peña, Ysamur, and Roberta J. Evanchuck. *Santería Altars and Garments: Speaking without a Voice*. Jackson: University Press of Mississippi, 1994.

Forte, Maximilian C., editor. *Indigenous Resurgence in the Contemporary Caribbean: Amerindian Survival and Revival*. New York: Peter Lang Publishing, 2006.

Frazer, James G. *The Golden Bough: A Study of Magic and Religion*. Abridged edition. New York: Macmillan, 1924.

Garrison, Vivian. "Doctor, Espiritista, or Psychiatrist?: Health-seeking Behavior in a Puerto Rican Neighborhood." *Medical Anthropology*, volume 1, number 1, 1977, pp. 65-191.

Geschiere, Peter. "Witchcraft and Modernity: Perspectives from Africa and Beyond." In *Sorcery in the Black Atlantic*. Edited by Luis Nicolau Parés and Roger Sansi. Chicago: University of Chicago Press, 2011, pp. 233–258.

Gleason, Judith, editor and translator. *Leaf and Bone*. New York: Viking Press, 1980.

Goldwasser, Michele Annette. "The Rainbow Madonna of Trinidad: A Study in the Dynamics of Belief in Trinidanian Religious Life." Ph.D. dissertation. University of California at Los Angeles, 1996.

Gomez-Beloz, Alfredo, and Noel Chavez. "The *Botánica* as a Culturally Appropriate Health Care Option for Latinos." *Journal of Alternative and Complementary Medicine*, volume 7, number 5, October 2001, pp. 537–546.

Gonzalez-Wippler, Migene. *Rituals and Spells of Santería*. New York: Original Publications, 1984.

———. *Santería: The Religion*. St. Paul, MN: Llewellyn Publications, 1994.

Graziano, Frank. *Cultures of Devotion: Folk Saints of Spanish America*. Oxford: Oxford University Press, 2007.

Gregory, Steven. *Santería in New York City: A Study in Cultural Resistance*. New York: Garland, 1999.

Guitar, Lynne. "Criollos: The Birth of a Dynamic New Indo-Afro-European People and Culture on Hispaniola." *KACIKE: The Journal of Caribbean Amerindian History and Anthropology*, volume 1, number 1, January–June 2000, pp. 1–17.

Harwood, Alan. *Rx: Spiritist as Needed: A Study of a Puerto Rican Community Health Resource*. Ithaca, NY: Cornell University Press, 1977.

Hayes, Kelly E. "Macumba Has Invaded All Spheres: Africanity, Black Magic, and the Study of Afro-Brazilian Religions." In *The African Diaspora and the Study of Religion*. Edited by Theodore Louis Trost. New York: Palgrave/Macmillan, 2007, pp. 167–180.

History and Commerce of New York, 1891. American Publishing and Engraving. N.p.: Ulam Press, 2012 [1891].

Howard, Philip A. *Changing History: Afro-Cuban Cabildos and Societies of Color in the Nineteenth Century*. Baton Rouge: Louisiana State University Press, 1998.

Idowu, E. Bolaji. *Olodumare: God in Yoruba Belief*. London: Longmans, 1962.

Isola, Akinwumi. "Religious Politics and the Myth of Sango." In *African Traditional Religions in African Society*. Edited by Jacob K. Olupona. New York: Paragon House, 1991, pp. 93–99.

Jacobs, Claude F., and Andrew J. Kaslow. *The Spiritual Churches of New Orleans: Origins, Beliefs, and Rituals of an African-American Religion*. Knoxville: University of Tennessee Press, 1991.

Jorge, Angela. "*La madama francesita*: A New World Black Spirit." In *Global Dimensions of the African Diaspora*, 2nd edition. Edited by Joseph E. Harris. Washington, DC: Howard University Press, 1993, pp. 205–222.

Johnson, Samuel. *The History of the Yorubas: From the Earliest Times to the Beginning of the British Protectorate*. Lagos, Nigeria: C.M.S. Bookshops, 1921 [1897].

Jones, Michael Owen, and Patrick A. Polk, with Ysamur Flores-Peña and Robert J. Evanchuck. "Invisible Hospitals: Botánicas in Ethnic Health Care." In *Healing Logics: Culture and Medicine in Modern Health Belief Systems*. Edited by Erika Brady. Logan, UT: Utah State University Press, pp. 39–87.

Kardec, Allan. *The Spirit's Book*. Sao Paulo, Brazil: Livraria Allan Kardec Editora, n.d.

Keen, Benjamin, "Introduction: Approaches to Las Casas, 1535–1970." In *Bartolomé de las Casas in History: Toward an Understanding of the Man and his Work*. Edited by Juan Friede and Benjamin Keen. DeKalb: Northern Illinois University Press, 1971, 3–63.

Kirsch, J. P. "St. Barbara." In *The Catholic Encyclopedia*, volume 2. Robert Appleton Company, 1907. http://www.newadvent.org/cathen/02284d.htm. Accessed April 25, 2014.

Kongtrul, Jamgön. *Creation and Completion: Essential Points of Tantric Meditation*. Translated and introduced by Sarah Harding. Boston: Wisdom Publications, 2002.

Koss-Chioino, Joan D. "Spirit Healing, Mental Health, and Emotion Regulation." *Zygon*, volume 40, number 2, June 2005, pp. 409–421.

Lachatañeré, Rómulo. "Los Jardines Botánicos en el Harlem." In *El Sistema Religioso de los Afrocubanos*. Havana: Editorial de Ciencias Sociales, 1992 [1942], pp. 393–395.

Lammoglia, José Antonio. "Botánicas: Presence in Miami, Absence in Cuba." M.A. thesis. Latin American and Caribbean Center. Florida International University, 2001.

Las Casas, Bartolomé de. *The Devastation of the Indies: A Brief Account*. Translated by Herma Briffault. Baltimore: Johns Hopkins University Press, 1992 [1552].

Lasso de la Vega, Luis. *Our Lady of Guadalupe* [1649]. Translated by Harriet de Onis. In *Religion in Latin America: A Documentary History*. Edited by Lee M. Penyak and Walter J. Petry. Maryknoll, NY: Orbis Books, 2006, pp. 96–98.

Leach, E. R., editor. *Dialectic in Practical Religion*. Cambridge: Cambridge University Press, 1968.

Lomnitz Adler, Claudio. *Death and the Idea of Mexico*. Brooklyn, NY: Zone Books, 1995.

Long, Carolyn Morrow. *Spiritual Merchants: Religion, Magic, and Commerce*. Knoxville: University of Tennessee Press, 2001.

Malinowski, Bronislaw. *Magic, Science and Religion and Other Essays*. Garden City, NY: Doubleday, 1954 [1925].

Marks, Morton. "Exploring *El Monte*: Ethnobotany and the Afro-Cuban Science of the Concrete." In *En Torno a Lydia Cabrera*. Edited by Isabel Castellanos and Josefina Inclán. Miami: Ediciones Universal, 1987, pp. 227–244.

Marrero, Levi. *Los esclavos y la Virgen del Cobre: Dos siglos de lucha por la libertad de Cuba*. Miami: Ediciones Universal, 1980.

Mason, John. *Orin Òrì à: Songs for Selected Heads*. New York: Yoruba Theological Archministry, 1992.

————. *Who's Knocking on My Floor?: Ù Arts in the Americas*. Brooklyn, NY: Yoruba Theological Archministry, 2003.

Matory, J. Lorand. *Sex and the Empire That Is No More: Gender and the Politics of Metaphor in Oyo Yoruba Religion*. Minneapolis: University of Minnesota Press, 1994.

————. "Free to Be a Slave: Slavery as a Metaphor in the Afro-Atlantic Religions." In *Africas of the Americas: Beyond the Search for Origins in the Study of Afro-Atlantic Religions*. Edited by Stephan Palmié. Leiden, The Netherlands: Brill, 2008, pp. 351–380.

McDannell, Colleen. *Material Christianity: Religion and Popular Culture in America*. New Haven, CT: Yale University Press, 1995.

Medina, Lara. "Altars and Shrines." In *Hispanic American Religious Cultures*. Volume 1. Edited by Miguel A. De La Torre. Santa Barbara, CA: ABC-CLIO, 2009, pp. 28–36.

Montejo, Esteban. *The Autobiography of a Runaway Slave*. Edited by Miguel Barnet. Translated from the Spanish by Jocasta Innes. New York: Pantheon Books, 1968.

Moreno Fraginals, Manuel. "Africa in Cuba: A Quantitative Analysis of the African Population in the Island of Cuba." In *Comparative Perspectives on Slavery in New World Plantation Societies*. Edited by Vera Rubin and Arthur Tudin. New York: New York Academy of Sciences, 1977, pp. 187–201.

Murphy, Joseph M. *Santería: African Spirits in America*. Boston: Beacon Press, 1992.

————. "Yoruba Religions in Diaspora." *Religion Compass*, volume 4, number 7, 2010, 400–409.

————. "'Changó 'ta 'veni'/Changó Has Come: Spiritual Embodiment in the Afro-Cuban Ceremony *Bembé*." *Black Music Research Journal*, volume 32, number 1, Spring 2012, 69–94.

Newby, C. Alison, Donna Riley, and Tomas Leal-Almeraz. "Mercury Use and Exposure among Santeria Practitioners: Religious versus Folk Practice in Northern New Jersey, USA." *Ethnicity & Health*, volume 11, number 3, August 2006, pp. 287–306.

O'Brien, David M. *Animal Sacrifice and Religious Freedom: Church of Lukumi Babalu Aye v. City of Hialeah*. Lawrence: University Press of Kansas, 2004.

Oggun Gbemi, Maria. *Ritual Use of Plants in Lucumi Tradition*. Raleigh, NC: Lulu Press, n.d., ca. 2008.

Orsi, Robert A. *Thank You, St. Jude: Women's Devotion to the Patron Saint of Hopeless Causes*. New Haven, CT: Yale University Press, 1996.

Ososki, Andreana, L., et al. "Ethnobotanical Literature Survey of Medicinal Plants in the Dominican Republic Used for Women's Health Conditions." *Journal of Ethnopharmacology*, volume 79, 2002, pp. 285–298.

Pachter, Lee M. "Culture and Clinical Care: Folk Illness Beliefs and Behaviors and Their Implications for Health Care Delivery." *Journal of the American Medical Association*, volume 271, number 9, March 2, 1994, pp. 690–694.

Palmié, Stephan. "Against Syncretism: 'Africanizing' and 'Cubanizing' Discourses in North American Òrì à Worship." In *Counterworks: Managing the Diversity of Knowledge*. Edited by Richard Fardon. New York: Routledge, 1995, pp.73–104.

————. *Wizards and Scientists: Explorations in Afro-Cuban Modernity and Tradition*. Durham, NC: Duke University Press, 2002.

————. "Is There a Model in the Muddle: 'Creolization' in African Americanist His-

tory and Anthropology." In *Creolization: History, Ethnography, Theory*. Edited by Charles Stewart. Walnut Creek, CA: Left Coast Press, 2007, pp. 178–200.

———. "Other Powers: Tylor's Principle, Father Williams's Temptations, and the Power of Banality." In *Sorcery in the Black Atlantic*. Edited by Luis Nicolau Pares and Roger Sansi. Chicago: University of Chicago Press, 2011, pp. 316–340.

Parrilla, Rosa E. *A Collection of Prayers for the Modern Spiritist*. Raleigh, NC: Lulu Press, 2008.

Pedraza, Silvia. *Political Disaffection in Cuba's Revolution and Exodus*. Cambridge: Cambridge University Press, 2007.

Pérez, Elizabeth. "Spiritist Mediumship as Historical Mediation: African American Pasts, Black Ancestral Presence, and Afro-Cuban Religion." *Journal of Religion in Africa*, volume 1, 2011, pp. 330–365.

Pieper, Jim. *Guatemala's Folk Saints*. Los Angeles: Pieper and Associates, 2002.

Polk, Patrick Arthur. *Botánica LA: Latino Popular Religious Art in the City of Angels*. Los Angeles: UCLA/Fowler Museum, 2004.

———. "Black Folks at Home in the Spirit World." In *Activating the Past: History and Memory in the Black Atlantic World*. Edited by Andrew Apter and Lauren Derby. Newcastle upon Tyne: Cambridge Scholars Publishing, 2010, pp. 371–413.

Polk, Patrick Arthur, and Michael Owen Jones. "Hermano Carlos and San Simón." In *Botánica Los Angeles: Latino Popular Religious Art in the City of the Angels*. Los Angeles: UCLA Fowler Museum of Cultural History, 2004, pp. 108–121.

Pollak-Eltz, Angelina. "Imagination in the Creation of New Spiritual Cults in Latin America: The Cult of Maria Lionza." In *Imagination in Religion and Social Life*. Edited by George F. McLean and John K. White. Washington, DC: Council for Research in Values and Philosophy, 2003, pp. 79–88.

Price-Mars, Jean. *Thus Spoke the Uncle*. Translated by Magdaline W. Shannon. Washington, DC: Three Continents Press, 1983 [1928].

Primiano, Leonard Norman. "Postmodern Sites of Catholic Sacred Materiality." In *Perspectives on American Religion and Culture*. Edited by Peter W. Williams. Malden, MA: Blackwell Publishing, 1999, pp. 187–202.

Puckett, Newbell Niles. *The Folk Beliefs of the Southern Negro*. New York: Dover, 1969 [1926].

Ramos, Miguel W. "Ashé in Flux: The Transformation of Lukumí Religion in the United States." Paper presented at the 47th Annual Conference of the Center for Latin American Studies at the University of Florida, Gainesville, FL, 1998.

———. "The Empire Beats On: Oyo Batá Drums and Hegemony in Nineteenth-Century Cuba." M.A. thesis. Florida International University, 2000.

Redfield, Robert. *The Little Community and Peasant Society and Culture*. Chicago: Phoenix Books, 1968 [1956].

Rey, Terry. *Our Lady of Class Struggle: The Cult of the Virgin Mary in Haiti*. Trenton, NJ: Africa World Press, 1999.

Rey, Terry, and Alex Stepick. *Crossing the Water and Keeping the Faith: Haitian Religion in Miami*. New York: New York University Press, 2013.

Romberg, Raquel. *Witchcraft and Welfare: Spiritual Capital and the Business of Magic in Modern Puerto Rico*. Austin: University of Texas Press, 2003.

———. *Healing Dramas: Divination and Magic in Modern Puerto Rico*. Austin: University of Texas Press, 2009.

Rostas, Susanna, and André Droogers. "The Popular Use of Popular Religion in Latin America: Introduction." In *The Popular Use of Popular Religion in Latin America*. Edited by Susanna Rostas and André Droogers. Amsterdam: CEDLA, 1993, pp. 1–16.

Rumbaut, Rubén G. "The Americans: Latin American and Caribbean Peoples in the United States." In *Americas: New Interpretive Essays*. Edited by Alfred Stepan. New York: Oxford University Press, 1992, pp. 275–307.

Salvo, Dana. *Home Altars of Mexico*. Albuquerque: University of New Mexico Press, 1997.

Scott, Robert A. *Miracle Cures: Saints, Pilgrimage, and the Healing Powers of Belief*. Berkeley: University of California Press, 2010.

Semple, Kirk. "At a Botanica, New Year Means Renewal, and Jinx Removal." *New York Times*, January 4, 2010.

Sherer, Frank F. *Sanfancón: Orientalism, Confucianism, and the Construction of Chineseness in Cuba, 1847–1997*. Toronto: Centre for Research on Latin America and the Caribbean, 1998.

Smith, Jonathan Z. "Religion, Religions, Religious." In *Critical Terms for Religious Studies*. Edited by Mark C. Taylor. Chicago: University of Chicago Press, 1998, 269–284.

Smith, Robert S. *Kingdoms of the Yoruba*. 3rd edition. Madison: University of Wisconsin Press, 1988 [1969].

Spiro, Melford E. "Religion: Problems of Definition and Explanation." In *Anthropological Approaches to the Study of Religion*. Edited by Michael Banton. London: Tavistock 1966, pp. 85–126.

Stanzione, Vincent. "Maximón." In *Encyclopedia of Religion*. Edited by Lindsay Jones. Detroit: Macmillan Reference USA, 2005, pp. 5790–5792.

State of Oregon v. Ramona E. de la Rosa. Court of Appeals of the State of Oregon. May 27, 2009. http://www.publications.ojd.state.or.us/Publications/A133793.htm.

Stenger, Victor J. *God: The Failed Hypothesis—How Science Shows That God Does Not Exist*. Amherst, NY: Prometheus Books, 2007.

Stewart, Charles, and Rosalind Shaw, editors. *Syncretism/Antisyncretism: The Politics of Religious Synthesis*. New York: Routledge, 1994.

Taussig, Michael. *Shamanism, Colonialism, and the Wild Man: A Study in Terror and Healing*. Chicago: University of Chicago Press, 1986.

Thompson, Robert Farris. *Flash of the Spirit: African and Afro-American Art and Philosophy*. New York: Random House, 1983.

———. *The Faces of the Gods: Art and Altars of Africa and the African Americas*. New York: Museum for African Art, 1993.

Torres, Maria de los Angeles. *In the Land of Mirrors: Cuban Exile Politics in the United States*. Ann Arbor: University of Michigan Press, 1999.

Tsemberis, Sam, and Ana Stefancic. "The Role of an Espiritista in the Treatment of a Homeless, Mentally Ill Hispanic Man." *Psychiatric Services*, volume 51, number 12, 2000, pp. 1572–1574.

Turner, Victor. "Betwixt and Between: The Liminal Period in *Rites de Passage*." In *The Forest of Symbols: Aspects of Ndembu Ritual*, by Victor Turner. Ithaca, NY: Cornell University Press, 1967, pp. 93–111.

Vega, Marta Moreno. "The Yoruba Orisha Tradition Comes to New York City." *African American Review*, volume 29, number 2, Summer 1995, pp. 201–206.

Verger, Pierre. *Notes sur le culte des Orisa et Vodun*. Dakar, Senegal: L'Institut Français d'Afrique Noire, 1959.

Viladrich, Anahí. "Beyond the Supernatural: Latino Healers Treating Latino Immigrants in NYC." *Journal of Latino-Latin American Studies*, volume 2, number 1, Spring 2006, pp. 134–148.

———. "Botánicas in America's Backyard: Uncovering the World of Latino Healers' Herb-Healing Practices in New York City." *Human Organization*, volume 65, number 4, Winter 2006, pp. 407–419.

Winslow, David J. "Bishop E.E. Everett and Some Aspects of Occultism and Folk Religion in Negro Philadelphia." *Keystone Folklore Quarterly*, volume 14, number 2, 1969, pp. 59–80.

Yoder, Don. "Toward a Definition of Folk Religion." *Western Folklore*, Symposium on Folk Religion, volume 33, number 1, January 1974, pp. 2–15.

Zayas, Luis H., and Philip O. Ozuah. "Mercury Use in Espiritismo: A Survey of Botanicas." *American Journal of Public Health*, volume 86, number 1, 1996, pp. 111–112.

Index

CHANGO

Se Vende todo tipo de Articulos Religiosos
al por Mayor y al Detalle

EL FABRICANTE MAS GRANDE DE CASCARILLA

Religious Articles • Wholesale & Retail

1180 Palm Avenue • Hialeah, Fl 33010
Fax 305.885.1668
305.885.1669

PACO'S BOTANICA
La LLave del exito

1864 Lexington Ave.
(El Barrio)
N.Y., N. Y. 10029
(212) 427-0820
www.pacosbotanicastore.blogspot.com

botanica san rafael

venta de perfumes,aceites,banos espirituales

maria calderon
lecturas de cartas

3533 14th st nw #2 washington dc 20010
esperitista cubana,mayonbera

botanicasanrafael@hotmail.com
cell 240-481-7988

TowaCrafts Corp.

Artesania Exclusiva
Yoruba - Palo Mayombe - Ifa
http://towacrafts.com

e-mail:towacrafts@gmail.com (305) 527-2053

B
BOTANICA
Boricua

Arlington, VA: 703-271-1248
Silver Spring, MD: 301-933-4611

**BOTANICA
SAN ANTONIO**

Lectura de Cartas Con Citas

• MEDICINAS NATURALES
• VEIAS
• INCENSOS
• ACEITES Y MAS

703.684.001
Phone/fax: 703.684.003

*Botanica
San
Cipriano*

We Specialize in * Candles * Incense
Spiritual Baths * Sprays * Herbs * Statues
Everything for Your Spiritual Needs
Mon - Sat 11.00 AM.- 7.00 PM

3304 Georgia Ave. NW
Washington, D.C. 20010
TEL: (202) 726-7300

ST NICOLAS BOTANICA

Spiritual Advisor and Healer Problems
Good Luck . Bad Luck
Money . Job . Card Reading . Ect.....
Voyant Spirituel sur tous les Domaines de la vie .

Marie
Goumen pou sa-w kwe
786-436-6921
5600 N.W. 2 AVE
Miami FL 33137

San Lazaro Flower:
Botanica

Gran Surtido de Imagenes Religiosa

Hierbas Frescas

Tel: (305) 884-1707 • Fax (305) 884-503
402 East 13th Street
Hialeah, Florida 33010

(860) 241-9077
860) 380 6888

Botanica Orula
Let Us Serve You With A Smile

Amalia Jimenez

OPEN
MON. THRU SAT.
10 A.M. TO 7 P.M.

167 ALBANY AVE.
HARTFORD, CT 06120

BOTANICA
YEMAYA & CHANGO
Artículos Religiosos

BAÑOS - VELAS - HI ERBAS
SOPERAS - IMAGENES - LIBROS
y mucho más...

6111 S.W. 8 Street,
Miami, FL. 33144

Tel: 305-267-7858
www.yemayachango.com

HALOUBA TEMPLE
MANMITA PRIESTESSE
101 NE Street Miami, Fl. 33137
SATISFACTION GARANTIE

Amour
Chance
Mariage
Affaires
Initiations

Lavement de Têt
L'orientation dan
Comment Contrôler Vos Esprits
que Nous Pouvons vous aide
avec n'importe quel type d
Travaux Spirituel

E-mail: manmita42@yahoo.co.
www.haloubatemple.com
C: 754 204 8867 / O: 340 473 059

*Botanica Pet Shop
El Viejo Lazaro*

Wholesale and Retail

5830 W Flagler Street, Miami Fl 33144
sales@viejolazaro.com
www.viejolazaro.com

Oba Oriate: Nelson Hernandez
President

Ph: 305.269.0045

San Elias Y Santa Marta
Botánica
ESPERANZA

CONSULTAS ESPIRITUALES
2617 Mount Vernon Ave.
Alexandria, VA 22301

Hours 9:00 - 6:30
Tel: 703.519.6129
703.519.9838

Martha

BOTANICA SANTA BARBARA

Baños Espirituales - Jabones
Artículos Religiosos
Libros - Velarodas
Limpias Espirituales
Lectura del Tabaco
(301) 277 - 2246
*4317 Kenilworth Ave.
Bladensburg, MD. 20710*

Abierto 7 Dias de la Semana

Maria Delah
Ide Aurore
DONDE LA CARIDAD ESTA COMPARTIDA

ALMACEN & BOTANICA OCHUN
Somos Distribuidores De:
Velas - Inciensos - Aceites - Perfumes
Plantas Frescas y Secas
Todos los Productos de Botanica

Tel. 212-831-9228 Fax: 212-534 - 6557
1630 Park Ave. New York, N.Y. 10031 Bet. 115-116 S
Email: oochun25@hotmail.com

Botanica La Africana
(305) 551.8215

Monday • Thru • Saturday
8:00 to 5:30 pm

9562 S.W. 40 St.
Miami, FL 33165

LA CARIDAD, INC.

Tenemos lo necesario
para su ayuda espiritual
Linea de Regalos
Prods. naturales para la salud
Envios de dinero
Computadoras y Taxes

111 University Blvd W 2° piso
Silver Spring, MD 20901
Tel: (301) 754-0071
Fax: 1(800) 524-9849
lacaridad5@yahoo.com
www.caridad5.com

"BOTANICA y REGALOS"

Tel: 718-367-9589

Fax: 718-367-3613

Original Products Company
2486-88 Webster Avenue
Bronx, New York 10458

JASON MIZRAHI
President

www.originalprodcorp.com

Botanica Los Sueños

•Ayudando con
enfermedades
desconocidas
•Consulta de Cartas
•Amarres, Conjuros y
Limpias

Lupe cell (415)410-5046
Negocio (415)642-1870
3274 23rd St entre calles
Mission y Capp en
San Francisco, CA 94110

Yemaya & Chango

BOTANICA YEMAYA OBATALA

ARTICULOS RELIGIOSOS-CERAMICA-
HIERBAS SANTORALES-ARTESANIA-
ENTREGAS PARA SANTOS-ANIMALES
1700 WEST 4TH AVENUE

Botanica Tres Potencias
Esperimenta "una sola parada" para
todas tus necesidades espirituales.
Experience the "one stop shop" for
all of your spiritual needs.